THE
JEWELRY
RECIPE
BOOK

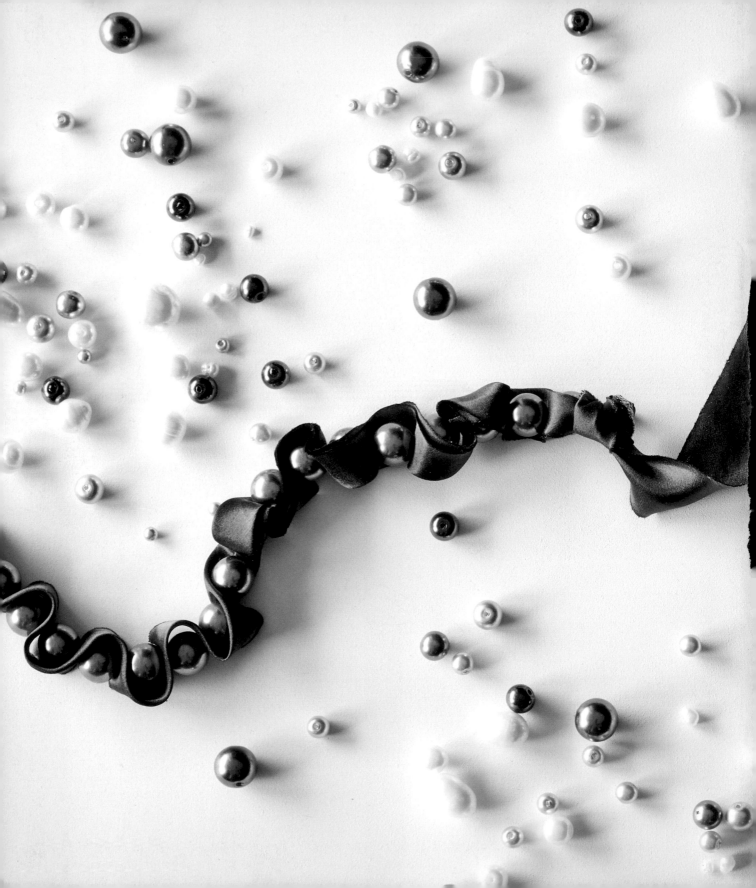

THE
JEWELRY
RECIPE
BOOK

Transforming Ordinary Materials
into Stylish and Distinctive Earrings,
Bracelets, Necklaces, and Pins

Nancy Soriano

Photographs by James Ransom

ARTISAN
NEW YORK

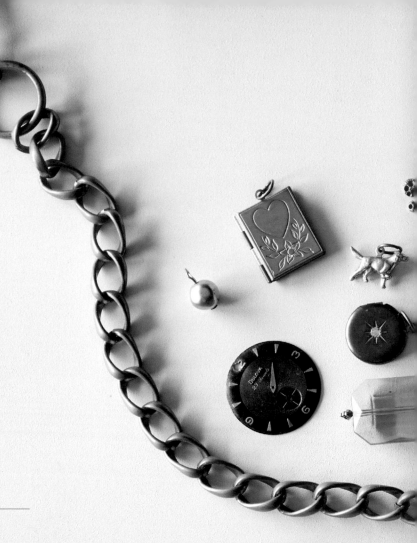

Copyright © 2015 by Nancy Soriano
Photographs copyright © 2015 by James Ransom

Project Manager: Jenn Andrlik
Styling: India Donaldson, Jenn Andrlik, and Nancy Soriano
Designers/Makers: India Donaldson, Tamara Schafhauser,
Jenn Andrlik, Laura Kaesshaefer, and Alison Caporimo
Painted Surfaces: Carol Kemery, Caromal Colours

Library of Congress Cataloging-in-Publication Data

Soriano, Nancy.
 The jewelry recipe book : transforming ordinary materials into stylish
and distinctive earrings, bracelets, necklaces, and pins / Nancy Soriano.
 pages cm
 ISBN 978-1-57965-618-8
 1. Jewelry making. I. Title.
 TT212.S66 2015
 745.594'2—dc23 2014035875

Design by Michelle Ishay-Cohen

Artisan books are available at special discounts when purchased in
bulk for premiums and sales promotions as well as for fund-raising or
educational use. Special editions or book excerpts also can be created
to specification. For details, contact the Special Sales Director at the
address below, or send an e-mail to specialmarkets@workman.com.

Published by Artisan
A division of Workman Publishing Company, Inc.
225 Varick Street
New York, NY 10014-4381
artisanbooks.com

Published simultaneously in Canada by Thomas Allen & Son, Limited

Printed in China
First printing, March 2015

10 9 8 7 6 5 4 3 2 1

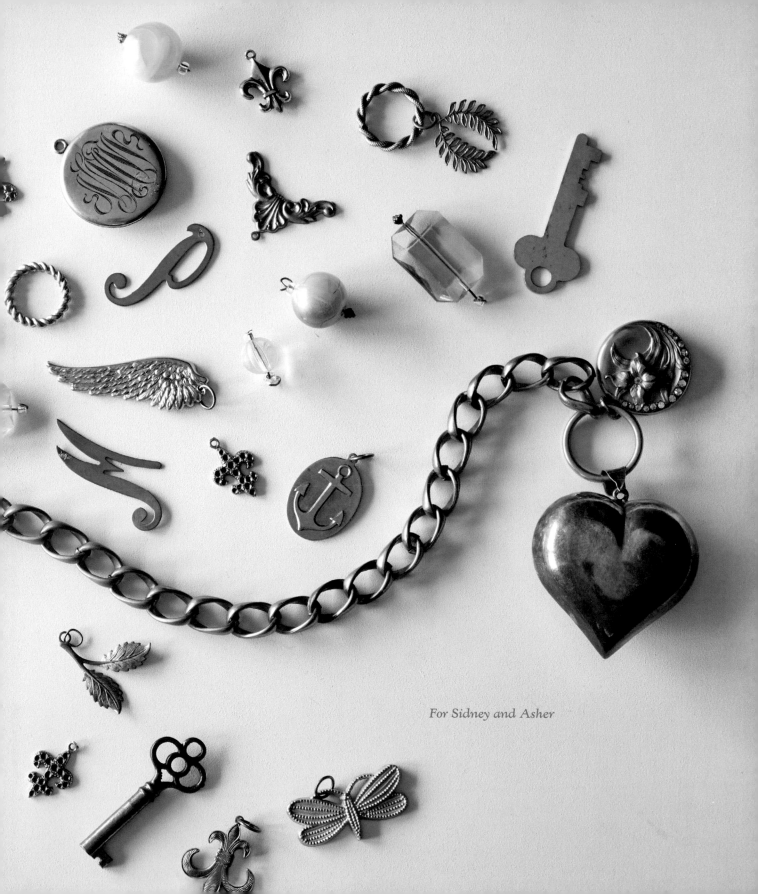

For Sidney and Asher

CONTENTS

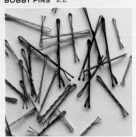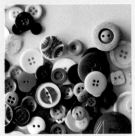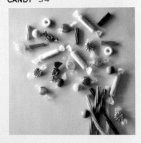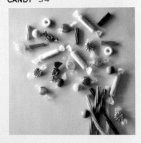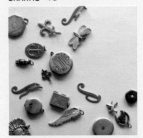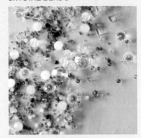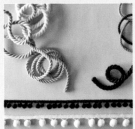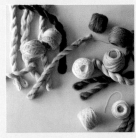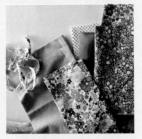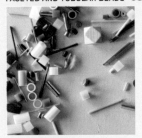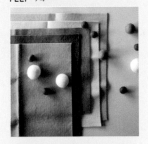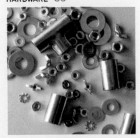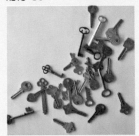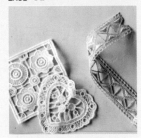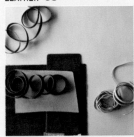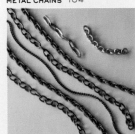

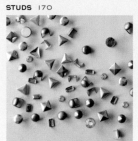
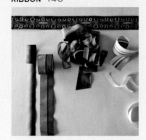
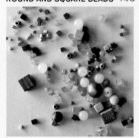
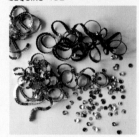
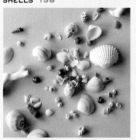
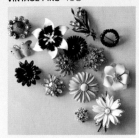
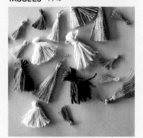

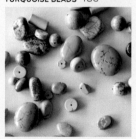
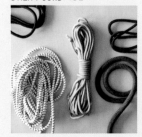
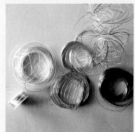

INTRODUCTION

Personal style evolves in each of us in very different ways, and we live in a time when inspiration is widely available and experimentation is encouraged. I was lucky to be given the freedom to experiment and develop my own eye from an early age.

My mother studied interior design, and most likely would have run her own firm had she not chosen to stay home to raise her children. She was always scouting flea markets and antique shows for great finds, and she loved searching Henri Bendel and Bergdorf Goodman for the perfect apparel and shoes. (Geoffrey Beene and Bill Blass were her favorite designers.) She let me tag along with her on shopping excursions, and I happily gave up many a Saturday with friends to accompany her. She also let me go through her drawers and dress up in her jewelry, and I enjoyed playing with combinations of vintage Miriam Haskell pieces, Monet and silver hoop earrings, and my own handmade beaded bracelets as my style grew and developed.

Later, when I was in high school, I took an anthropology class, which gave rise to curiosity about other cultures; I began to see that there were deeper reasons for how and why people make the choices they do in their interiors and with their dress. And then in college, as an art history major, I learned about culture, history, social change, and the world economy, all the while studying color, shape, construction, and craftsmanship.

Today, my personal style reflects my varied background—I love blending different looks to create something new, like pairing a bold cuff with a simple T-shirt, or layering vintage necklaces with classic pearls, similar to layering textiles and textures in interior designs. I look for a balance of scale and form, and I enjoy coming up with unexpected interpretations of a material or pairings of materials or colors, going against established norms, mixing pattern on pattern, playing with scale, and being bold (or not) with color.

Personal style today is affected by a wide range of influences, from street fashion to design magazines to runway shows, and there is a freedom to how we all dress, unrestricted by an overarching trend or norm. Everyone has the tools and the ability to create his or her own personal style, which is what makes fashion and design so thrilling, and what makes me so excited to bring *The Jewelry Recipe Book* to you.

The jewelry in this book, which combines the humblest of materials with the most classic to create something both unexpected and timeless, is a perfect reflection of where design is today. This isn't a book about one technique or one material—instead, I focus on a wide range of simple materials and techniques, broadening the possibilities for personal expression. I intentionally worked with materials that are accessible to all, whether online or in craft stores, and while you can use better-quality materials than I did in the book (for example, higher-quality pearls or finer crystal beads), you don't have to.

Each recipe captures a specific look as well as the nature of the material, and sometimes the material will surprise you. (Is that really made from polymer clay?) Some of the recipes are just plain fun and whimsical, perfect for children as well as adults, while other projects take a more sophisticated approach, looking at the material in a new way and pairing it with unlikely companions or colors.

At the heart of this book is the passion to create and be creative with personal style. Jewelry makes a statement, and it speaks to the core of how we see ourselves, how others see us, and how we have fun with our fashions. We can change our mood and our persona with just a necklace, a ring stack, or a cluster of bangles, so what better way to put our own stamp on our fashions than by making our jewelry ourselves? Don't be afraid to mix the classic with the unexpected—go ahead, dive in, and create. You will be surprised at what the simplest material can yield when you add a personal touch.

TOOLBOX

These are the basic tools used in this book:

Adhesives: Two standard adhesives for crafting are E6000 Permanent Craft Adhesive and Magna-Tac 809. Both are clear adhesives. I prefer to use Magna-Tac when working with softer materials, such as fabric. Both can be used on leather, wood, and metal.

Bead needles: Bead needles are very thin and flexible and come in different lengths to accommodate all types and sizes of beads. They are important to have for stringing beads, particularly small beads.

Crimp beads: Crimp beads are used to anchor both ends of a strand of beads, while simultaneously creating a loop for attaching a clasp or a jump ring.

Embroidery needle: It is good to have an embroidery needle in your tool kit. You will find the needle helpful beyond embroidery projects. I use one to tuck in threads when finishing a wrapped piece, as well as for separating threads when finishing off tassels. Embroidery needles come in different sizes: the higher the number, the smaller the needle. I suggest having both a larger- and smaller-size embroidery needle.

Hot glue gun: A hot glue gun creates and dispenses hot glue for use as an adhesive in many types of projects. If you do not have one, you should. It's very useful for anchoring materials, such as a thread before you begin to wrap, and for adhering objects to jewelry blanks.

Hot glue sticks: These are the sticks of solid glue used in a hot glue gun.

Japanese screw punch: This tool punches holes in paper, cardboard, leather, and even felt, easily and precisely. Tips come in different sizes.

Jump rings: Jump rings are round loops of metal that are not soldered, so they can be opened and closed with pliers. Their basic function is to connect two pieces to each other. Jump rings are a key supply in many of the recipes. You will use various sizes in chrome or yellow metal.

Nylon thread: Nylon thread is primarily used for beading. You can work with other materials for beading (wire and silk thread are two examples), but for a basic toolbox, I suggest you start with nylon. It is readily available, comes in various colors, and will hold heavier beads such as turquoise or crystal. In addition, it will not fray the way silk cord can when holding a rougher bead.

Pliers (round-nose and flat-nose): Jewelry pliers are essential to your toolbox. They will transform the experience of making jewelry, specifically working with jump rings. There are many types of pliers for jewelry making. However, for a basic toolbox, I would recommend two types: round-nose and flat-nose. Round-nose pliers have tapered round tips, which are a bit more pointed. They are ideal for opening and closing jump rings and for making loops and wrapping wire. Flat-nose pliers have flat, wider tips and are smooth on the inside. They are ideal for crimping, gripping, and holding in place wire or jump rings. See also "Wire snips" on the next page.

Ruler: You should have a stiff straight-edge ruler for measuring, for cutting against (with an X-Acto knife or a rotary cutter), and to use as a template when making tassels. It can be wood or metal.

Scissors: You should have a very good pair of all-purpose scissors with sharp blades. All-purpose scissors can be used to cut fabric. However, fabric scissors should never be used to cut paper or leather, as that will dull the blades.

Self-healing mat: This mat will protect table and counter surfaces when cutting. Because of the material it is made of, the mat itself will withstand repeated cuts and use. Measurement grids on the mat are helpful when precise cutting is important. Store flat.

Sewing needle and thread: A basic set of materials you will need for sewing any type of fabric together. Have a light- and a dark-colored thread.

Tailor's chalk: Tailor's chalk makes temporary markings on fabric or ribbon so that you know where to cut fabric or sew buttons, and it is available in a variety of colors. White chalk is good to use on darker colors. Use blue for lighter colors and whites. Consider wash-away chalk.

Tape: Painter's tape is used to block out areas that should (or should not!) be painted, leaving a smooth, clean edge once the paint has dried and the tape is removed. It can also be used on various textures, including cord, wood, and metal. Washi tape is a decorative tape used by crafters. It is generally made from natural materials, like bamboo, that give it a different texture and look from painter's tape. It comes in many different colors, patterns, and widths. I like having the smaller, narrower washi tapes in my toolbox to offset the wider rolls of painter's tape.

Wire snips: Wire snips are a type of pliers that cut wire.

X-Acto knife: This utility knife can be used for precision cutting of leather and paper. You can also use it to cut polymer clay pieces. The blades are interchangeable.

You might also like to have the following items on hand:

Fray Check: Fray Check is a clear liquid plastic applied to the edge of cut fabric to prevent fraying. It is machine washable.

Hole punch: Hole punches are used to make holes in paper and thin materials. They come in a variety of sizes; I generally use a standard size with a cushioned grip.

Marking pencils: Marking pencils are used to mark areas to cut, punch, or stitch. Consider a silver pencil for light materials and a white pencil for darker ones. Often made of chalk, the pencils are soft, and marks will wash out.

Mod Podge: Mod Podge is a glue known for its use in decoupage and also for paper and fabric projects. It comes in a variety of formulas; we used Classic Mod Podge.

Rotary cutter: Rotary cutters are excellent for cutting layers of fabric, felt, paper, and leather.

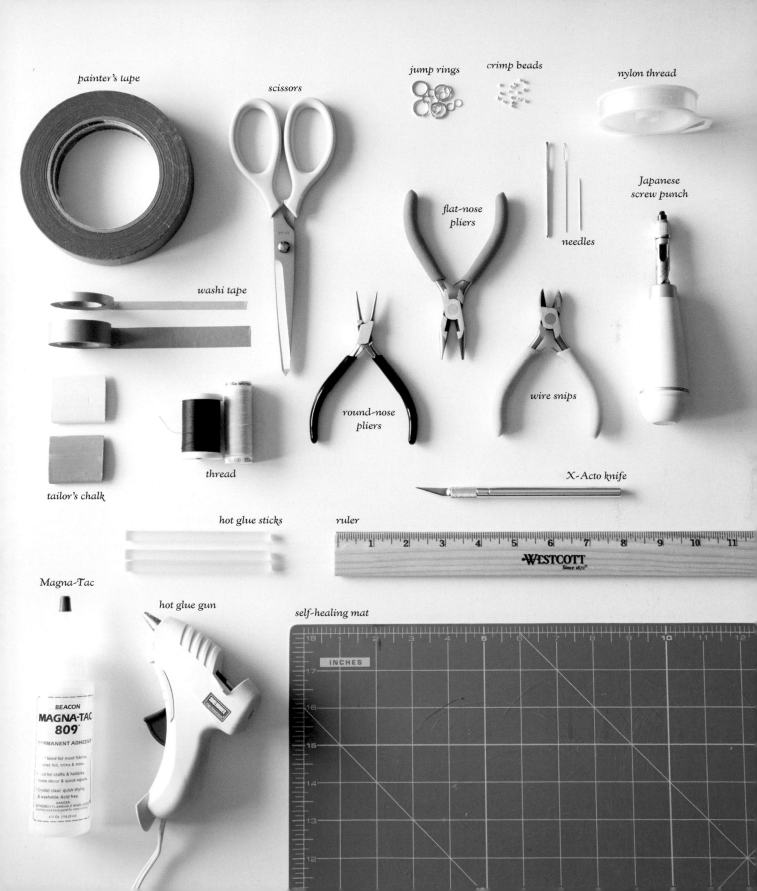

painter's tape

scissors

jump rings

crimp beads

nylon thread

flat-nose
pliers

Japanese
screw punch

needles

washi tape

round-nose
pliers

wire snips

thread

tailor's chalk

X-Acto knife

hot glue sticks

ruler

WESTCOTT
Since 1872

Magna-Tac

hot glue gun

self-healing mat

BEACON
MAGNA-TAC
809™
PERMANENT ADHESIVE

Here are some general tips and techniques to keep in mind when following the recipes in this book.

CRIMPING

Basic: String a crimp bead onto the beading wire after you've strung beads onto the necklace you're making. Using flat-nose pliers, flatten the crimp bead to hold the components in place. Add as many crimp beads as desired.

Crimping and creating loops for jump rings: String a crimp bead onto the beading wire. Thread the end of the wire back through the crimp bead, creating a loop. Position the end of the wire so that it is poking out approximately ¼ inch past the edge of the crimp bead. Pull the longer piece of the wire to make the loop approximately 3 mm—it only needs to be large enough to fit a jump ring through. Use flat-nose pliers to flatten the crimp bead and hold it in place on the wire. String on the desired amount of beads, making sure to hide the short wire tail near the crimp under the first bead. When the beading is complete, string a paper clip into the loop at the beginning of the strand. Using the paper clip ensures that the strand has the appropriate amount of give in the wire and allows you to more easily tighten the wire at the end by giving you something to hold and pull against. String a crimp bead onto the wire after the last bead. Pass the beading wire through the paper clip near where the other end of the strand is sitting and thread it back down through the crimp bead and one bead after the crimp. Pull the wire tight, making sure that no loose wire is exposed between the beads. Use flat-nose pliers to flatten the crimp bead and hold it in place on the wire. Trim any excess wire as close to the beads as possible. Slip the strand off of the paper clip.

CROCHET CHAIN

Before you begin, wind the yarn into two separate balls. Use two different yarn colors for a tweedy necklace. Make a slip knot with the yarn and insert the hook into the slip knot. Yarn over by wrapping the yarn around the hook from back to front. Draw the yarn over through the loop on the hook. Repeat.

DULLING PIN TIPS

When using vintage pins in jewelry, you always want to be mindful of the pointed ends on the pin spokes. There are multiple ways to protect yourself from unwanted pokes while you enjoy your new jewelry:

- You can cut and/or file the tip of the pin spoke. Any metal reaching out farther than is needed to catch the pin latch can be trimmed away. A file can be used to soften the end of the spoke (cut or uncut) to help keep it from scratching your skin.

- You can also apply glue over the closure of the pin to keep the sharp pin spoke away from your skin and to ensure that the pin stays closed and in place.

- A rubber earring back can be used to cap a sharp pin spoke if you do not want to cut, file, or apply glue to it. This is a great option when using a vintage pin that you would prefer to keep in its original condition.

DYEING

To make a dye bath, fill a plastic or glass bowl (a container you do not use for food) halfway to the top with warm water. Be sure it's large enough to accommodate the number of items you wish to dye. Wear an apron and gloves. (RIT dye washes or wears off in a day or two if it comes into contact with your skin.) Add RIT liquid dye (see below to determine how much) and stir once using a metal, plastic, or bamboo spoon so that dye is distributed evenly throughout. Always mix the bath prior to adding what is being dyed. Then add the lace or beads. When dyeing wooden beads, try different techniques to force the beads to stay submerged in the dye bath, as they will float! You can use the lid of a plastic container, gloved hands, or a heavy spoon to weigh the beads down. I prefer submerging them with my gloved hands, holding them under for 1 to 2 minutes. I then let them float for 2 minutes and repeat until the beads reach the desired hue.

To achieve color:

• Red is Cherry Red: 3 tablespoons RIT dye in 6 cups of water, item(s) submerged for 8 to 10 minutes

• Yellow is Lemon Yellow: 4 tablespoons RIT dye in 6 cups of water, item(s) submerged for 10 to 12 minutes

• Orange is Sunshine Orange: 3 tablespoons RIT dye in 6 cups of water, item(s) submerged for 8 to 10 minutes

• Pink is Cherry Red: 3 tablespoons RIT dye in 6 cups of water, item(s) submerged for 3 to 5 minutes

The longer the items stay in, the darker they get. The more dye you use vs. water, the darker they get.

JUMP RINGS

Grasp the jump ring on either side of the opening with two pairs of pliers (round-nose pliers are best for opening and closing jump rings; flat-nose pliers are for gripping). If you don't have two pairs of pliers, you can use one pair (I suggest round-nose pliers) and your fingers.

Twist the jump ring open by holding one side in place and moving the other in a sideways motion. Only open the ring as much as necessary to fit the item(s) you wish to add or connect. When done, twist the jump ring closed, wiggling the ends as close together as possible at the opening and closing the gap as tightly as possible.

KNOTTING

For some of the recipes in this book, you'll use a lark's head knot. Fold the cord or ribbon in half. Then pass the folded end of the cord a few inches through the hole at the top of the pendant. String the ends of the cord through the loop and pull the ends of the cord until the knot rests snugly at the top of the pendant.

POLYMER CLAY

I prefer to use Sculpey brand polymer clay. It dries with a nice matte finish.

It's hard to give an exact baking time for polymer clay, since every oven is different. Unless the clay is rolled very thin, you will usually bake it for at least 90 minutes, but check on it periodically. Polymer clay won't completely harden until it is removed from the oven. If it still feels soft after hours of baking, remove it from the oven and let it cool.

Everything sticks to polymer clay (dirt, lint, dust in the air, etc.). To keep beads clean, thoroughly wash and dry your hands before handling them. Sanding can also help remove dirt or grit after beads are baked.

POM-POMS

For a medium-sized pom-pom, first cut two pieces of yarn, each 5 inches long, and set aside. Wrap more yarn around two fingers (pointer and middle) roughly sixty to eighty times, until you have about a ½-inch-thick yarn "nest." Slide the nest off your fingers. Wrap the two pieces of yarn you first cut around the middle of the nest and double-knot the strings to secure. With scissors, cut the strands of thread on both sides of the nest. Fluff the pom-pom and trim along the outside to it make it even and round.

SHRINK PLASTIC

Always cook shrink plastic on a metal surface (never stone). Everything that needs to be done to the shrink plastic, such as drawing a design on it or punching any holes into it, must be done *before* you bake it. Shrink plastic reduces to approximately 75 percent of its original size and can double in thickness as it bakes. Therefore, make pendants proportionally larger than you want the finished pendant to be.

Shrink plastic is easily scratched, so remove all rings and bracelets before working with it.

For hole punching, place the hole as close to the corner as possible without cutting into the corner of the plastic. Keep a little bit of material on all sides of the desired hole.

As pieces shrink in the oven, they will also curl up. But don't be afraid! When shrink plastic is fully baked, it will lie flat again. If for some reason it's not lying flat, remove the baking sheet from the oven and flatten the shrink plastic pieces with a spatula.

Cover the pieces with a layer or two of parchment paper to prevent them from sticking to themselves when curling in the baking process.

STITCHING

French knot: Insert the needle from the back to the front of the fabric. Hold the floss taut and wrap it around the needle twice. Insert the needle from the front to the back of the fabric a short distance from the exit point. For larger knots, wrap more than twice.

Straight stitch: Insert the needle from the back to the front of the fabric. Moving a short distance in any direction, insert the needle from the front to the back of the fabric. Repeat.

Whipstitch: Insert the needle from the back to the front of two layers of fabric, near the outer edge. Loop the thread over the outside edge of the fabric from back to front again. Continue, moving along the edge of the fabric, placing the stitches equal widths apart.

TASSELS

Cut a piece of cardboard to the desired length of the tassel, or use a ruler. The important thing is to use a straight edge that won't bend. Cut a 3-inch length of floss and thread it onto a needle. Wrap additional floss around the cardboard template five to ten times, depending on the thickness of the floss. Pass the needle under one end of the floss wrapped on the cardboard and knot the ends. Cut the floss wrap at the opposite end of the template to release. Cut a 3-inch length of floss and wrap it around the tassel, about ½ inch from the top, multiple times. Knot the ends together; thread the tails onto a needle, and draw them through the center of the tassel. Trim the ends evenly.

WIRE LOOPS

Use round-nose pliers to bend a 90-degree angle ⅜ inch from the end of a wire. Grasp the very tip of the wire with round-nose pliers and rotate the pliers to form a loop in the wire so that the end of the wire meets the base of the 90-degree bend. String on the desired bead(s). Repeat the process, bending a 90-degree angle and snipping the wire to leave a ⅜-inch tail before creating the loop.

WRAPPING THREAD

To change colors when wrapping, trim the old color, leaving a 1-inch tail. Lay a 1-inch length of the new color next to the old color, and wrap the new color around both tails to cover.

WEARING JEWELRY

The rules of what is appropriate for a particular situation are pretty much a thing of the past (though I still think too much bling can be distracting at work or on a lazy weekend), so it's up to each of us to create a mix we love and are comfortable with. With that said, I also think it's important to understand the foundations and definitions of jewelry styles, particularly necklaces, when you are creating the pieces. At the end of the day, it's about how you feel in what you're wearing. These are just some simple guidelines to keep in mind.

NECKLACES

Necklaces come in many different lengths, but did you know that each has a name?

Choker (14–16 inches): The choker sits snug above the neckline. Chokers work well with just about any style of top. You can give them a more casual look by mixing in other necklaces such as chains and beads.

Princess (17–19 inches): The princess lies below the throat line. Often a classic strand of pearls is princess length. I like this length with V-necks, turtlenecks, and crew necks.

Matinee (20–24 inches): Matinee lengths fall right above the bustline. They pair best with a high neckline.

Opera (28–36 inches): The opera length sits near the breastbone. It can be wrapped to create a shorter look.

Rope (36 inches): A rope-length necklace is meant to be wrapped, knotted, and looped.

Lariat: Generally longer than rope length, the lariat is made without a clasp. You can wear a lariat many different ways: wrapped several times at different lengths around your neck, wrapped and knotted, or doubled with the two ends passed through the loop.

KEEP IN MIND

The Basics

• Know what works for you and what makes you comfortable.

• Don't always be matchy-matchy, whether in color or style.

• Feel free to mix metals.

• Don't be afraid of color.

• Embrace and incorporate costume jewelry.

• When layering, play with scale and length.

• Dress for the occasion—or create the occasion by how you dress.

• If you're looking to make a bold statement with jewelry, play with the scale (mixing chunky and delicate chains), combine different materials (a classic strand of pearls with turquoise beads), or repeat an item (the same cuff on each wrist).

Layering

- When layering, consider both the length and the scale of the items you're using. Play with the pieces to make sure you haven't layered too much. You want to make a statement but also have each piece shine through.

- Create a focal point. For example, if you wear a lot of bracelets, wear fewer necklaces (or no necklace) and vice versa.

- When wearing a statement necklace, underplay other elements by pairing it with simple stud or drop earrings.

- If you're looking to make an arm-candy statement, mix and match away. Don't be afraid to combine handmade bracelets with more expensive pieces. Add different metals, gems, and beads.

Work with Your Body

- Consider your height, frame, face shape, outfit, and the occasion when choosing jewelry.

- If you are a tall person, make sure the pieces stand out. Delicate jewelry is great, but it can get lost. Conversely, sometimes a bold necklace will overpower a smaller-framed person, while it feels just right for someone tall and bigger-boned.

Color, Tone, Material

- Think about the tone and patina of materials and how they will play off of one another; try mixing creamy pearls with a vintage rhinestone clasp or pin. A vintage item or something with a patina can make what is a more traditional, sometimes formal piece—like a strand of pearls—more accessible and everyday.

- Consider the play of materials—for example, the contrast of a hard material like metal or glass beads with a soft material like ribbon or something textured like leather cord.

Remember, the beauty of fashion today is how we can each create our own mix and style regardless of price point, location, or guidelines. What is key is to find what feels comfortable for you. And to work it in your own way.

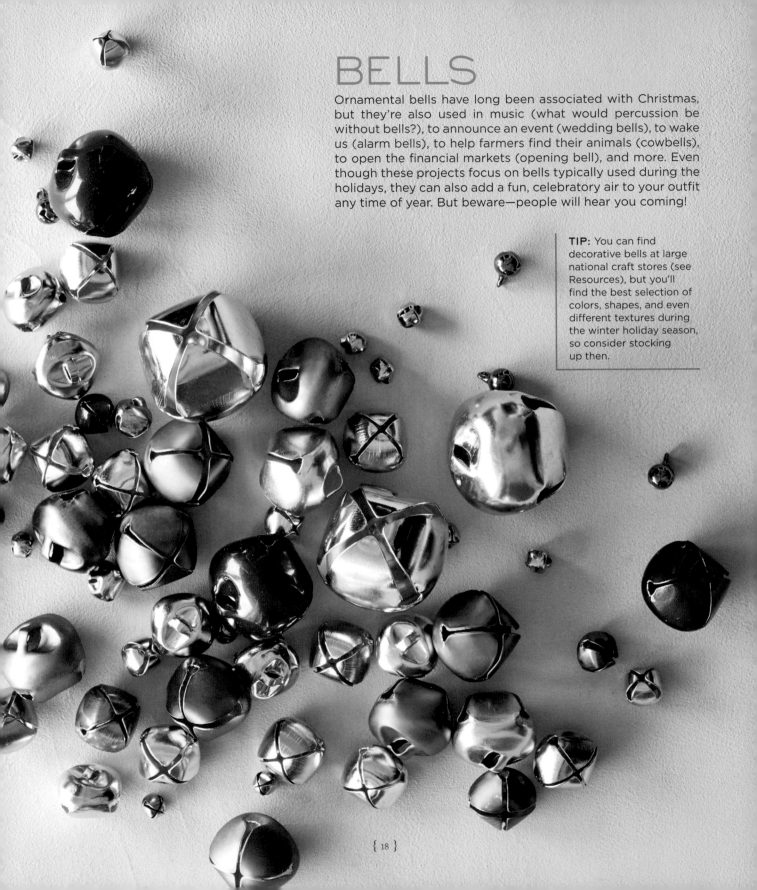

BELLS

Ornamental bells have long been associated with Christmas, but they're also used in music (what would percussion be without bells?), to announce an event (wedding bells), to wake us (alarm bells), to help farmers find their animals (cowbells), to open the financial markets (opening bell), and more. Even though these projects focus on bells typically used during the holidays, they can also add a fun, celebratory air to your outfit any time of year. But beware—people will hear you coming!

TIP: You can find decorative bells at large national craft stores (see Resources), but you'll find the best selection of colors, shapes, and even different textures during the winter holiday season, so consider stocking up then.

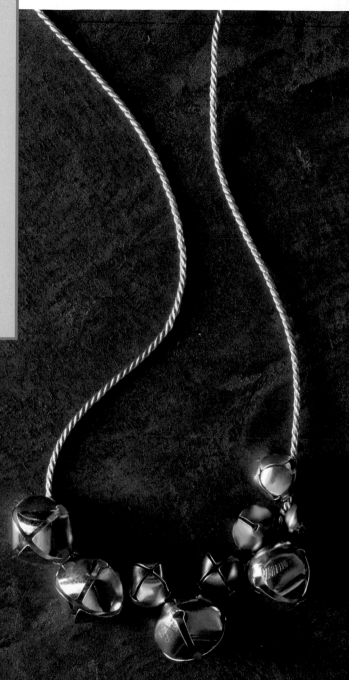

BELLS
RECIPE 1:
HOLIDAY NECKLACE

MATERIALS

9 bells ranging
in size from ¾ inch to
1 inch in diameter
(4 larger gold,
5 smaller multicolor)

38-inch length
of twisted cord,
about ⅛ inch
in diameter

TOOLS

Scissors

1. String the bells onto the cord in the following order: large, large, small, large, small, large, small, small, small.

2. Tie the ends of the cord together for your desired length, and trim.

RECIPE 2:
FESTIVE CLUSTERED EARRINGS

MATERIALS

2 purchased hoop
earrings, ¾ inch
in diameter

Two 8 mm jump rings

Twelve 6 mm
jump rings

Twelve 4 mm
jump rings

24 bells, ¼ inch
in diameter

TOOLS

Round-nose and
flat-nose pliers

1 Using pliers, attach an 8 mm jump ring to the loop at the base of an earring hoop (see page 13).

2 Attach a 6 mm jump ring to twelve of the bells and a 4 mm jump ring to the remaining twelve bells.

3 Take one 4 mm jump ring–bell combination and one 6 mm jump ring–bell combination and attach the two jump rings together. Repeat eleven times. You will have twelve clusters consisting of two jump rings and two bells each.

4 Attach three jump ring–bell clusters to the jump ring at the base of the earring by connecting one of the 6 mm jump rings in the cluster to the 8 mm jump ring. Continue attaching jump ring–bell clusters to each other, adding length as you go. Repeat for the second earring.

NOTES

Lay your jump ring–bell clusters out on a surface as you create the piece to see how long you would like to go.

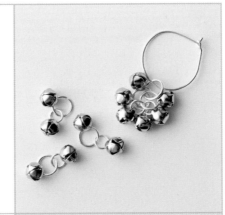

Use a large bell instead of multiple small bells to make another style of earring.

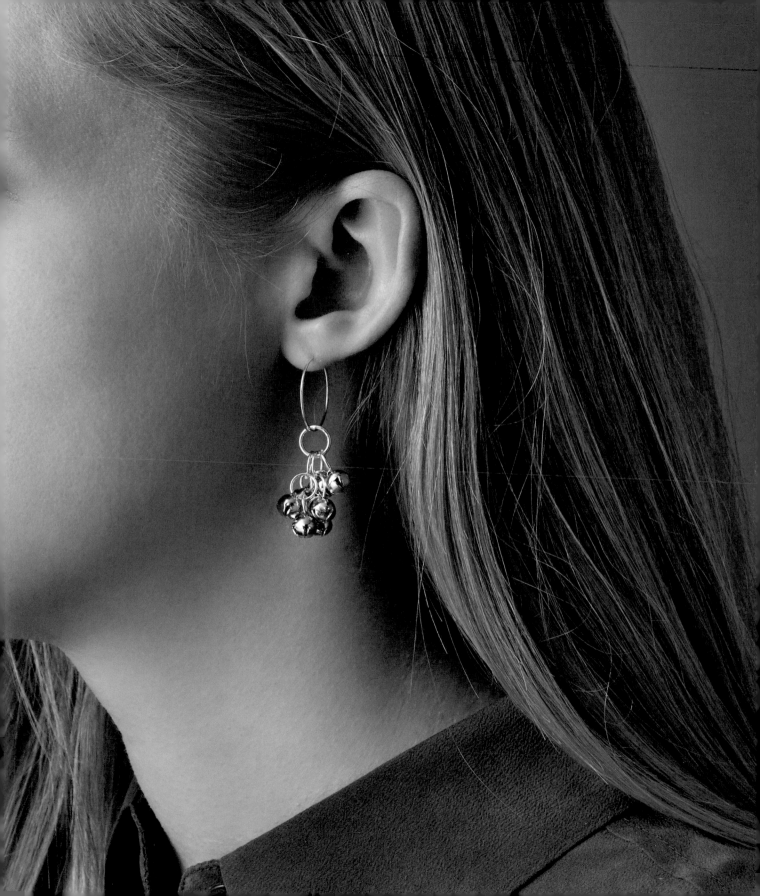

BOBBY PINS

These familiar hairpins came into use in 1899 thanks to the popularity of the bob hairstyle, but the name "bobby pin" wasn't widely used until the 1920s, when the hairstyle really took off. Most of us are familiar with bobby pins, whether we remember watching our grandmothers use them to secure pin curls or recall the concentration it took to put our hair in a chignon for the first time, but probably never thought to use them in jewelry. These projects elevate the humble bobby pin to a new level, using simple techniques to craft them into jewelry with a luxe yet whimsical quality.

TIP: You can find bobby pins at beauty supply stores or your neighborhood drugstore. They come in all sizes and various shapes, so take care to select the right size for the wearer. For example, if you have a long neck or want something a bit more dramatic, you might select longer bobby pins for the Dangly Chevron Earrings, but if you're looking for a more basic look, you might select a mini bobby pin. Or better yet, choose several sizes and experiment!

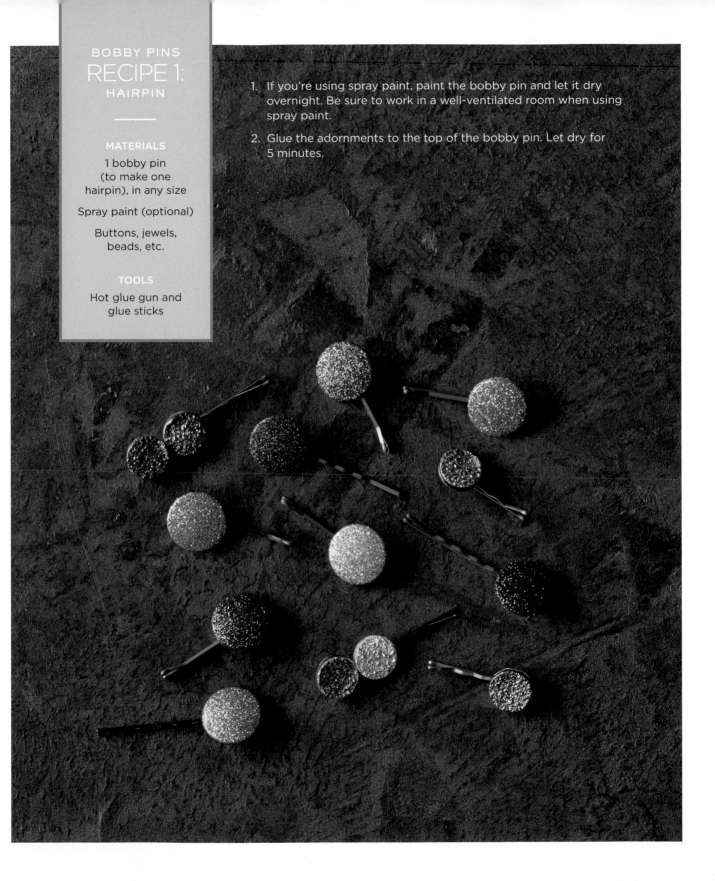

MATERIALS

1 bobby pin
(to make one
hairpin), in any size

Spray paint (optional)

Buttons, jewels,
beads, etc.

TOOLS

Hot glue gun and
glue sticks

1. If you're using spray paint, paint the bobby pin and let it dry overnight. Be sure to work in a well-ventilated room when using spray paint.

2. Glue the adornments to the top of the bobby pin. Let dry for 5 minutes.

BOBBY PINS
RECIPE 2:
GRECIAN NECKLACE

MATERIALS

About 100 black
bobby pins,
2 inches long

Montana Gold acrylic
spray paint
in Malachite

25 inches of 18-gauge
silver jewelry wire

2 small crimp beads

1 lobster clasp
with ring

TOOLS

Painter's tape

Flat-nose pliers

Wire snips

1 Leave the bobby pins on the cardboard they came on (or, if using loose bobby pins, line them up on a thin piece of cardboard). Place painter's tape where you do not want the paint to be applied.

2 Spray-paint the bobby pins (be sure to work in a well-ventilated room), let them dry for 2 hours, and then gently remove the painter's tape.

3 Slide the bobby pins onto the jewelry wire.

4 Slide a crimp bead over the end of the wire on both sides, loop through the clasp and the ring at each end, and then crimp using flat-nose pliers (see page 12). Trim any excess wire.

NOTES

Leaving the bobby pins on the cardboard they came on to paint them will keep them nicely lined up so you get an even, clean painted edge.

Smooth out and align the pins when you put the necklace on to achieve the crisp, structured look of the design.

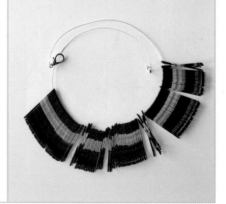

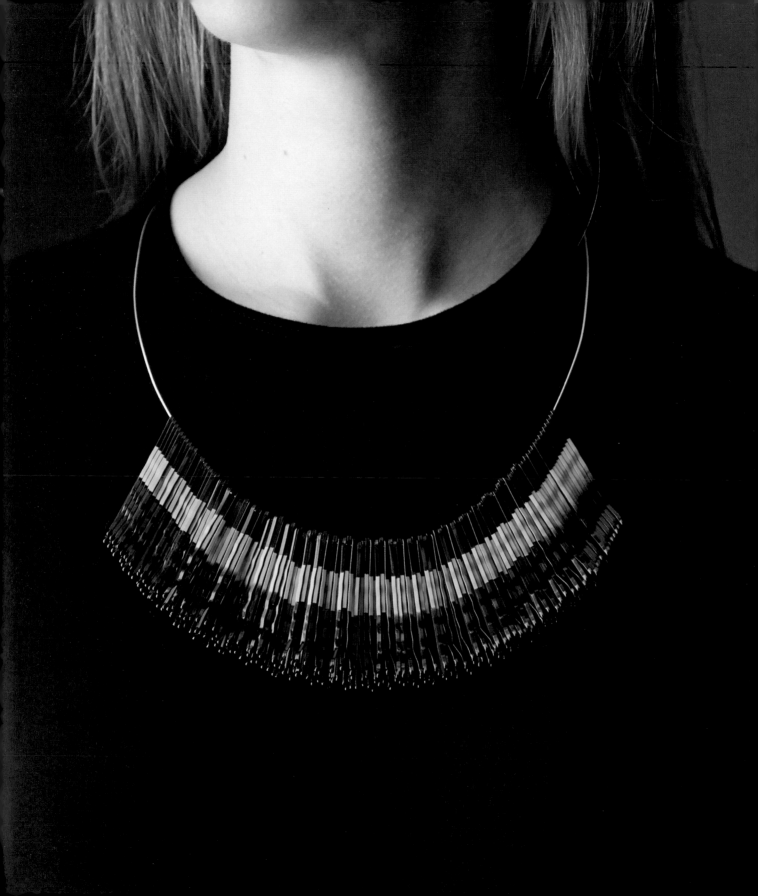

Arrange eight bobby pins with the ridges all facing in the same direction. Thread the bobby pins onto a head pin; repeat with the second set of bobby pins and head pin.

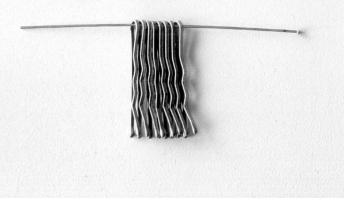

2 Create a chevron pattern by taping off areas that will not be painted. Apply a thin coat of nail polish, being careful not to let any polish seep under the tape. Repeat with the second earring. Apply additional thin coats as necessary to get the desired hue. Let dry for 2 hours, then slowly remove the tape from the bottom. Put some nail polish on a piece of parchment paper or plastic wrap and, holding the head pin, dip the bottom edges of the bobby pins into the polish. Let dry for 2 hours and remove the remaining tape.

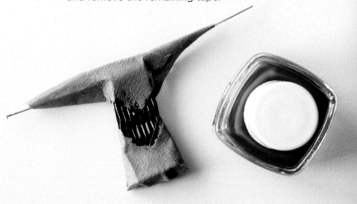

3 Use round-nose pliers to bend the head pin on each side of the bobby pins to create a triangle shape. Repeat with the second earring. Use wire snips to remove the pinhead.

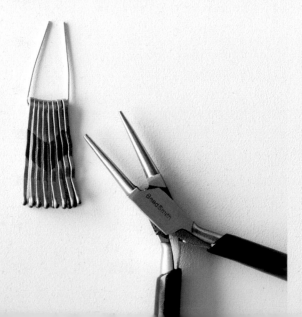

4 Thread the head pin through the earring blank hole. Fold one side of the head pin slightly over the other, then slide a crimp bead over the ends of the head pin where they overlap, and crimp, using pliers (see page 12). Repeat with the second earring.

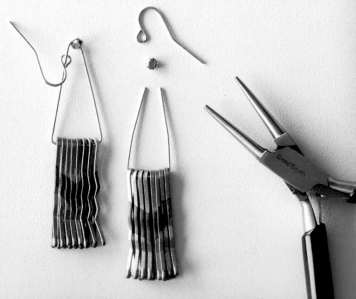

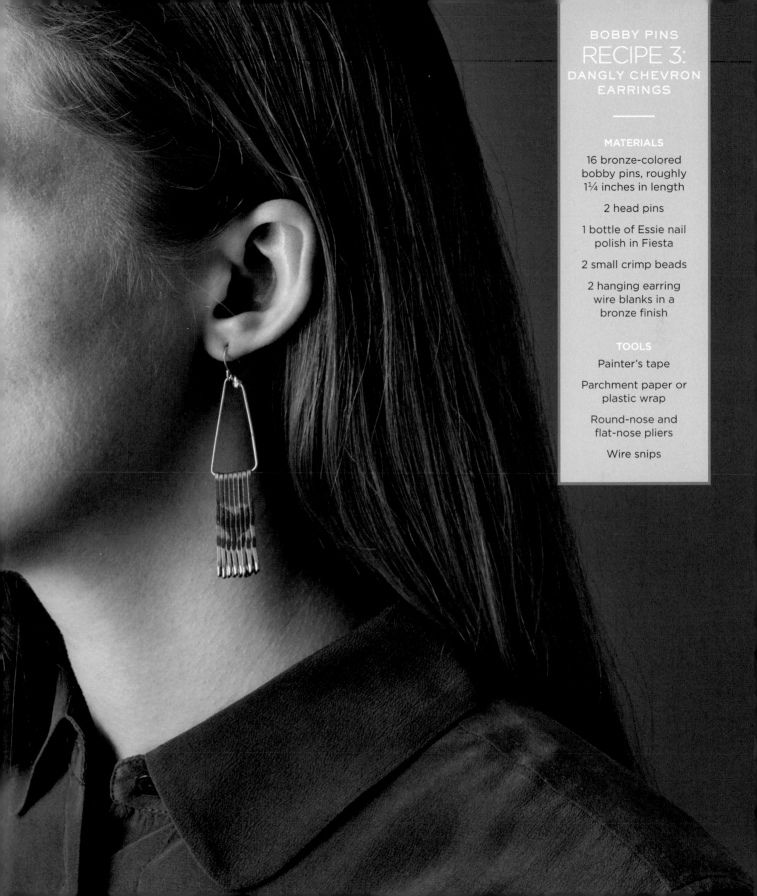

MATERIALS

16 bronze-colored bobby pins, roughly 1¼ inches in length

2 head pins

1 bottle of Essie nail polish in Fiesta

2 small crimp beads

2 hanging earring wire blanks in a bronze finish

TOOLS

Painter's tape

Parchment paper or plastic wrap

Round-nose and flat-nose pliers

Wire snips

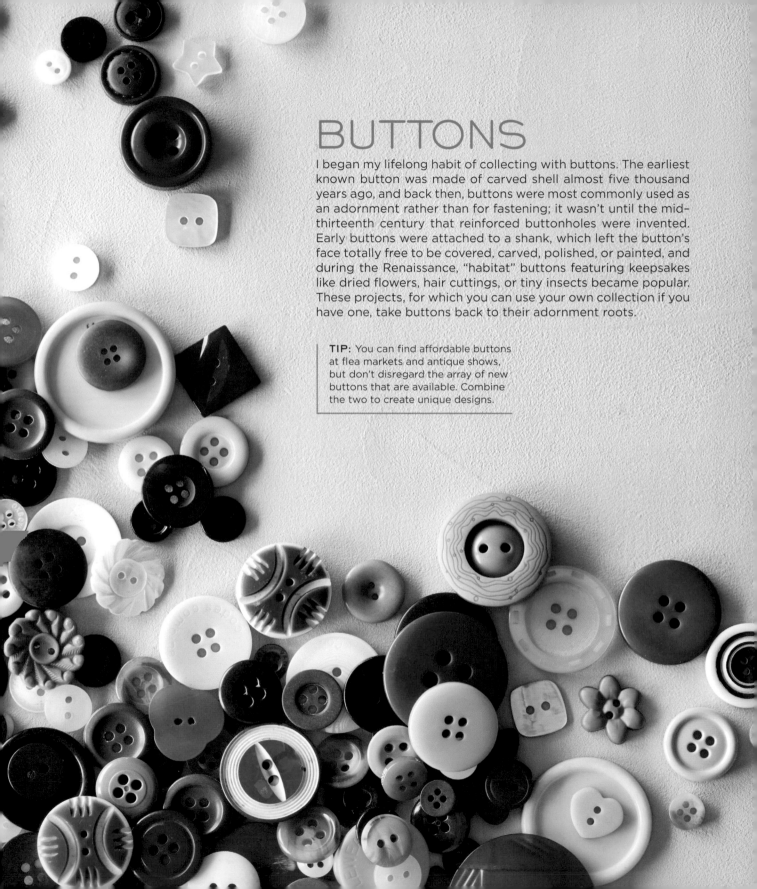

BUTTONS

I began my lifelong habit of collecting with buttons. The earliest known button was made of carved shell almost five thousand years ago, and back then, buttons were most commonly used as an adornment rather than for fastening; it wasn't until the mid–thirteenth century that reinforced buttonholes were invented. Early buttons were attached to a shank, which left the button's face totally free to be covered, carved, polished, or painted, and during the Renaissance, "habitat" buttons featuring keepsakes like dried flowers, hair cuttings, or tiny insects became popular. These projects, for which you can use your own collection if you have one, take buttons back to their adornment roots.

TIP: You can find affordable buttons at flea markets and antique shows, but don't disregard the array of new buttons that are available. Combine the two to create unique designs.

RECIPE 1:
BUTTON STUD EARRINGS

MATERIALS

Two ⅜- to ¼-inch bone-like buttons

Post earring blanks smaller than the buttons

TOOLS

Hot glue gun and glue sticks

1. Select two buttons of the same size—be sure to choose buttons with a diameter measuring larger than the flat back of a post earring blank.

2. Using very little glue, so that it will not seep through the button holes, hot-glue the back of a button to the flat side of an earring blank at the center; let dry. (The glue will dry in 5 minutes, but let it sit for a solid hour.) Repeat for the second earring.

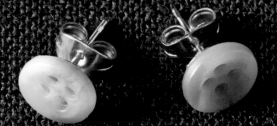

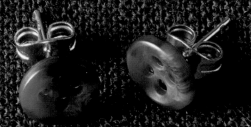

RECIPE 2:
FULL-OF-FUN RINGS

MATERIALS

Plastic buttons in varying sizes, including oversized (2 per ring)

Adjustable metal ring blanks with ¼- to ½-inch-diameter flat surface

TOOLS

Hot glue gun and glue sticks

1 Choose combinations of chunky plastic buttons in various sizes. Lay out buttons for each ring accordingly.

2 Using a small amount of glue, glue the buttons together in layers (large circles on top of larger petal shapes, small circles on top of larger circles, etc.). Let dry for 15 minutes.

3 Glue the layered buttons to the ring blank. Hold for the first 30 seconds of drying time.

4 Let sit for 1 hour before wearing. Adjust the ring blank to fit as needed.

NOTES

Choose playful combinations for the button layering. Play with shapes: a small circle fits nicely on top of a flower. Have fun with color: pair bright colors.

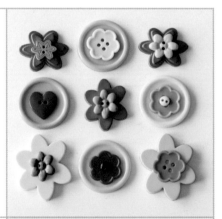

Do not use too much glue when layering buttons. Otherwise, the glue will seep through the button holes. A small dot of glue is fine. If you end up with hot glue strands, clean and remove with small scissors once the items are fully dried.

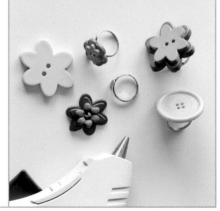

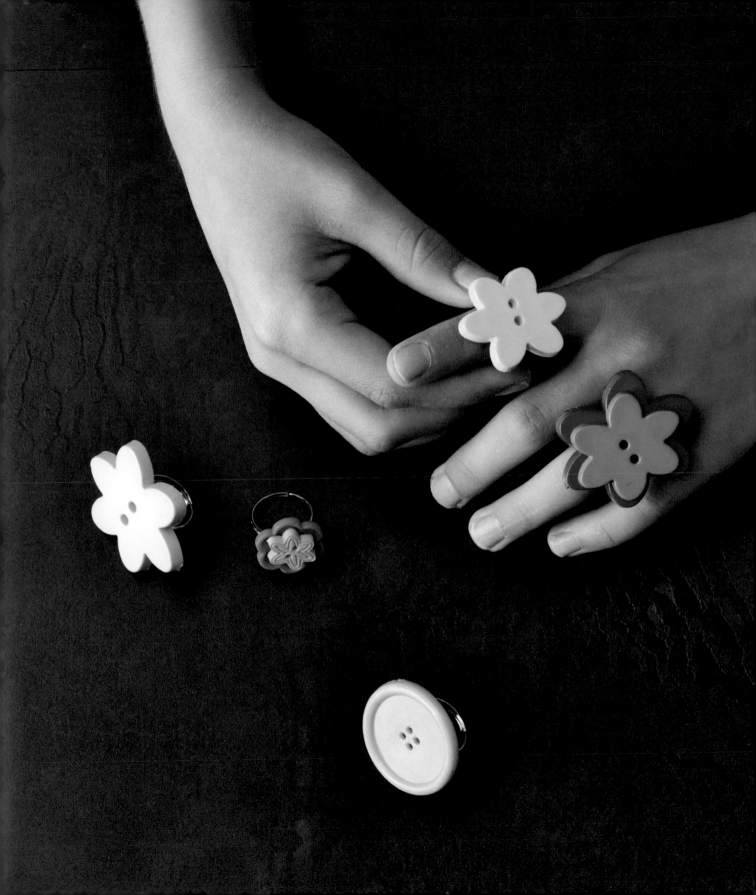

Select similarly shaped and colored buttons. Lay them on the ribbon, spacing them evenly so that you have enough buttons to cover the entire necklace, leaving 1½ inches on each end free of buttons. Mark each button's place with tailor's chalk. Take a photo of the button arrangement on the ribbon so that when you pick it up to sew on the buttons, you have a reference.

Remove the buttons and, using a needle and thread, sew each of the buttons onto the ribbon in the predetermined design.

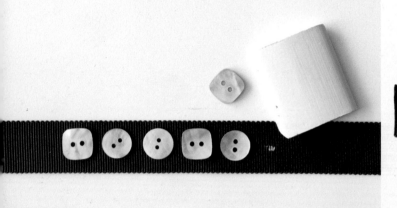

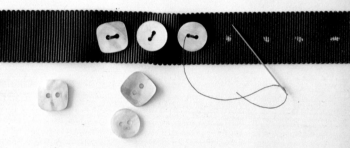

Place the right sides of the ends of the ribbon together so that they're overlapping, creating an upside-down V. Temporarily hold the pieces together with a small paper clip or binder clip.

With a needle and thread, sew diagonally through both pieces of ribbon. Trim the excess ribbon.

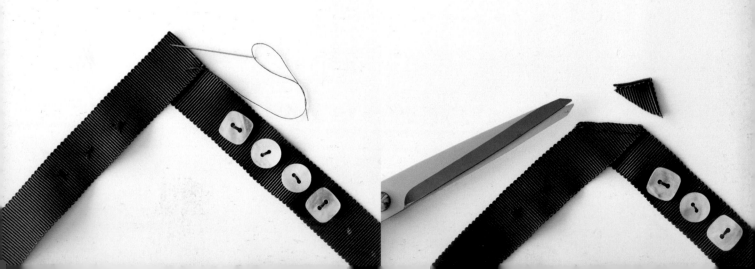

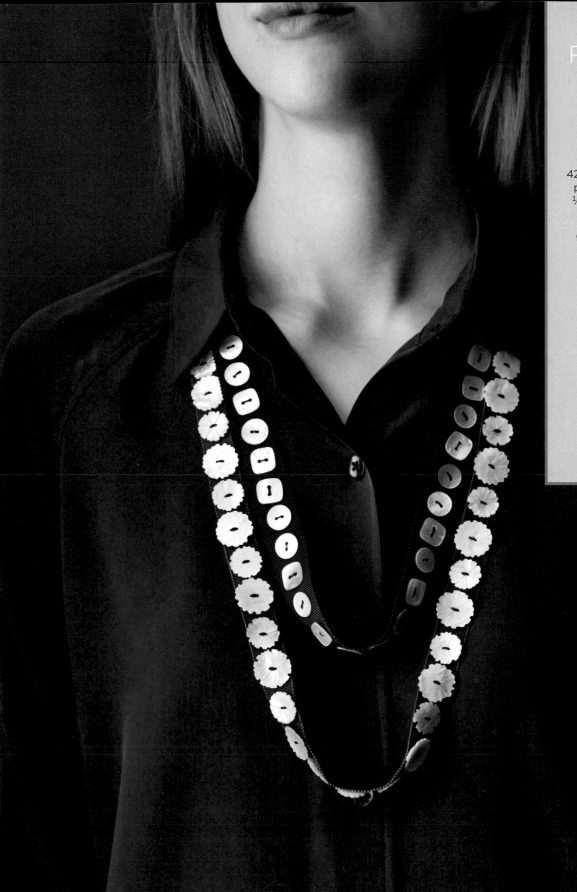

BUTTONS
RECIPE 3:
GROSGRAIN
BUTTON
NECKLACE

MATERIALS

42 round and square
pearlized buttons,
½ inch in diameter

31-inch piece of
grosgrain ribbon,
⅞ inch wide

TOOLS

Ruler

Tailor's chalk

Camera

Sewing needle
and thread

Small paper clip
or binder clip

Scissors

Iron

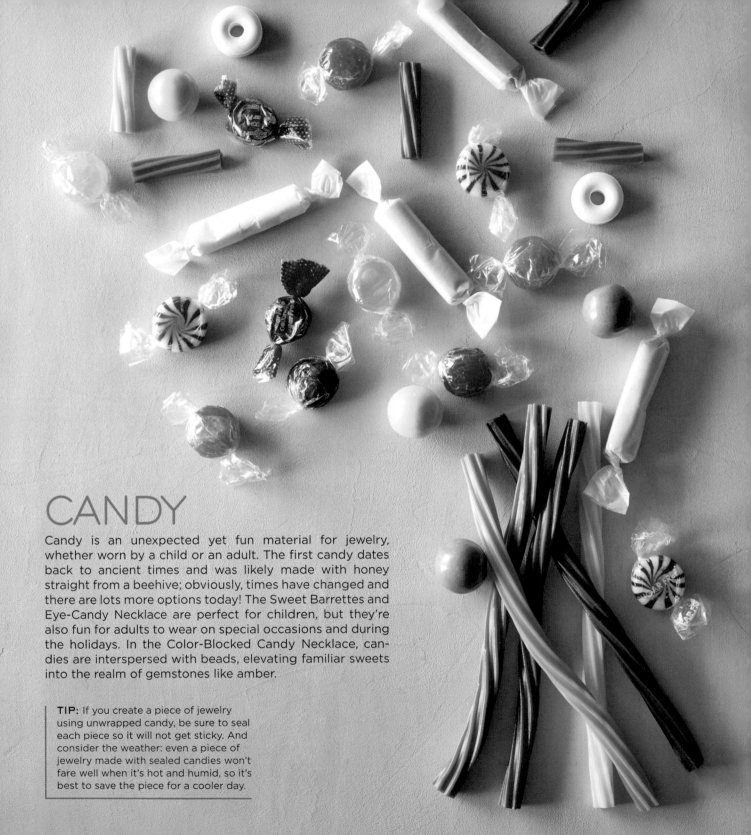

CANDY

Candy is an unexpected yet fun material for jewelry, whether worn by a child or an adult. The first candy dates back to ancient times and was likely made with honey straight from a beehive; obviously, times have changed and there are lots more options today! The Sweet Barrettes and Eye-Candy Necklace are perfect for children, but they're also fun for adults to wear on special occasions and during the holidays. In the Color-Blocked Candy Necklace, candies are interspersed with beads, elevating familiar sweets into the realm of gemstones like amber.

TIP: If you create a piece of jewelry using unwrapped candy, be sure to seal each piece so it will not get sticky. And consider the weather: even a piece of jewelry made with sealed candies won't fare well when it's hot and humid, so it's best to save the piece for a cooler day.

MATERIALS

Oversized piece of
wrapped hard candy

Barrette blank

TOOLS

Hot glue gun and
glue sticks

1. Choose a piece of wrapped hard candy that covers the barrette blank nicely so that you can't see any metal. Consider a candy with a bright color and fun wrapping. You can use a flat, hard wrapped candy or a wrapped gumball, depending on the look you want to achieve.

2. Glue the candy to the barrette blank at the exact center of the candy; hold it in place to dry for 1 minute. Then let it dry on a flat surface for 10 minutes. If you are working with a round gumball, hold the gumball for 2 minutes after you have glued it to the barrette. While it's drying, keep the barrette candy-side-up so that the gumball does not weigh it down and possibly fall off.

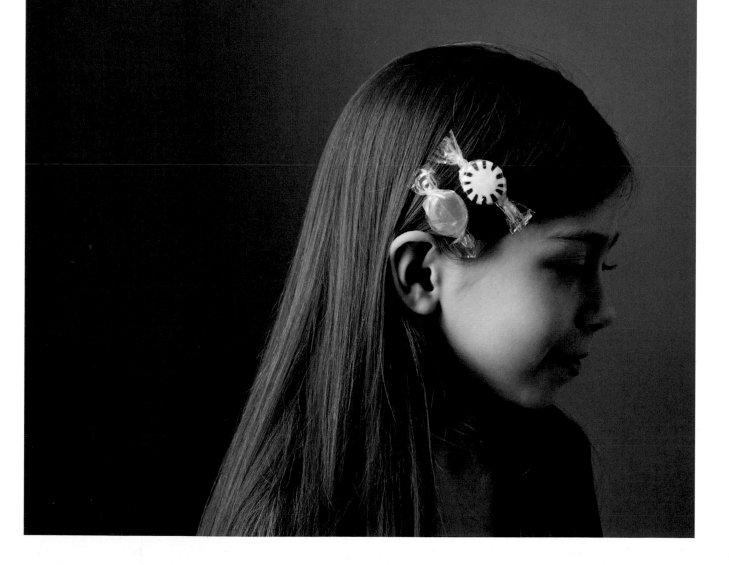

CANDY
RECIPE 2:
EYE-CANDY NECKLACE

MATERIALS

20 to 25 wrapped candies, preferably with long edges, such as hard candies wrapped in foil, or 13 to 15 pieces of saltwater taffy wrapped in wax paper

TOOLS

Clear twist ties (see Resources)

Scissors or wire snips

1 Lay the candies out in order until they measure 30 inches end to end.

2 Using twist ties, connect one end of a wrapper to the next until they form a long circle.

3 Secure the twist ties tightly and trim the excess with wire snips.

NOTES

You can achieve several different looks for a wrapped candy necklace depending on the candy selected. Candies with the same color palette will have a more sophisticated look; bright colors will be playful; and seasonal candies, such as peppermints, will say Christmas.

As you secure your candies to one another with the twist ties, trim the ends. You do not have to use the entire tie to connect the candies. Trimming the ties will create less bulk in the necklace.

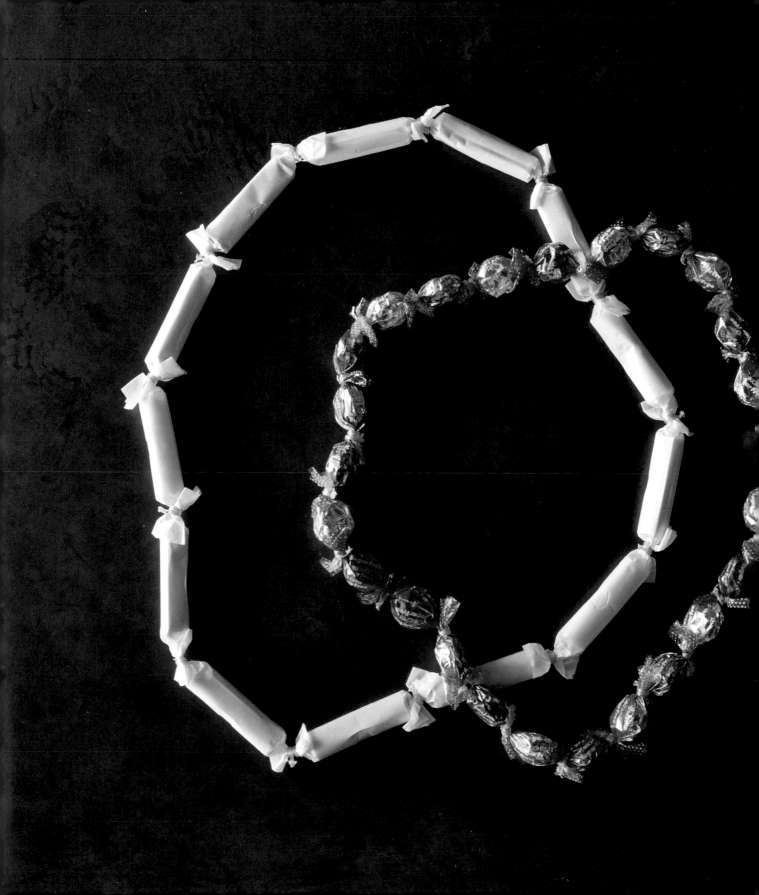

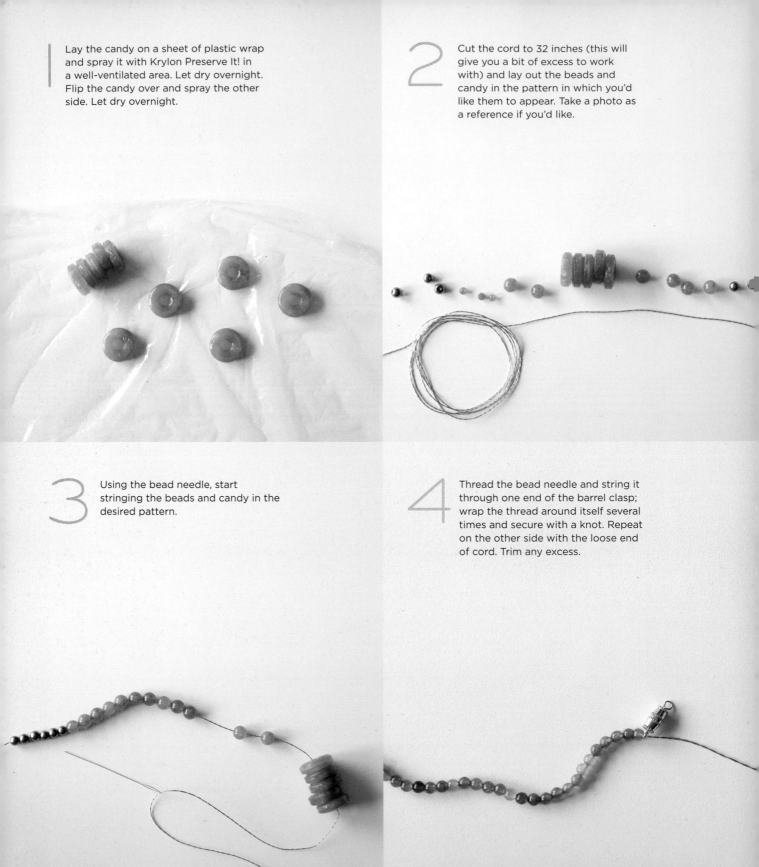

Lay the candy on a sheet of plastic wrap and spray it with Krylon Preserve It! in a well-ventilated area. Let dry overnight. Flip the candy over and spray the other side. Let dry overnight.

2 Cut the cord to 32 inches (this will give you a bit of excess to work with) and lay out the beads and candy in the pattern in which you'd like them to appear. Take a photo as a reference if you'd like.

3 Using the bead needle, start stringing the beads and candy in the desired pattern.

4 Thread the bead needle and string it through one end of the barrel clasp; wrap the thread around itself several times and secure with a knot. Repeat on the other side with the loose end of cord. Trim any excess.

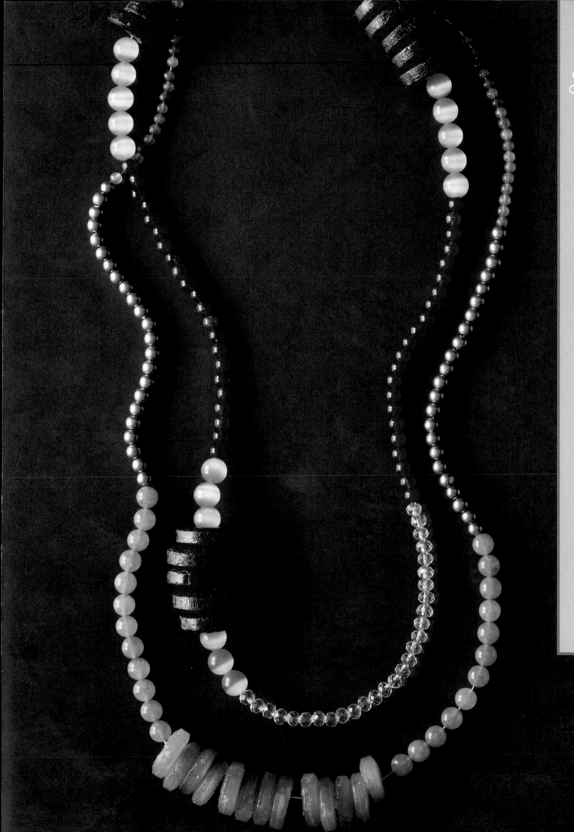

MATERIALS

13 Life Savers (pictured here: Wild Cherry and Butter Rum)

Wild Cherry: Twenty-six 10 mm pink glass beads, forty-two 6 mm cherry glass beads, 34 faceted blush pink glass beads (approximately 6 mm)

Butter Rum: Twenty-four 8 mm amber glass beads, forty-six 6 mm brass beads, sixty 4 mm amber glass beads

32 inches of cord (here: 2-ply lamé cord)

Barrel clasp

TOOLS

Plastic wrap

Scissors

Krylon Preserve It!

Camera (optional)

Bead needle

CHARMS

My mother's charm bracelet is one of my greatest treasures. Starting in the 1970s, she brought home a charm from every trip, and she passed the bracelet on to me when I was in my twenties. I love wearing the stories of my family on my wrist, and many others have been captivated by charms for similar reasons. Queen Victoria wore small lockets containing family portraits and locks of hair from her beloved husband, Prince Albert, and charm bracelets reached the height of their popularity in the United States after World War II, when American soldiers returned home with souvenir charms from their travels. These two recipes are made with a blend of new and vintage charms and lockets, leaving you free to experiment with styles, sizes, and themes.

TIP: In this virtual, tech-driven world, I believe charms can take on an even more significant meaning. They represent the experiences and intimacy that we all long to create away from a screen; collect them, gift them, and use them to record your memories.

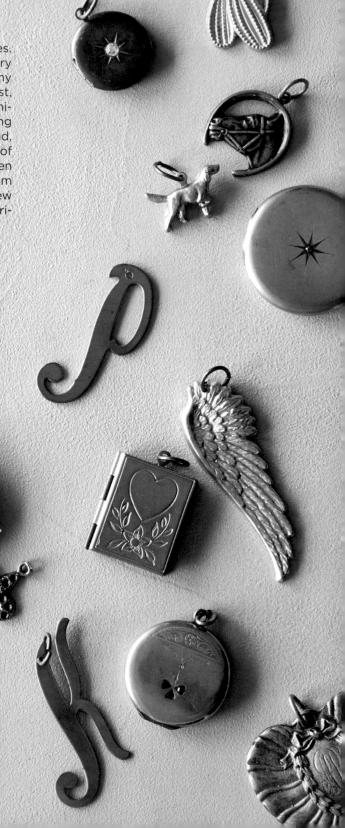

RECIPE 1:
CHARMING EARRINGS

MATERIALS

Four 6 mm
jump rings

2 large charms

2 medium charms

2 small charms

1 pair of
earring wire blanks

TOOLS

Round-nose and
flat-nose pliers

1. Open a jump ring (see page 13) and add on one large charm, one medium charm, and one small charm. Close the jump ring.

2. Open a second jump ring and use it to attach the jump ring with the charms to the loop of an earring blank.

3. Repeat steps 1 and 2 to complete the second earring.

RECIPE 2:
CHARMED NECKLACE

MATERIALS

One ½- to 1-inch-diameter textured ring

3 charms of varied sizes and shapes

Three 8 mm jump rings

1 yard of ½-inch-wide ribbon

TOOLS

Round-nose and flat-nose pliers

Scissors

Clear nail polish or Fray Check

1 Decide on the order in which you want the charms to hang from the textured ring. The largest charm will look best placed in the center.

2 Attach the charms to the textured ring using pliers and jump rings (see page 13).

3 Tie the ribbon to the textured ring using a lark's head knot (see page 13).

4 To help keep the ends from fraying, cut the ribbon at an angle and apply clear nail polish or Fray Check to the edges. Tie the ends of the ribbon in a knot or a bow to wear the necklace at the desired length.

NOTES

If there is a "front" side to the pendant, string the folded end of the cord from the front of the pendant to the back to ensure that the front of the knot faces in the correct direction. Before pulling the ends of the cord tight, be sure that they are positioned evenly at the same length.

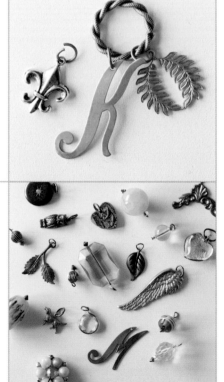

Consider using a variety of charms to personalize this necklace: letters for the initials of friends and family, motifs based on hobbies and passions, or an eclectic mix of old charms from flea markets with more modern ones.

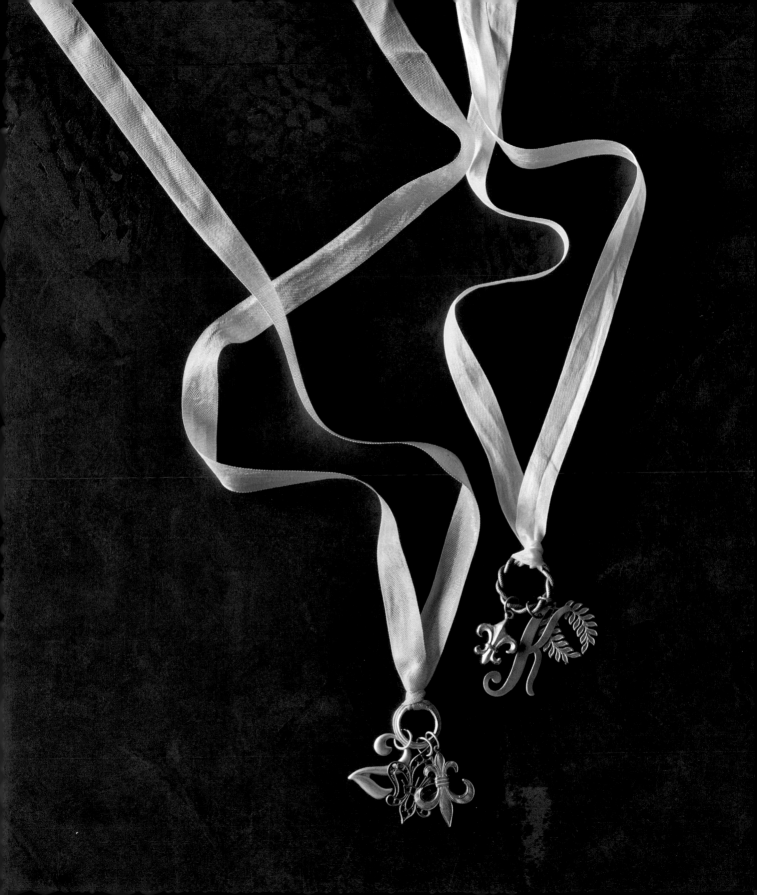

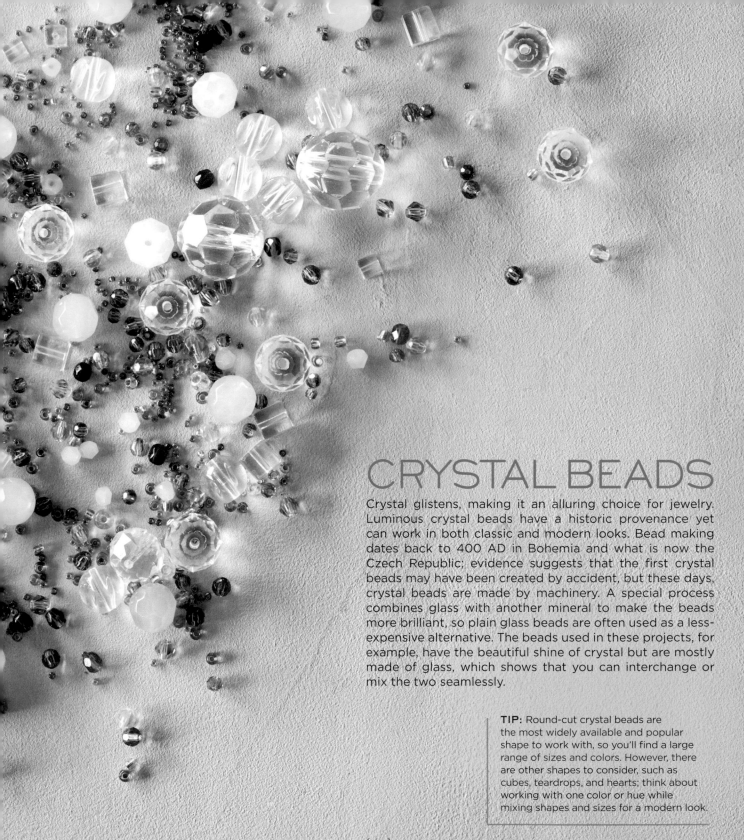

CRYSTAL BEADS

Crystal glistens, making it an alluring choice for jewelry. Luminous crystal beads have a historic provenance yet can work in both classic and modern looks. Bead making dates back to 400 AD in Bohemia and what is now the Czech Republic; evidence suggests that the first crystal beads may have been created by accident, but these days, crystal beads are made by machinery. A special process combines glass with another mineral to make the beads more brilliant, so plain glass beads are often used as a less-expensive alternative. The beads used in these projects, for example, have the beautiful shine of crystal but are mostly made of glass, which shows that you can interchange or mix the two seamlessly.

TIP: Round-cut crystal beads are the most widely available and popular shape to work with, so you'll find a large range of sizes and colors. However, there are other shapes to consider, such as cubes, teardrops, and hearts; think about working with one color or hue while mixing shapes and sizes for a modern look.

RECIPE 1:
ICELAND NECKLACE

MATERIALS

2 small crimp beads

Two 6 mm jump rings

40 inches of clear beading filament, size 0.25 mm

Assorted crystal and/ or glass beads, round and square, ranging in size from 6mm to 12 mm, about 140 beads total

1 spring ring clasp

TOOLS

Beading needle

Flat-nose pliers

Scissors

1. Thread one crimp bead and then one jump ring onto the filament, leaving a 2-inch tail at one end. Thread the filament back through the crimp bead and close it using pliers (see page 13). Thread the beads onto the filament, arranging them as desired. Don't be afraid to mix shapes and sizes. This will add interest.

2. When you have used all the beads or feel the necklace is long enough, thread the other crimp bead and jump ring onto the filament. Thread the filament back through the crimp bead and close it with the pliers. To finish, trim the excess cord and attach the clasp (see page 13).

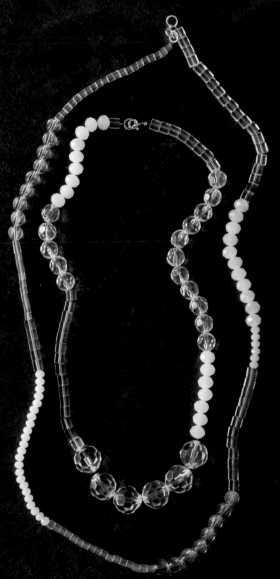

RECIPE 2:
TUBE BRACELET

MATERIALS

8-inch length of refrigerator tubing (or similar), about ¼ inch in diameter

2 end caps, ¼ inch in diameter and large enough to cover the tubing

Crystal or glass seed beads, approximately 12/0 to 16/0

Two 8 mm jump rings

1 large spring ring clasp

TOOLS

Hot glue gun and glue sticks

Small funnel (optional)

Round-nose and flat-nose pliers

1 Glue an end cap onto one end of the tubing, and allow it to dry for 30 minutes.

2 Fill the tube with seed beads. (Consider using a funnel, to avoid spillage.)

3 Glue the second end cap to the open end of the tubing; allow to dry for 30 minutes.

4 Attach a jump ring to each end cap (see page 13). Attach the clasp to one of the jump rings.

NOTES

Refrigerator tubing is a fun material to work with and is readily available at most home-improvement stores. Sharp scissors will cut it to the desired length. This project technique can also be used to fabricate a necklace.

To fill the tube with the beads, send them through a small cone made out of paper, a pastry tip, a small funnel, or a coffee filter with a small hole snipped at the base. This will help direct the beads and prevent spillage.

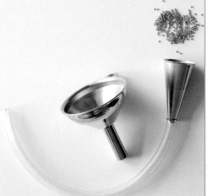

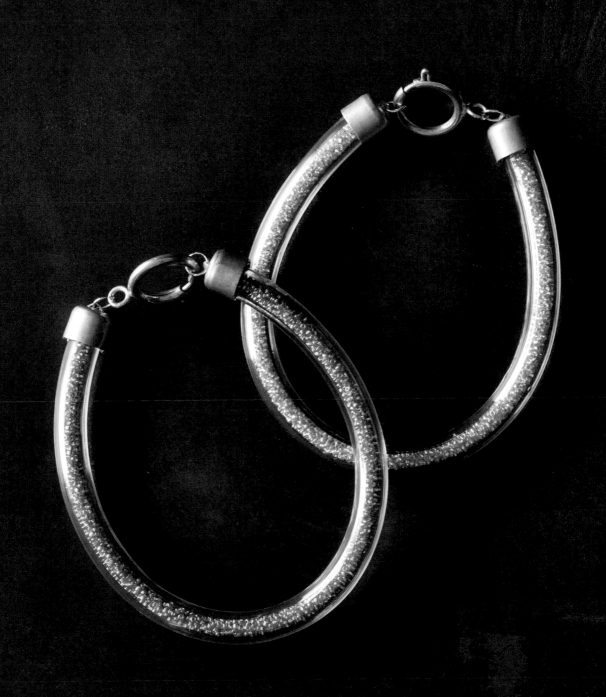

Size the ring before you start. The ring base should be a little bit too big for the wearer's finger, as the wire wrapping will make the ring tighter. Wrap the wire around the ring base, covering one-third of the base. (Use pliers if you like.)

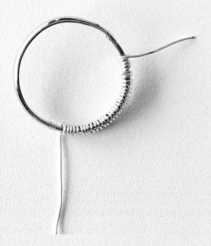

2 Thread the wire through the first bead and wrap it around the ring to secure the bead to the top of the ring blank. Tightly wrap the wire around the ring two or more times, depending on the size of the ring (we wrapped two times for a size-six ring).

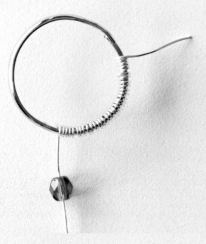

3 Repeat wrapping and threading beads, arranging the beads in a line over the top third of the ring. Be sure the wire wrapping is tight.

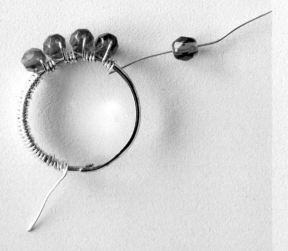

4 Once the last bead is threaded, continue wrapping the wire to cover the final third of the ring. Trim the wire.

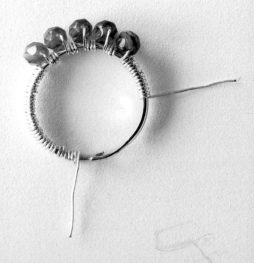

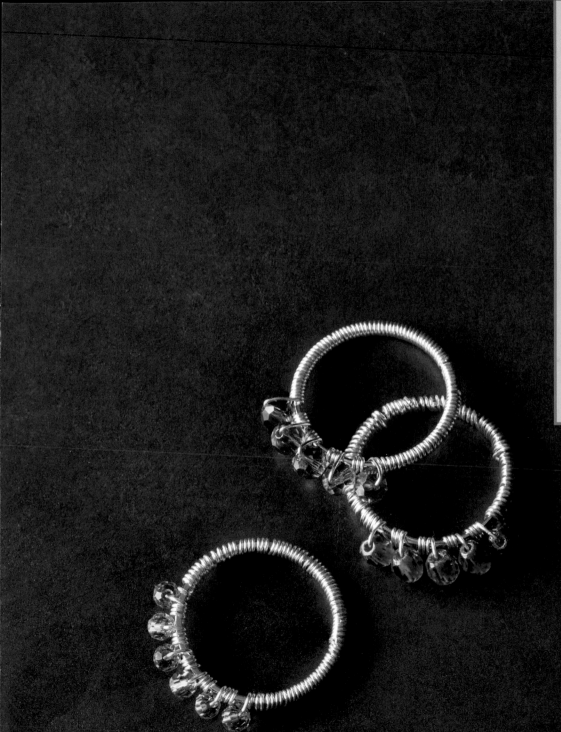

MATERIALS

Adjustable metal ring blank

12 to 20 inches of 26-gauge plastic-coated wire, depending on ring size

5 or 6 small crystal or glass beads, about ¼ inch in diameter each

TOOLS

Round-nose pliers (optional)

Wire snips

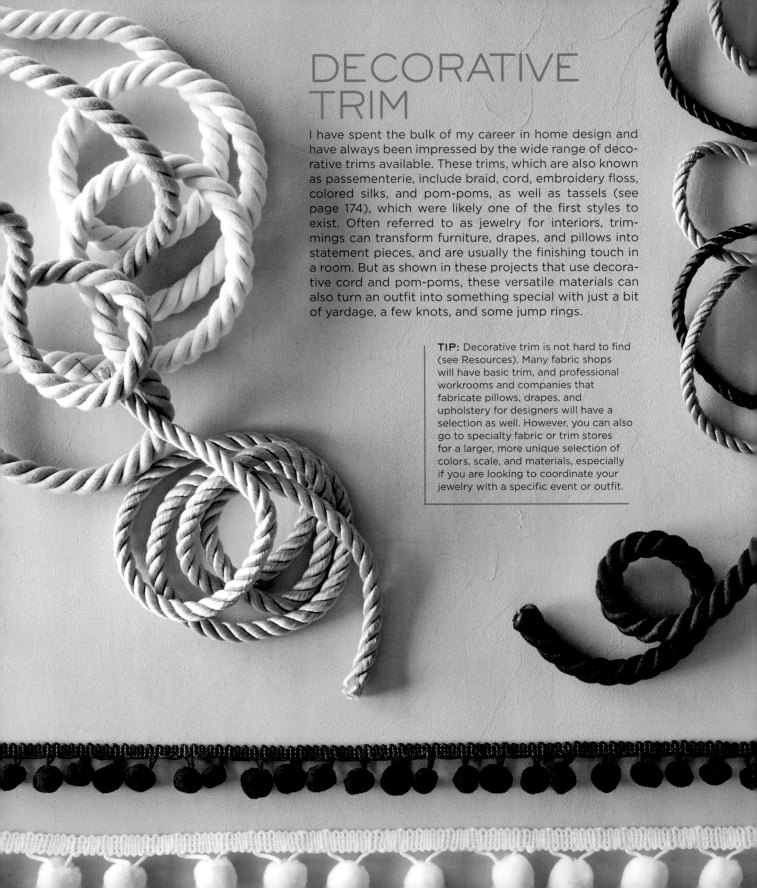

DECORATIVE TRIM

I have spent the bulk of my career in home design and have always been impressed by the wide range of decorative trims available. These trims, which are also known as passementerie, include braid, cord, embroidery floss, colored silks, and pom-poms, as well as tassels (see page 174), which were likely one of the first styles to exist. Often referred to as jewelry for interiors, trimmings can transform furniture, drapes, and pillows into statement pieces, and are usually the finishing touch in a room. But as shown in these projects that use decorative cord and pom-poms, these versatile materials can also turn an outfit into something special with just a bit of yardage, a few knots, and some jump rings.

TIP: Decorative trim is not hard to find (see Resources). Many fabric shops will have basic trim, and professional workrooms and companies that fabricate pillows, drapes, and upholstery for designers will have a selection as well. However, you can also go to specialty fabric or trim stores for a larger, more unique selection of colors, scale, and materials, especially if you are looking to coordinate your jewelry with a specific event or outfit.

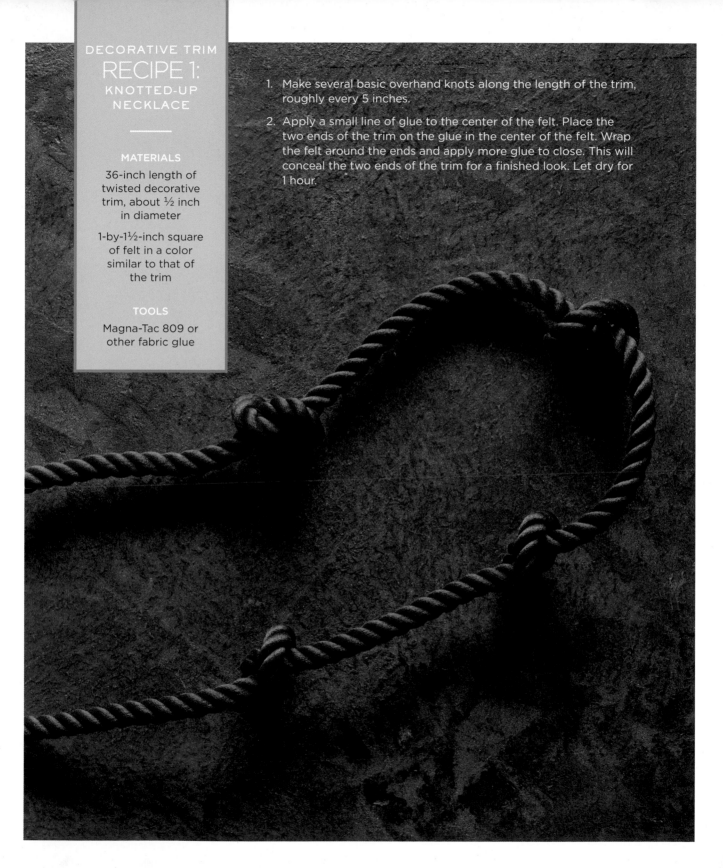

DECORATIVE TRIM
RECIPE 1:
KNOTTED-UP NECKLACE

MATERIALS

36-inch length of twisted decorative trim, about ½ inch in diameter

1-by-1½-inch square of felt in a color similar to that of the trim

TOOLS

Magna-Tac 809 or other fabric glue

1. Make several basic overhand knots along the length of the trim, roughly every 5 inches.

2. Apply a small line of glue to the center of the felt. Place the two ends of the trim on the glue in the center of the felt. Wrap the felt around the ends and apply more glue to close. This will conceal the two ends of the trim for a finished look. Let dry for 1 hour.

RECIPE 2:

POM-POM NECKLACE

MATERIALS

2 lengths of pom-pom trim with ½-inch-wide pom-poms: 24 inches and 26 inches

Two 8 mm jump rings

One ¾-inch spring ring clasp

TOOLS

Magna-Tac 809 or other fabric glue

Round-nose and flat-nose pliers

1 Holding the ends of the pom-pom trim together, draw them through a jump ring and fold, roughly ½ inch.

2 Apply a dab of glue under each fold to secure. Hold for 5 minutes, then let dry for 15 minutes.

3 Repeat with the opposite ends of the pom-pom trim.

4 To finish, use pliers to attach the clasp to one of the jump rings (see page 13).

NOTES

I like to use Magna-Tac 809 glue, but any good fabric glue will work to secure the ends of the trim around the jump ring. If the end of your trim is not lying flat, you can stitch it with a basic needle and thread.

Create new styles of this necklace by changing up the size of the pom-pom trim and mixing colors. Try using large and small pom-poms together, or go for contrasting colors for a bolder statement.

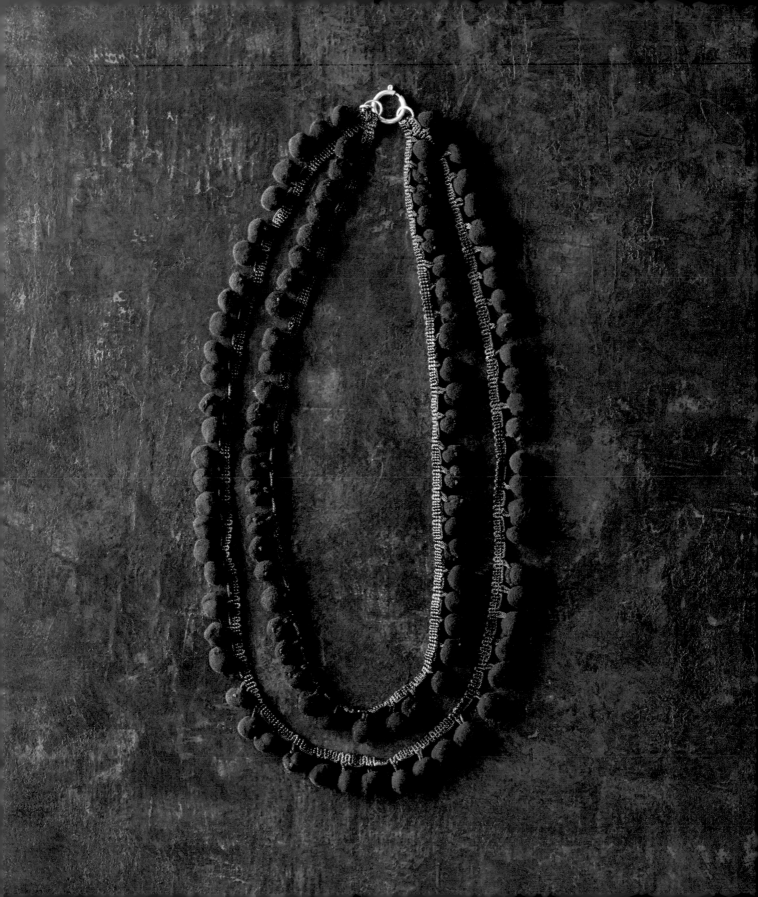

Lay the lengths of trim side by side, lining up the ends. Use a sewing needle and thread to sew the ends together, working across the trim multiple times to secure it well.

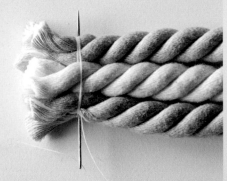

2

Loosely braid the three strands together.

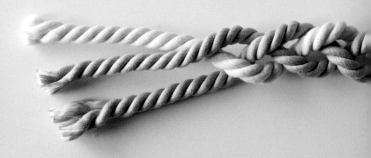

3

Sew the loose ends of braid together as you did in step 1. Apply glue to the sewn ends and connect both ends.

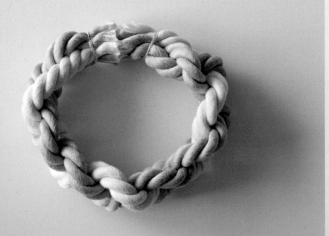

4

Wrap floss around the glued section for 2 inches to cover and reinforce the connection. Thread the floss end through a large-eyed blunt-tipped embroidery needle and weave it under the wraps to secure. Trim the end.

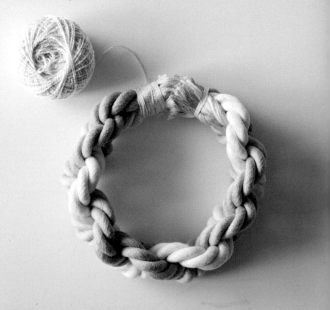

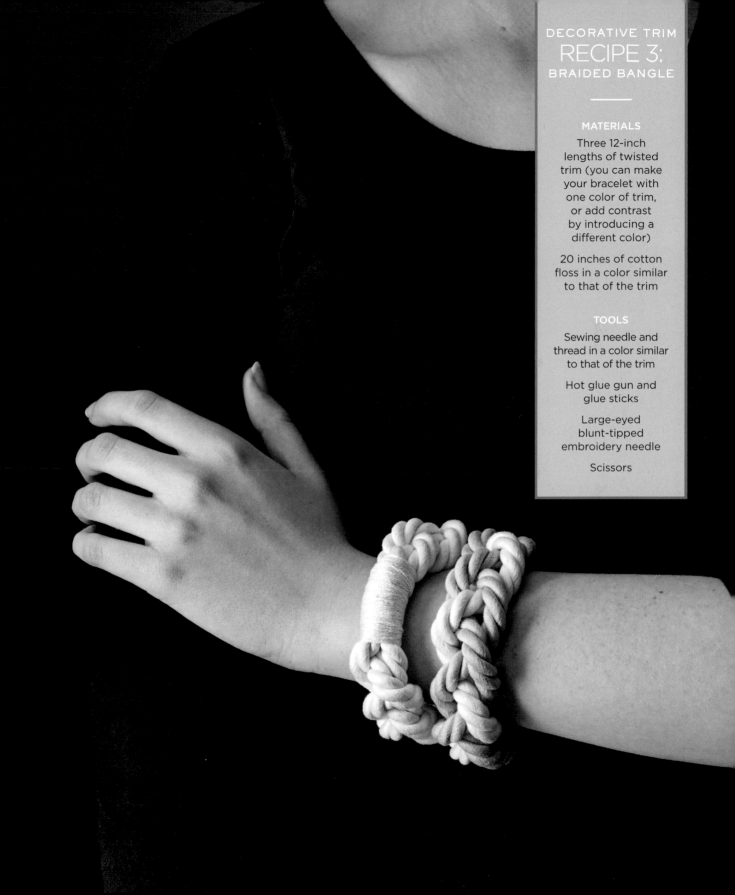

MATERIALS

Three 12-inch lengths of twisted trim (you can make your bracelet with one color of trim, or add contrast by introducing a different color)

20 inches of cotton floss in a color similar to that of the trim

TOOLS

Sewing needle and thread in a color similar to that of the trim

Hot glue gun and glue sticks

Large-eyed blunt-tipped embroidery needle

Scissors

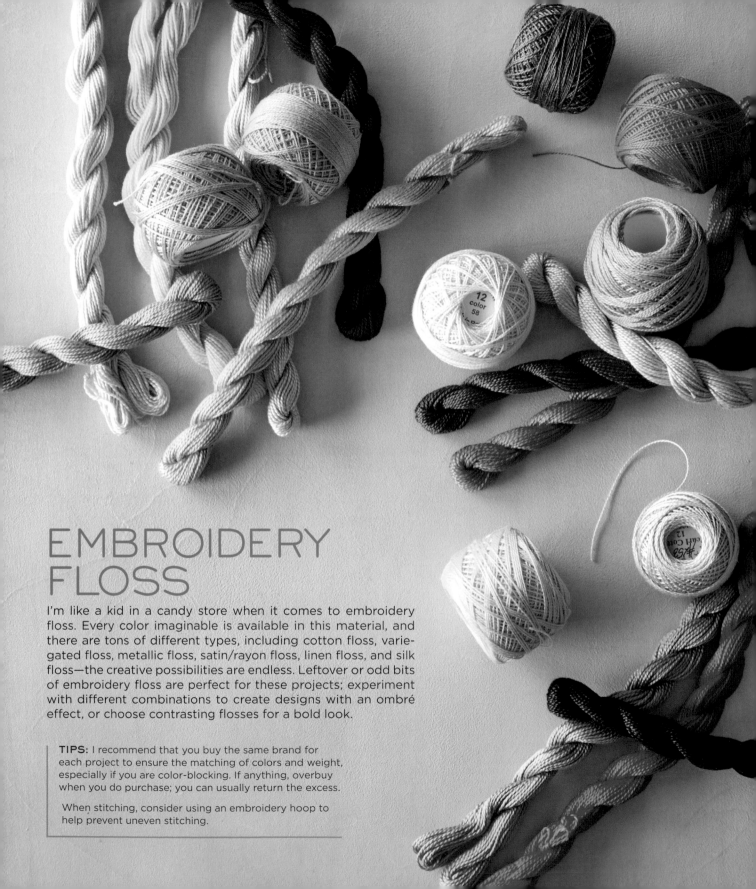

EMBROIDERY FLOSS

I'm like a kid in a candy store when it comes to embroidery floss. Every color imaginable is available in this material, and there are tons of different types, including cotton floss, variegated floss, metallic floss, satin/rayon floss, linen floss, and silk floss—the creative possibilities are endless. Leftover or odd bits of embroidery floss are perfect for these projects; experiment with different combinations to create designs with an ombré effect, or choose contrasting flosses for a bold look.

TIPS: I recommend that you buy the same brand for each project to ensure the matching of colors and weight, especially if you are color-blocking. If anything, overbuy when you do purchase; you can usually return the excess.

When stitching, consider using an embroidery hoop to help prevent uneven stitching.

RECIPE 1:
COMB WRAPS

———

MATERIALS

Embroidery floss
in various colors, at
least 20 inches of
length per comb

3- to 4-inch-wide
hair combs

TOOLS

Embroidery needle

Scissors

Hot glue gun and
glue sticks

1. Hold two strands of embroidery floss together. Tie the floss to one end of a comb, leaving a 1-inch tail.

2. Wrap the strands of embroidery floss around the base of the comb and between the teeth, covering the tail.

3. Cut the floss, leaving a 3-inch tail; thread the tail through the needle. Weave the loose ends under the floss wraps; trim. Add a dab of hot glue to secure.

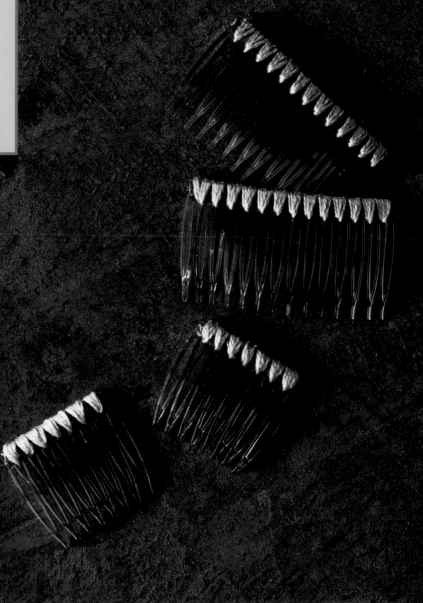

RECIPE 2:
COLOR-BLOCKED
NECKLACE

MATERIALS

26-inch length of
¼-inch-diameter
rope (you can use
clothesline cord from
a hardware store or a
similar thickness
of rope)

Embroidery floss
in various colors,
roughly 2 yards
per color

TOOLS

Scissors

Embroidery needle

Hot glue gun and
glue sticks

1 Cut the ends of the rope diagonally for a clean finish when the ends are overlapped later. Tie on a length of embroidery floss about 4 inches from one end, leaving a 1-inch tail.

2 Wrap the embroidery floss tightly around the rope, covering the tail as you go.

3 Change colors of embroidery floss as desired and continue wrapping the rope (see page 15). When finished wrapping, leave 4 inches of unwrapped cord at the opposite end of the cord.

4 Connect the ends of the cord with hot glue. Let dry. Continue wrapping the ends, so that they are completely covered with embroidery floss, until you reach the beginning of the wrap. Cut the floss, leaving a 3-inch tail. Thread the tail onto a needle and weave it under the floss wraps; trim any excess.

NOTES

As you wrap the embroidery floss around the rope, pull the embroidery floss taut.

To create stripes or blocks of colors, wrap the second color of embroidery floss around the 1-inch tail of the first color and continue wrapping.

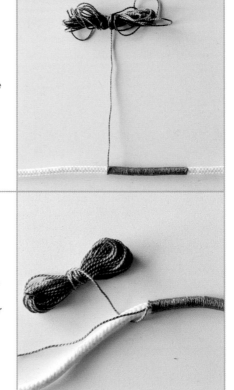

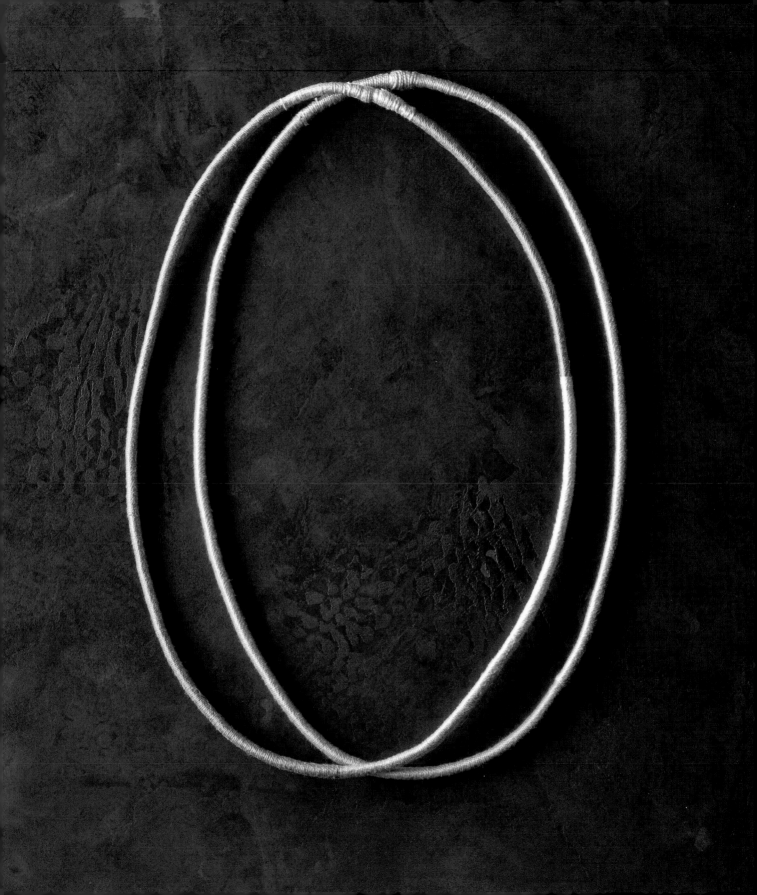

Embroider three 1-inch-long lines of
straight stitches (see page 14), about
½ inch apart, onto the fabric.

(see page 14)

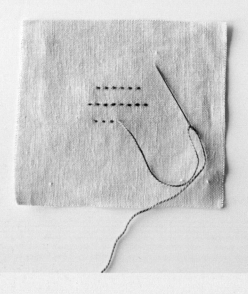

2
Trace a circle 2½ inches in diameter
onto the fabric, placing the stitches
in the center of the circle. (To get
a perfect circle shape, trace with
tailor's chalk around the base of a
cup or small jar.) Cut out the circle.

3
Secure the fabric circle to the top
of the button base, then press the
button backing on to secure.

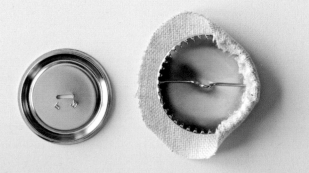

4
Cut away the button loop with wire
snips and glue the pin back to the
back of the button.

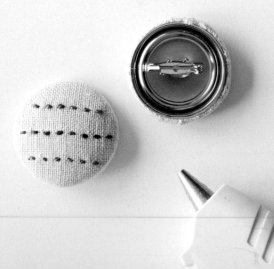

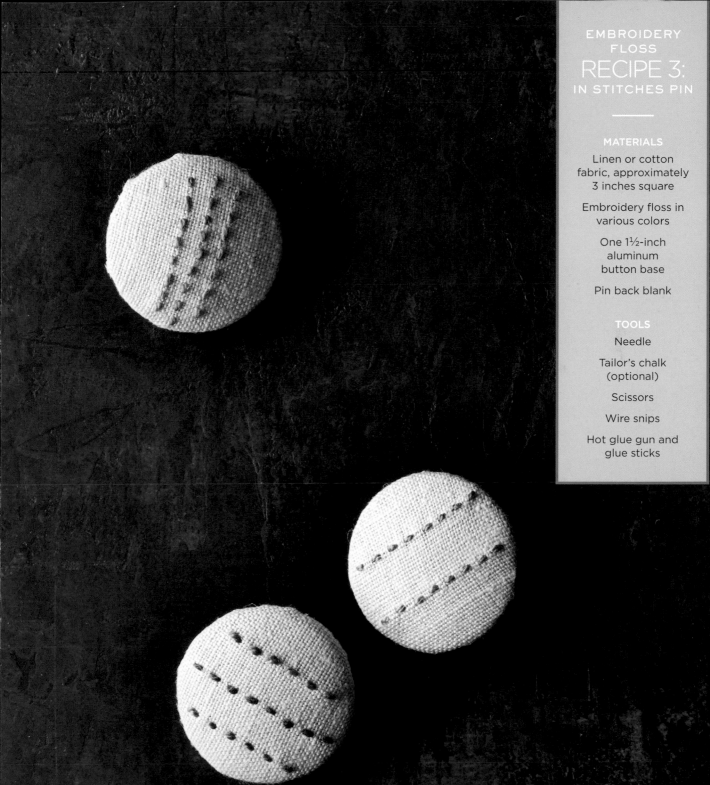

MATERIALS

Linen or cotton
fabric, approximately
3 inches square

Embroidery floss in
various colors

One 1½-inch
aluminum
button base

Pin back blank

TOOLS

Needle

Tailor's chalk
(optional)

Scissors

Wire snips

Hot glue gun and
glue sticks

FABRIC

Natural fibers have been woven for use in garments and home design for thousands of years. We often take for granted that we can make just about any article of clothing, item of home décor—think quilts, pillows, drapes—or fashion accessory from pretty much all types of new and vintage fabrics. But for centuries, that wasn't the case. The need to clothe ourselves was a necessity, a protection from the natural elements. Early clothing most likely started with the use of animal skins and evolved into many different types of fabrics and textiles, as well as a form of personal self-expression. Today, with shows like *Project Runway* contributing to the rise of the handmade, working with fabric is a passion for many. I have a huge fabric stash and often use the scraps for hair ribbons and gift wrapping. However, fabric is also a great material for jewelry; you can easily braid, wrap, pinch, or stitch it into many designs without needing a sewing machine. These projects focus on cottons and silk chiffon, but feel free to dig into your stash to create your own combinations.

TIPS: These projects showcase techniques you can employ with many different fabrics, so follow your design sensibility to create something you love. You could use alternating colors of solid fabrics, choose all florals or graphic patterns, or mix different patterns of one color.

Don't be afraid to tear fabric into strips. The frayed edges will add to the texture and overall design of your jewelry.

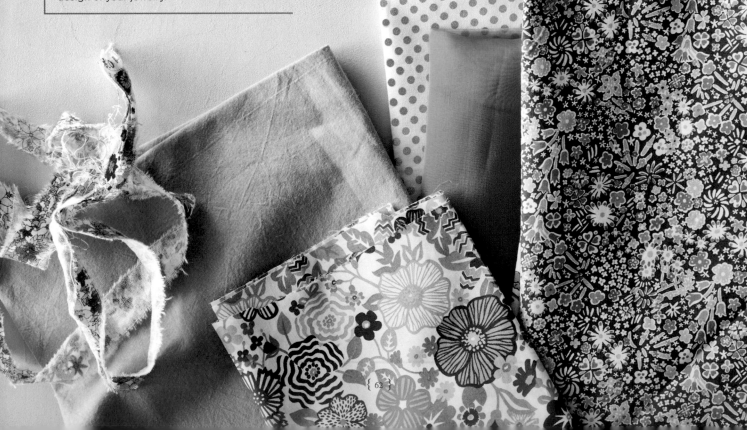

RECIPE 1:
SCRAP BRACELETS

MATERIALS

Scrap fabric

Bangle blanks in
several widths,
1 blank per bracelet

TOOLS

Fabric scissors

Hot glue gun and
glue sticks

1. Cut or tear fabric strips measuring ¼ inch by 6 inches; you'll
 need one or two strips per bracelet. Place a dot of glue on
 the inside of the bangle blank and lay the fabric strip on top,
 anchoring it before you start to wrap. Let the glue set for
 15 minutes.

2. Begin wrapping the fabric strip around the bracelet. If you need
 an additional fabric strip, stop wrapping when you are close to the
 end of the strip. Glue down the end to the bangle (preferably on
 the underside). Begin a new fabric strip, glue it down over the last
 strip, and continue to wrap. Use different fabric strips if desired.

3. When you have completely wrapped the bangle, place a dot of glue
 on the inside, pull the working strip taut, and lay it over the glue,
 pressing down. Let dry and trim the excess fabric.

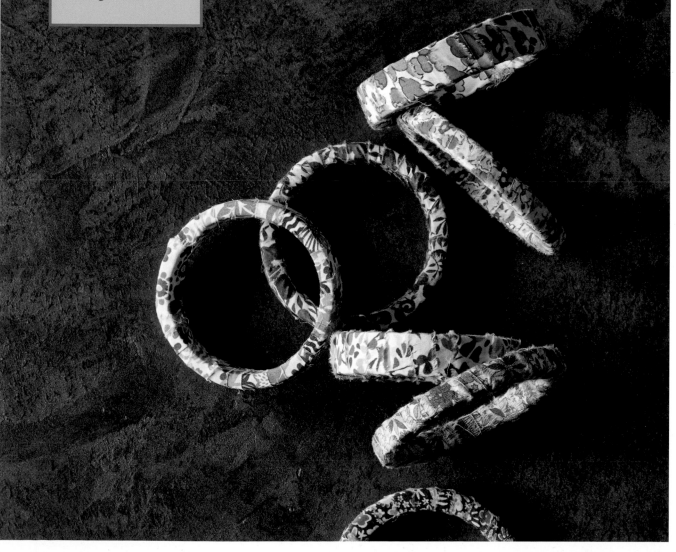

FABRIC
RECIPE 2:
ORGANZA PIN

―――――

MATERIALS
¼ yard of organza

1 pin back blank

TOOLS
Fabric pencil or pen

Fabric scissors

Fray Check (optional)

Sewing needle
and thread

Hot glue gun and
glue sticks

1 With a fabric pencil, draw a freehand circle on the fabric that is about 7 inches in diameter. Draw three more circles: 6 inches, 5 inches, and 4 inches in diameter. Don't worry if they aren't perfect!

2 Cut out the shapes. If desired, apply Fray Check to the edges of the circles to prevent them from fraying.

3 Thread the needle and set it aside. Stack the fabric circles, then pinch the center of the stack to create a flower. Holding the flower together, carefully take several stitches through the center of the group to join the pieces, about ¼ inch from the bottom.

4 Sew the flower to the pin back, and add a dab of hot glue to secure.

NOTES

When pinching the circles together, avoid folding the circles into quarters. Pinch from the center.

Organza is an excellent fabric for this type of design—it's sheer enough to layer colors, yet firm enough to hold the shape of a flower.

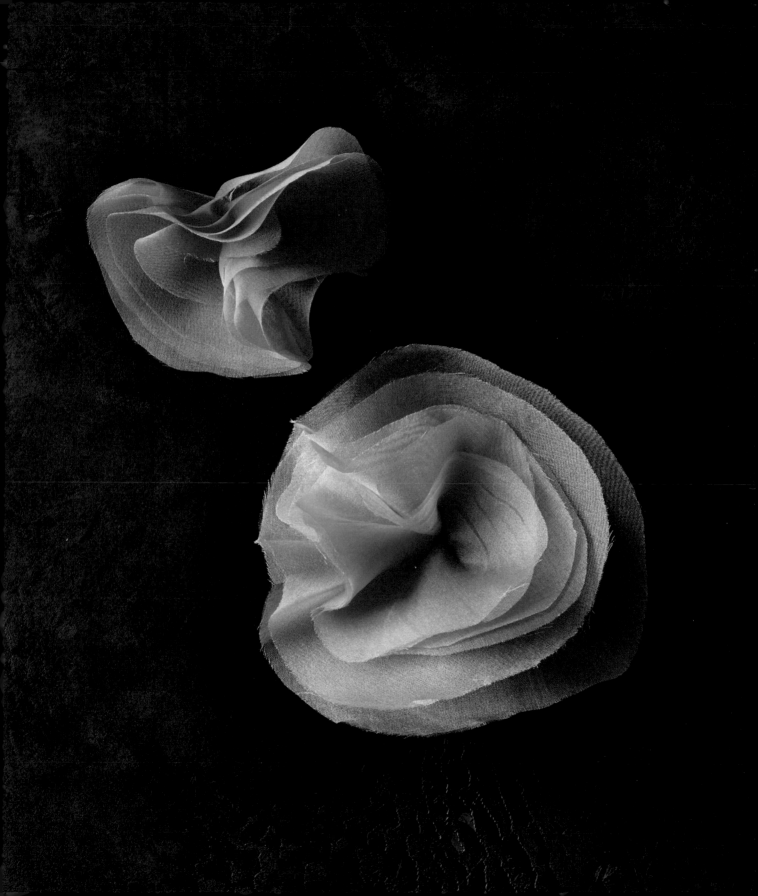

Lay the fabric (wrong side facing up) on a flat surface. String a wooden bead onto the long (42-inch) piece of cord about 16 inches from the end, and then lay the cord with the bead on top of the fabric, about ½ inch away from the edge.

2 Fold the long edge of the fabric over the bead and lightly anchor it with a dab of glue, making sure the fabric fully covers the bead. Take one of the small pieces of cord and tie the fabric so that it is taut against the bead and cord. Take another small piece of cord and repeat on the other side of the bead. To make the ties between the beads really tight, either double knot them or add a dab of hot glue to secure.

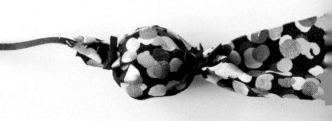

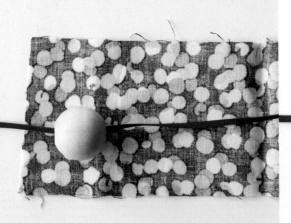

3 String the remaining five beads onto the cord, repeating steps 2 and 3 to cover the beads with fabric, tying off between the beads.

4 Tie the two ends of the cord together to secure.

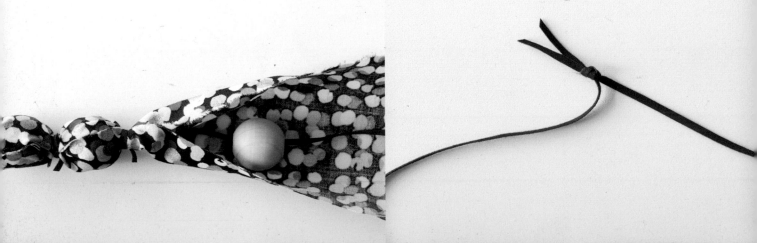

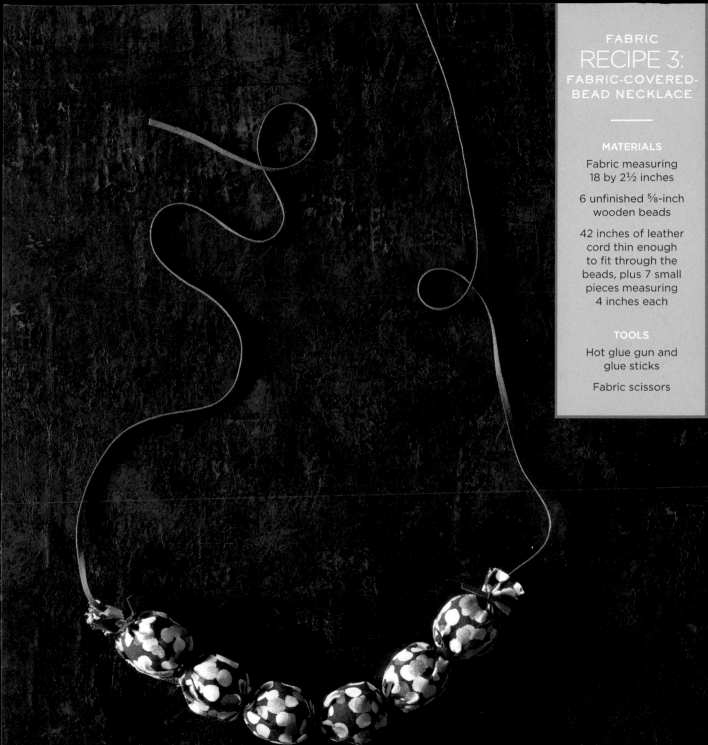

FABRIC

RECIPE 3:
FABRIC-COVERED-
BEAD NECKLACE

MATERIALS

Fabric measuring
18 by 2½ inches

6 unfinished ⅝-inch
wooden beads

42 inches of leather
cord thin enough
to fit through the
beads, plus 7 small
pieces measuring
4 inches each

TOOLS

Hot glue gun and
glue sticks

Fabric scissors

FACETED AND TUBULAR BEADS

Faceted and tubular beads seem to be made for each other; the angular, faceted beads play beautifully with the smooth, hollow tubular beads to create playful, sophisticated results. The bright, simple shapes of the Tubular Bead Necklace give a nod to more ethnic materials and designs—and while the necklace is made using plastic tube beads often associated with children's jewelry, the necklace is anything but childish.

TIP: Beads offer an infinite number of possibilities, but there are two easy ways to make a striking statement: First, use beads of the same scale and shape to streamline the design, but make color the focal point; second, repeat a pattern across multiple strands to go from a simple design to a statement piece.

RECIPE 1:
TUBULAR BEAD NECKLACE

MATERIALS

30- to 36-inch length of hemp or linen cord

About 60 tubular straw beads, ¼ inch to ½ inch long, in various colors

TOOLS

Camera (optional)

Scissors

1. Drape the cord around your neck to determine the desired length. Add 4 inches and trim the cord.

2. Select the beads and organize a pattern (take a photo if you want to replicate the pattern exactly).

3. String the beads onto the cord and knot the ends together. Trim the ends or slip the knot into one of the beads for a clean, finished look.

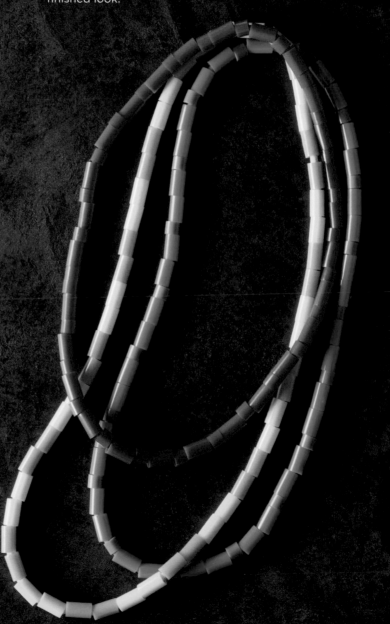

RECIPE 2:
GEO BEADED NECKLACE

MATERIALS

3 brass tubular beads,
⅝ inch long

40-inch length of
waxed cord

4 short brass tubular
beads, ⅛ inch long

2 brass faceted
beads, ¼ inch long

1 small brass clasp

TOOLS

Scissors

1 Thread one long tubular bead onto the waxed cord, positioning it at the center of the cord. Then thread one short tubular bead, one faceted bead, and another short tubular bead onto the left-hand end of the cord, in that order. Fold this set of three beads over the long tubular bead so that they are stacked on top.

2 Thread the right-hand end of the cord back through the three beads you have just threaded and pull both ends of the cord taut.

3 Continue threading and stacking beads in this manner, alternating layers of long tubular beads with layers of three short beads. Make five layers total, ending with a long tubular bead.

4 Knot the ends of the cord to the clasp, then trim any excess.

NOTES

Be sure to lay the first bead flat and level. This will set the foundation and make stringing and layering the other beads easy.

Play with different sizes and shapes of beads to make a different style necklace. You can play with the color of the beads as well as the cord.

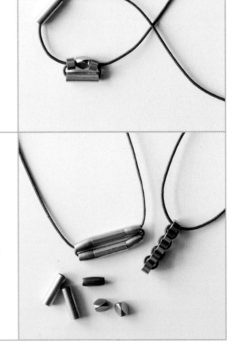

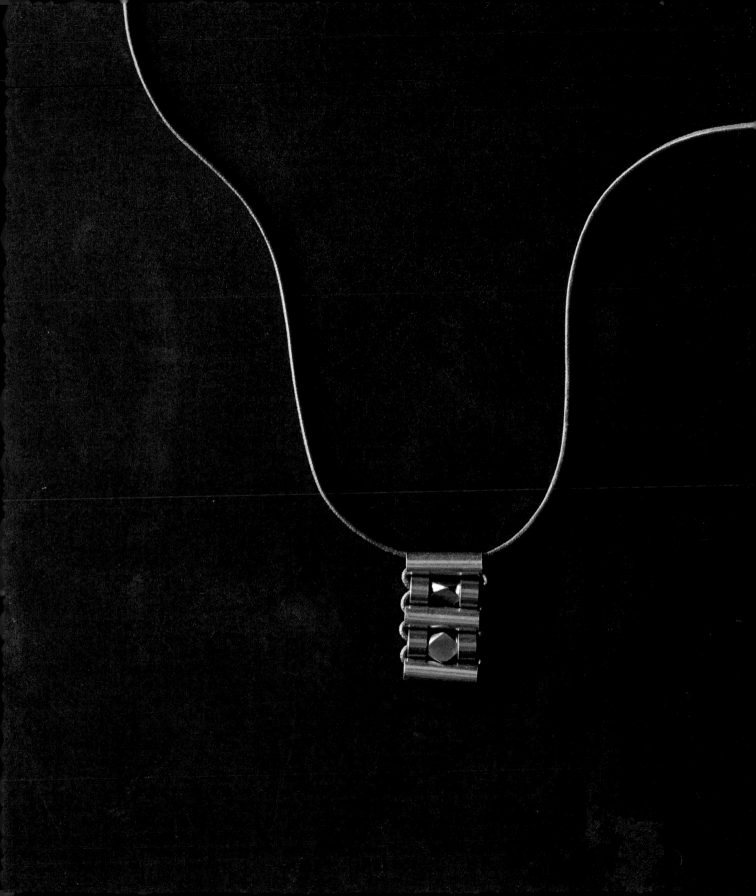

1 Thread a bead onto a head pin.

2 Using wire snips, trim the pin, leaving ½ inch, and make a small loop using round-nose pliers. Do not close the loop all the way.

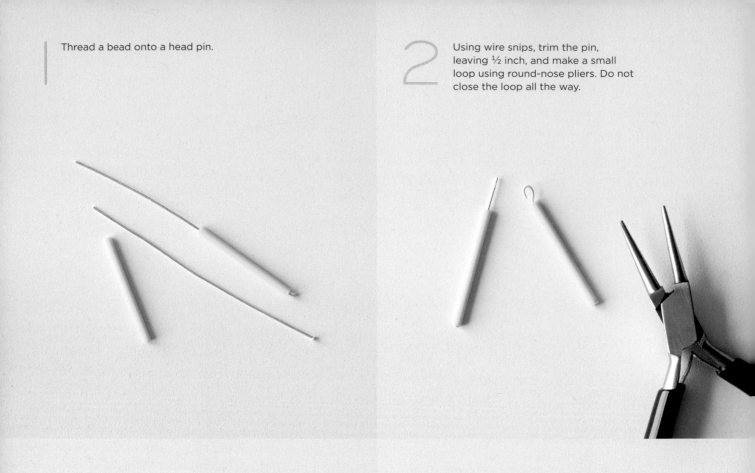

3 Using flat-nose pliers, slip one end of the chain onto the loop and close it.

4 Use a jump ring to connect the other end of the chain to the ball post (see page 13). Repeat to make the second earring.

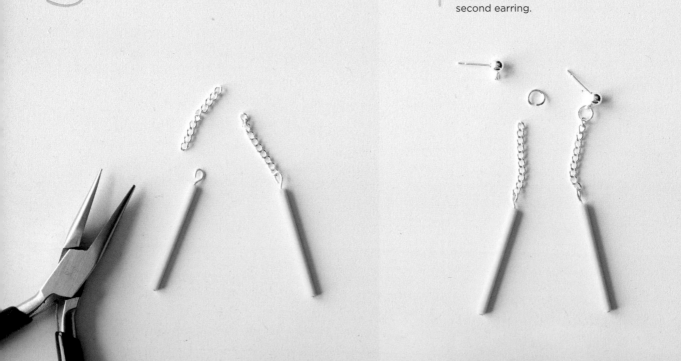

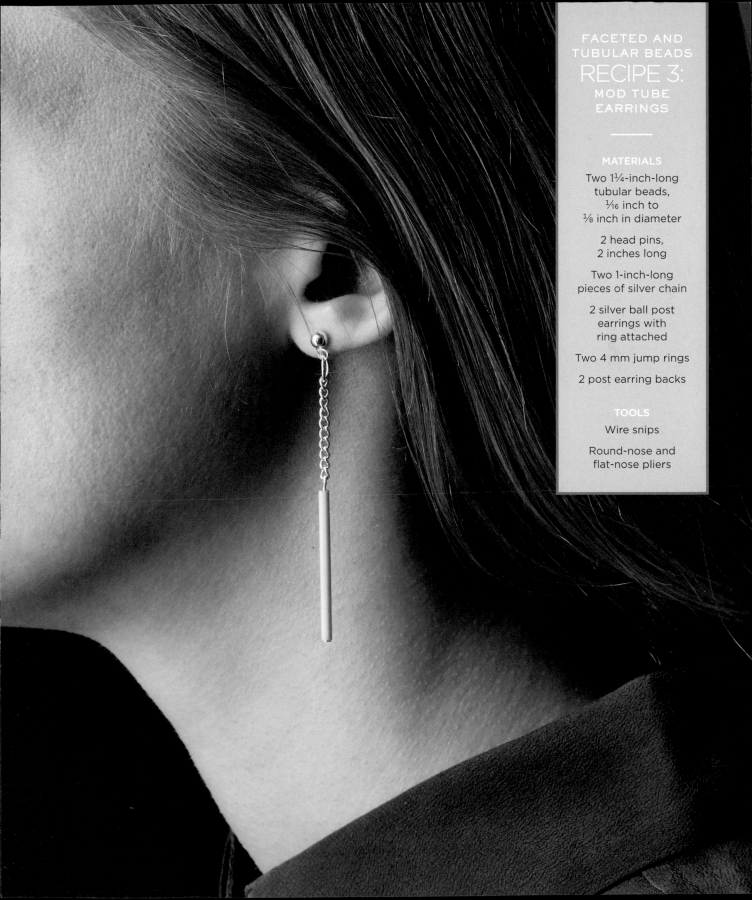

MATERIALS

Two 1¼-inch-long
tubular beads,
¹⁄₁₆ inch to
⅛ inch in diameter

2 head pins,
2 inches long

Two 1-inch-long
pieces of silver chain

2 silver ball post
earrings with
ring attached

Two 4 mm jump rings

2 post earring backs

TOOLS

Wire snips

Round-nose and
flat-nose pliers

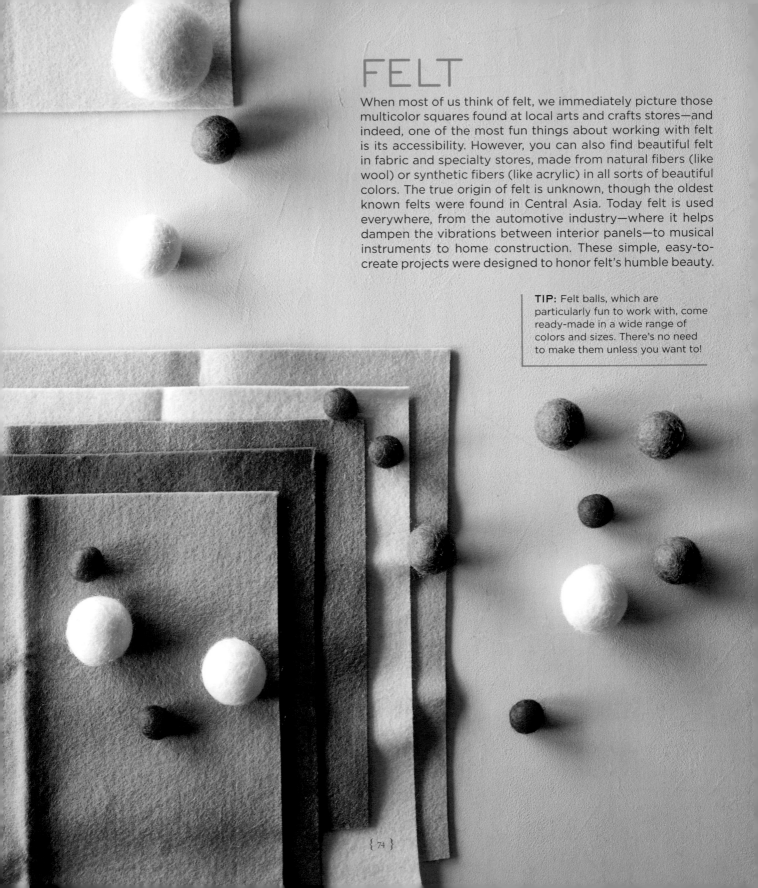

FELT

When most of us think of felt, we immediately picture those multicolor squares found at local arts and crafts stores—and indeed, one of the most fun things about working with felt is its accessibility. However, you can also find beautiful felt in fabric and specialty stores, made from natural fibers (like wool) or synthetic fibers (like acrylic) in all sorts of beautiful colors. The true origin of felt is unknown, though the oldest known felts were found in Central Asia. Today felt is used everywhere, from the automotive industry—where it helps dampen the vibrations between interior panels—to musical instruments to home construction. These simple, easy-to-create projects were designed to honor felt's humble beauty.

TIP: Felt balls, which are particularly fun to work with, come ready-made in a wide range of colors and sizes. There's no need to make them unless you want to!

MATERIALS

46-inch length of white cotton ribbon, ¾ inch wide

5 store-bought felt balls, 1 inch in diameter or desired size, but not smaller than ¾ inch

TOOLS

Sharp embroidery needle

1. Thread the ribbon onto the needle, then thread a felt ball onto the ribbon.

2. Tie an overhand knot, slide it close to the ball, and pull tight.

3. Continue with the remaining felt balls and finish with a knot at either end of the line of five felt balls. Tie a bow at the back to close.

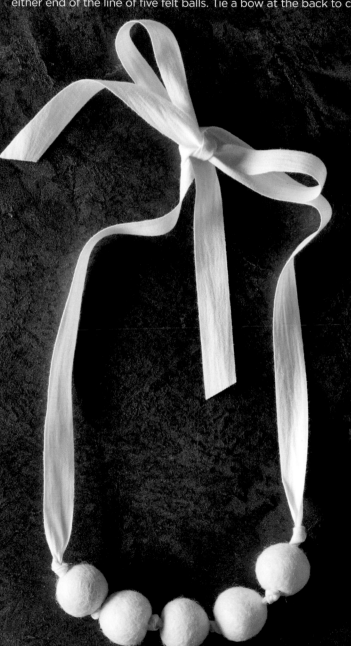

RECIPE 2:
WOVEN FELT BRACELET

MATERIALS

12-by-3-inch
piece of felt

1 snap closure, ¾ inch
in diameter

TOOLS

Fabric scissors or
rotary cutter

Metal ruler

Self-healing mat
(optional)

Magna-Tac 809 or
other fabric glue

Sewing needle
and thread to
match felt

1 Cut two strips from the felt: ½-inch-wide strips for a thin bracelet, 1-inch-wide strips for a medium bracelet, or 1½-inch-wide strips for a thick bracelet.

2 Position the felt strips perpendicular to each other and secure them at one end at a ninety-degree angle with fabric glue and a few stitches.

3 Fold the lengths of felt over each other until you reach the end of the strips. Sew the loose ends together at a ninety-degree angle with a few stitches. Add a dab of glue to secure.

4 Sew a snap to each of the flat ends of the folded felt piece.

NOTES

Use two different colors to create a color-blocked look. (This also shows off the folding technique.)

Using a rotary cutter, a metal ruler, and a self-healing mat will ensure that you get a clean, straight edge.

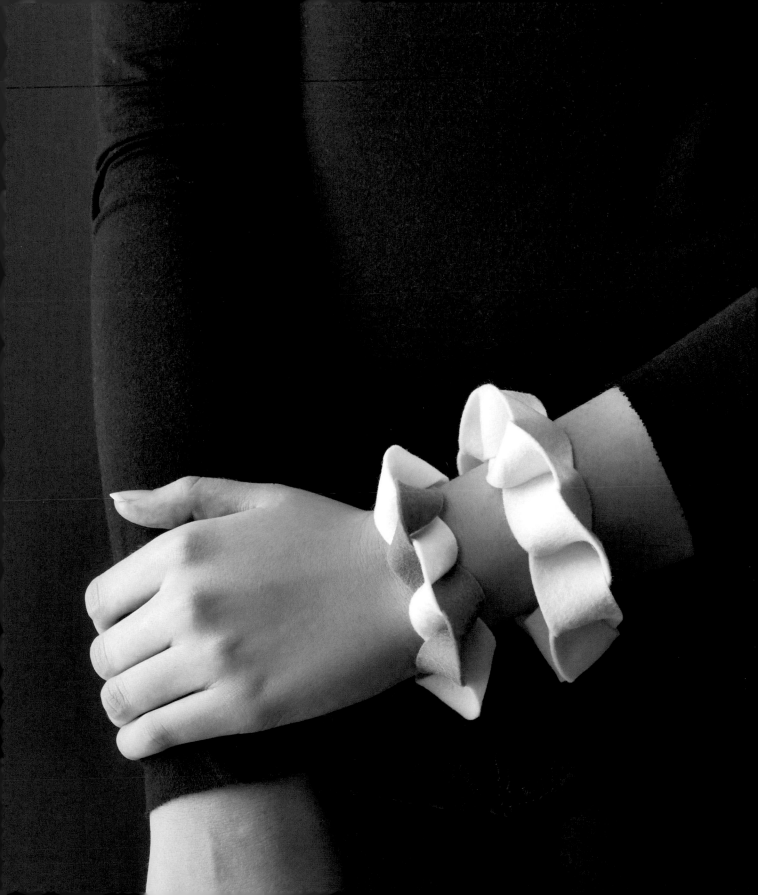

To make each large 3-D ball, trace four circles onto the felt, about 1½ inches in diameter, and cut them out. Stack two circles on top of each other and hand-stitch them together using a straight stitch (see page 14) down the center of the circles. You will need to create three felt balls for the necklace.

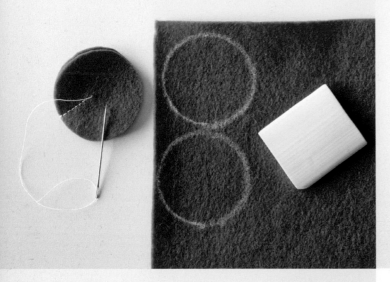

2 Fold the sewn circles along the seam, then stack the two remaining felt circles on either side. Hand-stitch the four layers together in a straight line, overlapping with the center seam connecting the center layer. Knot and trim the loose ends of the thread. When layering the four circles for the felt ball, hold them together with a binder clip or a safety pin so that they don't shift as you sew.

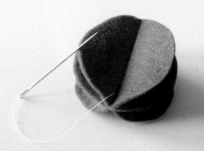

3 Thread each large felt ball onto an eye-head pin down the center seam. Make a loop at the other end of each pin. Use the wire snips to trim the pin wire if it is too long.

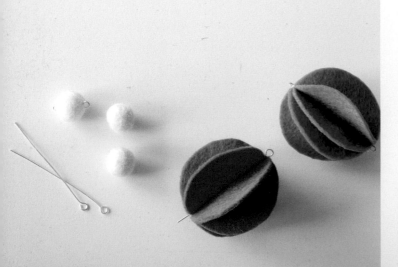

4 With wire snips, cut the chain necklace in half in the center (opposite the clasp). Connect all the felt balls by their metal loops as follows: small, small, big, small, big, small, big, small, small. Connect the string of felt balls to the chain by slipping the chain onto the metal loops at the end and tightly closing the loops with pliers, much like you would with a jump ring (see page 13).

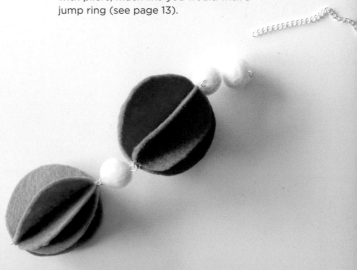

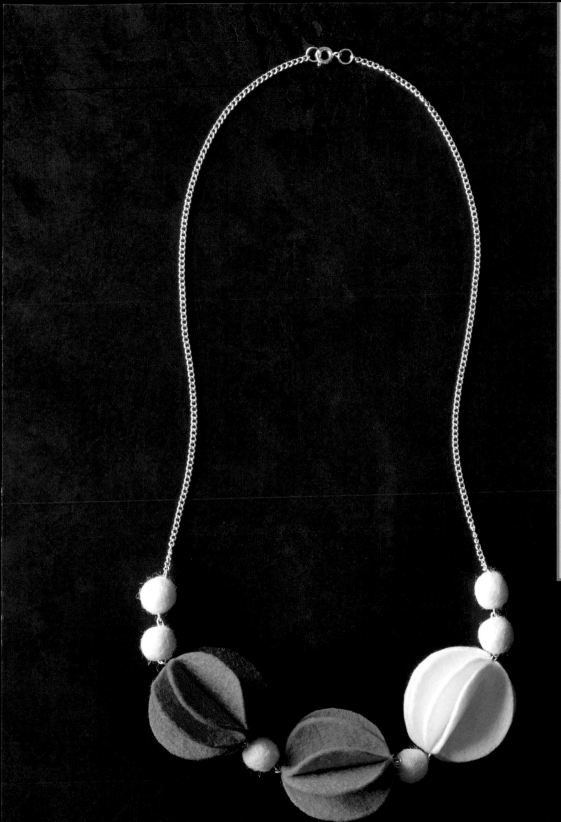

FELT

RECIPE 3:
3-D FELT BALL
NECKLACE

MATERIALS

6 small felt balls,
½ inch in diameter

Felt fabric in three
different colors, each
piece measuring at
least 2 inches by
9 inches

18-inch chain
necklace with
clasp (and links
large enough to
accommodate the
width of the eye-
head pins)

6 eye-head pins

TOOLS

Scissors

Sewing needle and
thread to match felt

Round-nose and
flat-nose pliers

Wire snips

Binder clip or
safety pin

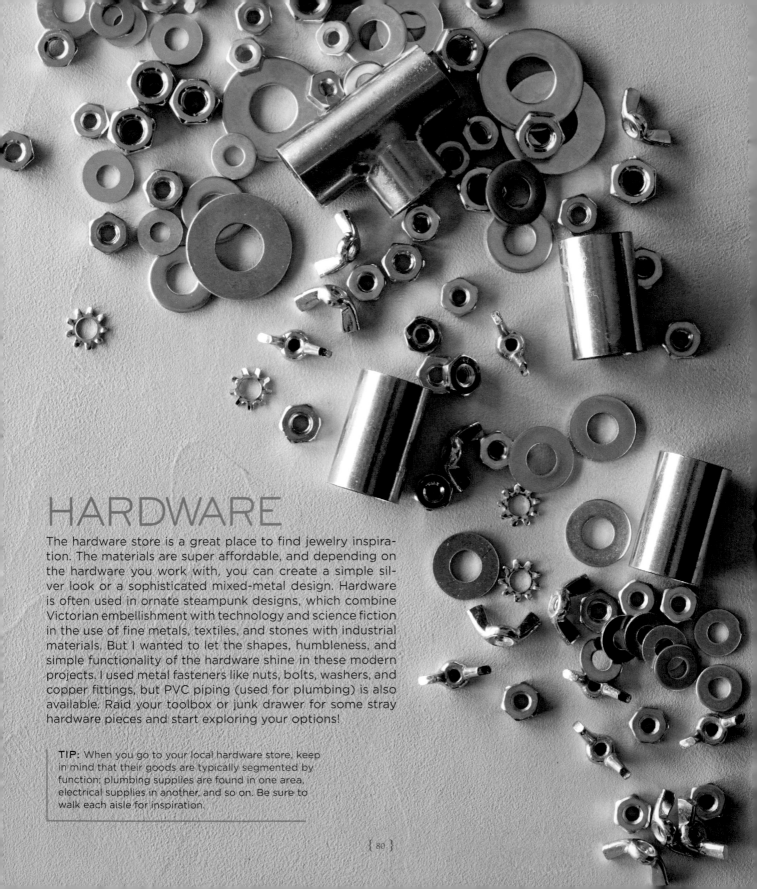

HARDWARE

The hardware store is a great place to find jewelry inspiration. The materials are super affordable, and depending on the hardware you work with, you can create a simple silver look or a sophisticated mixed-metal design. Hardware is often used in ornate steampunk designs, which combine Victorian embellishment with technology and science fiction in the use of fine metals, textiles, and stones with industrial materials. But I wanted to let the shapes, humbleness, and simple functionality of the hardware shine in these modern projects. I used metal fasteners like nuts, bolts, washers, and copper fittings, but PVC piping (used for plumbing) is also available. Raid your toolbox or junk drawer for some stray hardware pieces and start exploring your options!

TIP: When you go to your local hardware store, keep in mind that their goods are typically segmented by function; plumbing supplies are found in one area, electrical supplies in another, and so on. Be sure to walk each aisle for inspiration.

RECIPE 1:
NEON HARDWARE
BRACELET

MATERIALS

7 silver nuts
or washers—
standard size

7-inch-long elastic
cord, ⅛ inch thick

1 end-cap closure
that fits snugly over
the cord

TOOLS

Magna-Tac 809

1. Thread the washers or nuts onto the cord.

2. Squeeze a dab of glue into the inside of each end-cap closure.
 Place the cord ends inside the caps and allow to dry for 2 hours.

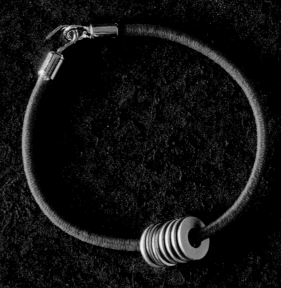

RECIPE 2:
MIXED NUTS NECKLACE

MATERIALS

About 60 small gold and silver nuts and thin washers, ⅛ inch to ¼ inch

2 wing nuts

Liquitex spray paint in Cerulean Blue

31-inch length of navy blue suede cord

1 lobster clasp

TOOLS

Kraft paper

E6000 craft adhesive or other craft glue

1 | Lay one-quarter to one-third of the hardware on kraft paper and spray-paint one side; let dry for 60 minutes in a well-ventilated room, then repeat for the other side.

2 | Organize a design with the "beads."

3 | Beginning at one end, string the hardware onto the cord until you have strung all of it.

4 | Knot a washer to one end of the cord and the lobster clasp to the other and reinforce with a dot of glue (due to the weight of the hardware) where you've knotted each end of the cord.

NOTES

Spray-paint some of the hardware to give it a different look, and mix in some other colors. Once the hardware is dry, make sure you turn the pieces over and paint the underside.

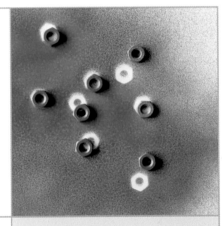

Play with different colors and widths of cord to make other bracelets and necklaces. If you use a thick cord, the hardware will stay in place, so you can space the pieces out accordingly.

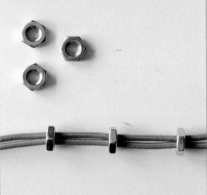

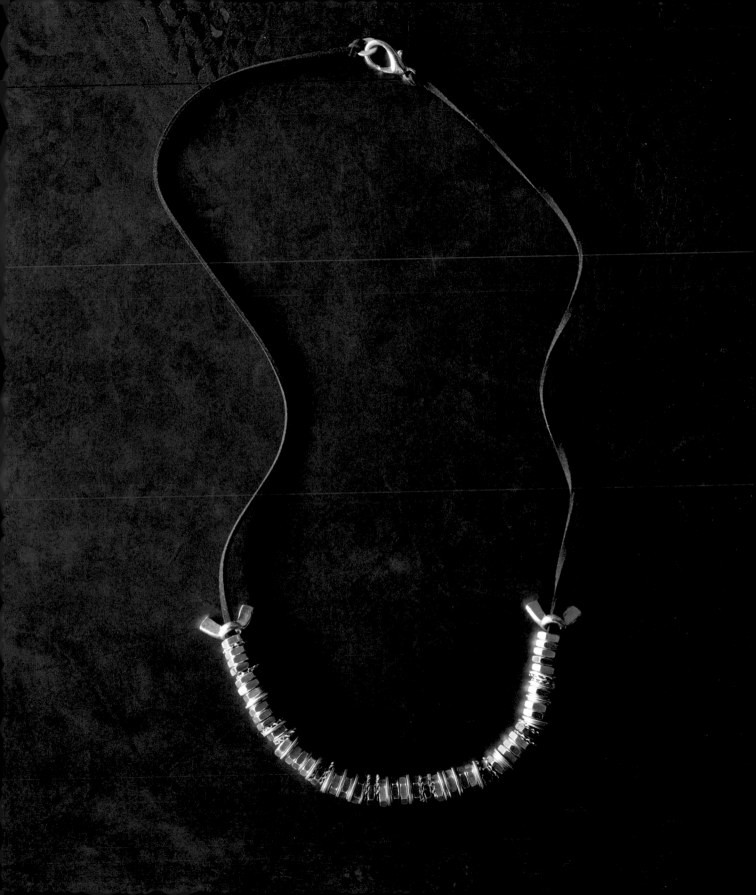

Thread the rope through the right side of the T, then through the top end. Position the T at the center of the rope.

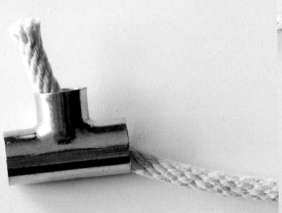

2 Loop the other end of rope around the bottom of the T, and then back through the left side and out through the top. Both ends of rope will be coming out of the top of the T. Check that the rope lengths remain equal.

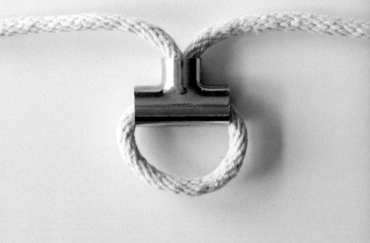

3 Fold each end of the rope back over itself, placing the ends inside the top of the T. Check that the folded ropes remain equal in length and make any necessary adjustments. Secure the ends with a dab of hot glue inside the tube.

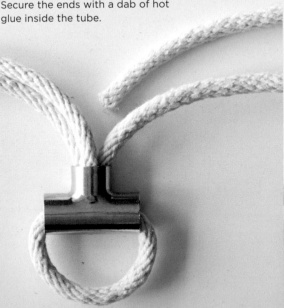

4 Cover the folded rope ends with the clasp of copper pipe, checking that the pipe clasp remains centered above the T piece that forms the pendant. Secure the rope ends with dabs of hot glue inside the pipe clasp.

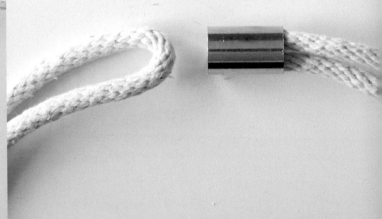

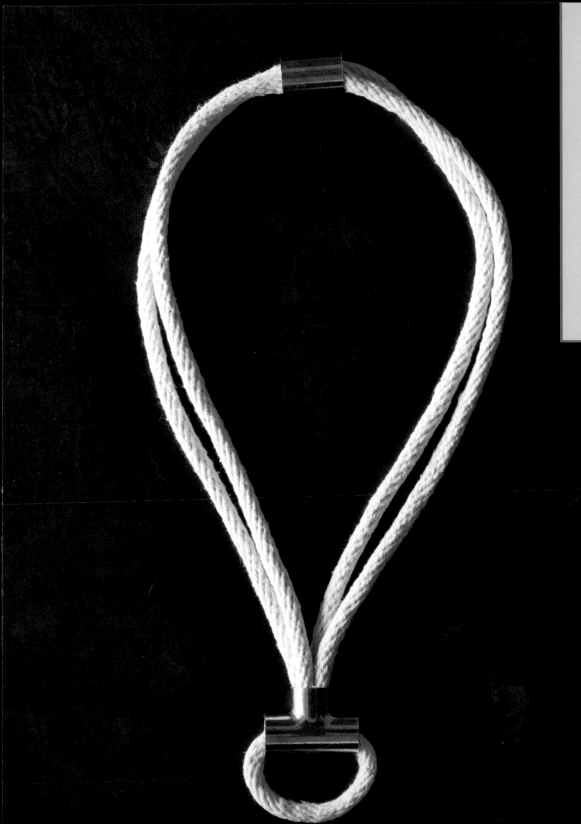

HARDWARE
RECIPE 3:
COPPER-T
NECKLACE

MATERIALS

2 yards of
⅜-inch rope

1-inch copper T

1⅛-inch-long copper
pipe piece, ¾ inch in
diameter

TOOLS

Hot glue gun and
glue sticks

KEYS

I still have my first apartment key; I didn't save it intentionally, but there it sits in my top drawer. We use keys every day, so in a way they chronicle our lives, whether they remind us of a first home, protect treasures in a safe-deposit box, keep the secrets of a diary, reveal a treasure in a locket, or take us for a spin in a vintage car. Many keys are being replaced in our increasingly digital world, but the key will always have symbolism attached to it. Use a vintage or meaningful key to make a striking pendant (as in the Color-Blocked Skeleton Key Necklace), or transform a new key into a piece of personal bling (as in the Wrapped Key Bracelet).

TIP: If you are using older keys, make sure to lightly clean them with soapy water and dry thoroughly before using. If your skin is sensitive, coat the key with clear nail polish—just keep in mind that this will change the patina by adding some shine. You can also consider purchasing a new reproduction key that looks like a vintage or old-fashioned version.

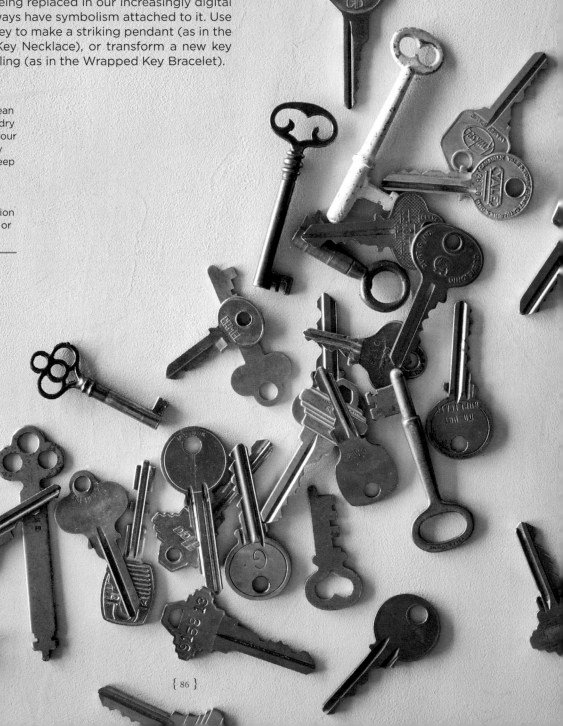

RECIPE 1:
COLOR-BLOCKED SKELETON KEY NECKLACE

———

MATERIALS

Vintage skeleton key

Nail polish
(shown here: OPI
Green-wich Village)

1 yard of
suede cording

1. Use nail polish to paint the middle section of the key with a color block. Allow to dry for 2 hours.

2. Tie the key onto the suede cording using a lark's head knot (see page 13).

3. Tie the ends of cord in a knot or a bow to wear the necklace at the desired length.

RECIPE 2:
KEY CHARM NECKLACE

MATERIALS

4 vintage keys approximately 2 inches in length (one must have a flat, wider midsection)

1½ inches of clear rhinestone cup chain

Six 8 mm jump rings in an antique brass finish

Five 10 mm round, gold-toned beads with holes large enough to fit over the chain

16-inch 4 mm chain in an antique brass finish

1 lobster clasp in an antique brass finish

TOOLS

E6000 craft adhesive or other craft glue

Round-nose and flat-nose pliers

1. Add the rhinestone cup chain to the key with the best surface. This will be the focal point of the necklace. Glue the section of cup chain to the key, pushing the rhinestones together so that they lie side by side. Allow to dry for 1 hour.

2. Attach a jump ring (see page 13) to each of the keys using the hole at the top of the key. Decide the order in which the keys should be arranged on the necklace. The rhinestone-styled key should be placed closer to the center of the design. Alternating shapes, sizes, and metal tones will provide the best result.

3. String the keys onto the chain in the order chosen, adding a bead after each one for spacing. Begin with a bead and then alternate, stringing a key followed by a bead, until you have strung all the beads and keys.

4. Attach the lobster clasp to one end of the chain using pliers and a jump ring. Attach a jump ring to the other end of the chain to complete the clasping mechanism for this piece.

NOTES

To gain better control of glue application for rhinestone beads, squeeze a dab of glue onto a piece of paper and use a toothpick to apply it to the pieces as desired. This allows for more precise positioning of items on the key.

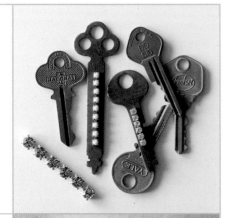

To give this design a more modern look, consider spray-painting the keys with a matte white spray paint. Or go bold and playful with primary colors. Keep the structure, but add different types of beads.

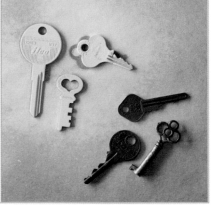

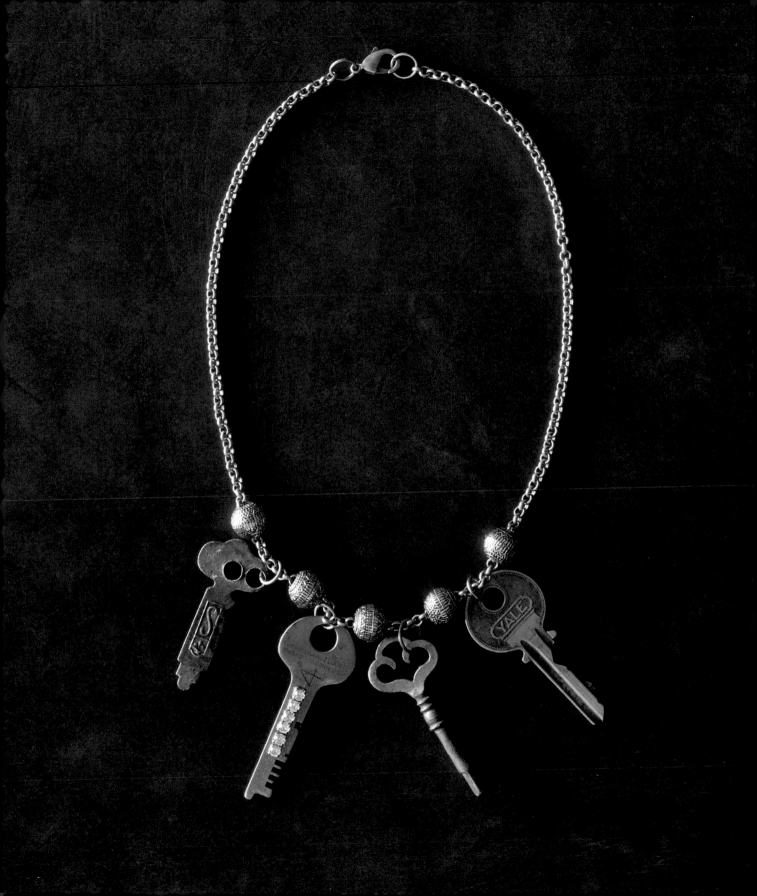

Insert the 2-inch piece of wire into the focal bead. Using round-nose pliers, make a loop on each end of the wire (see page 13). Using a jump ring (see page 13), attach the lobster clasp to the wire loop on one side of the focal bead and close tightly. Set aside.

2 Use 8 to 10 inches of craft wire to wrap a section of the key near the end. Begin by finding a notch on the key where you can securely anchor the wire. Lay the very end of the wire across the width of the key at that point, allowing the wire to "sit" in the notch on the edge of the key. Bring the wire around the key and wrap it over the beginning of the wire to secure it in place. Continue wrapping the wire around the key approximately six more times, crossing over previous wire wraps at odd angles to create an organic design. When the desired look is complete, finish by cutting the wire ⅜ inch from the edge of the wrapping and using round-nose pliers to tuck the end into and/or under the rest of the wire.

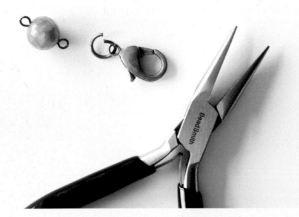

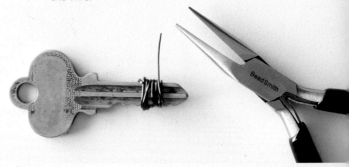

3 Look for a secure piece of wire within the wire-wrapped section on the key. Hook an open jump ring into this spot. (You might need to adjust the wrapped wire with pliers to open up space for the jump ring.) Slide an end link of the chain onto the open jump ring once it is hooked into the wire and close the jump ring to attach the chain. Secure tightly.

4 Use a jump ring on the other end of the chain to attach to the remaining empty loop on the focal bead.

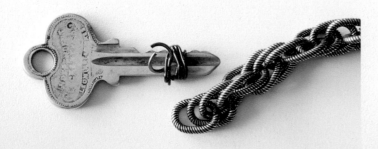

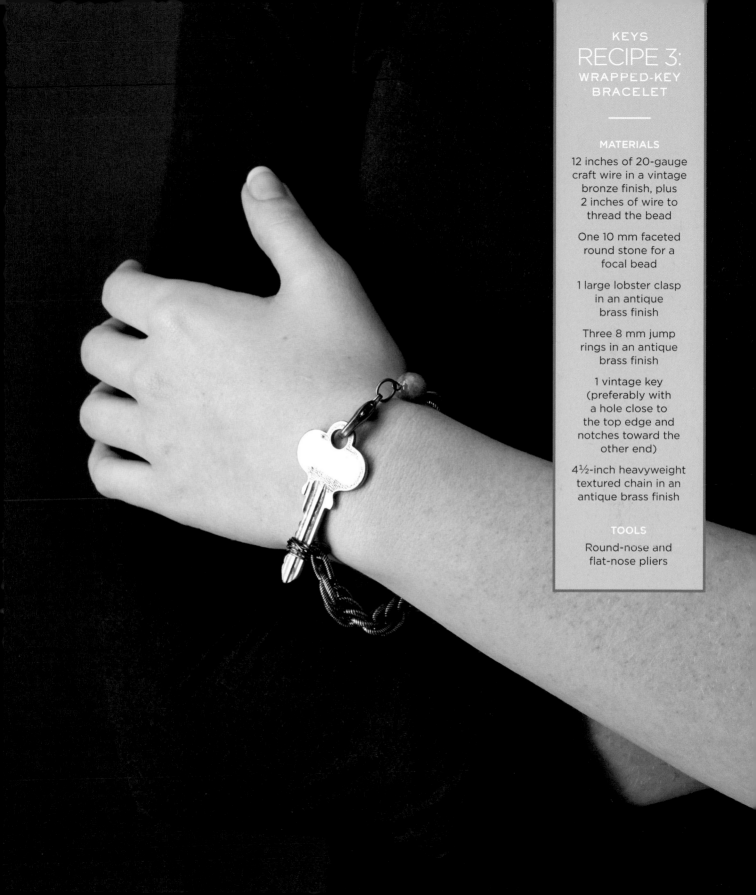

MATERIALS

12 inches of 20-gauge craft wire in a vintage bronze finish, plus 2 inches of wire to thread the bead

One 10 mm faceted round stone for a focal bead

1 large lobster clasp in an antique brass finish

Three 8 mm jump rings in an antique brass finish

1 vintage key (preferably with a hole close to the top edge and notches toward the other end)

4½-inch heavyweight textured chain in an antique brass finish

TOOLS

Round-nose and flat-nose pliers

LACE

Many people associate lace with another era—or, at the very least, with their grandmother. However, lace and other needle arts are back in vogue, both in clothing and in the home. Fashion has always driven lace production; toward the end of the sixteenth century, standing collars demanded bold geometric needle lace, while in the early 1600s, softer collars required many yards of narrow linen bobbin lace. Today, there are several different types of lace, including needle lace, cutwork lace, bobbin lace, tape lace, knotted lace, crocheted lace, and knitted lace. These projects show that lace can truly be worn every day whether you're dressing up or down!

TIP: There are many good sources for machine-made lace (see Resources). However, you can also use antique lace to make something truly unique; hunt through flea markets and secondhand stores for lace remnants. You can dye gently worn pieces (see page 13) to conceal many small stains or worn spots. Whether you use modern machine-made lace, antique lace, or both, you can mix different widths and patterns as in the Lace Cuff.

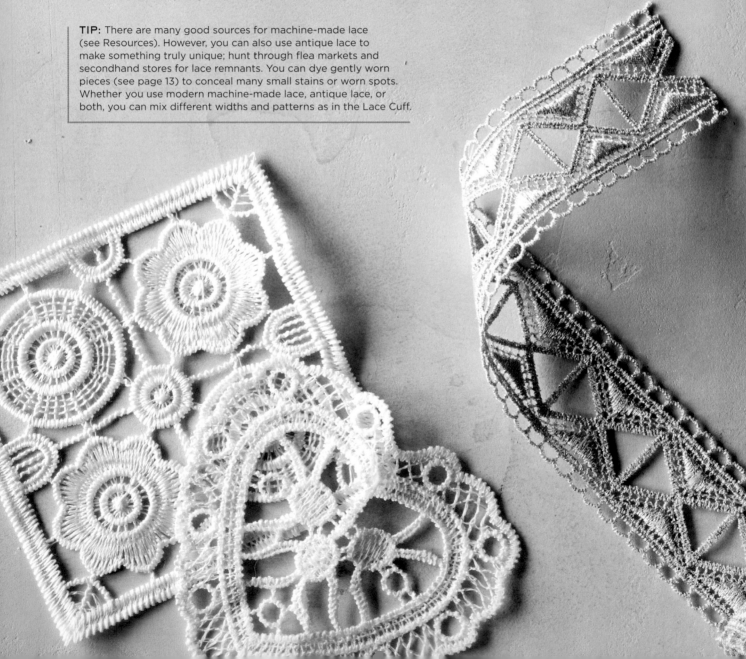

RECIPE 1:
LACE EARRINGS

MATERIALS

2 lace appliqué motifs, about 2 inches wide and 2½ inches long

Two 7 mm jump rings

2 earring wire blanks

TOOLS

Iron

Round-nose and flat-nose pliers

1. Iron the lace.

2. Slip a jump ring onto the center top of the lace motif (see page 13). Slip the earring wire on the jump ring, and close the ring tight with pliers.

3. Repeat for the second earring. Note: If the lace is not reversible, make sure to make a right and a left earring. To do this, place the earring wire onto the jump ring in opposite directions on each earring.

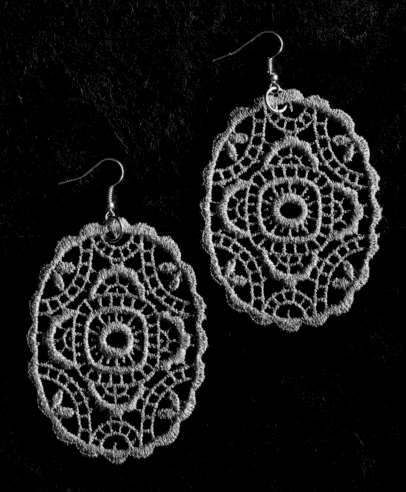

MATERIALS

10-inch length of metallic lace in the desired width (¾ inch to 2½ inches)

TOOLS

5-by-10-inch sheet of plastic wrap

Mod Podge or white craft glue

1-inch-wide paintbrush or foam brush

Scissors

Hot glue gun and glue sticks

Small hair clip or bobby pin (optional)

1. Lay plastic wrap on a flat crafting surface. Pour a quarter-sized pool of Mod Podge onto the crafting surface. Using a brush, apply a generous amount of Mod Podge to both sides of the lace.

2. Allow to dry overnight.

3. Once the lace is dry, peel it off the plastic wrap. Measure against your hand to make sure the cuff will fit over your hand with ease. Trim to size so that the ends are neat.

4. Apply a small dot of hot glue at one end. Overlap the ends ¼ inch to connect the bangle loop, and hold it together to set the glue. Let dry overnight (secured with a small hair clip or a bobby pin if you like) before wearing.

NOTES

Make sure the lace is completely covered with Mod Podge, but wipe off any excess that is sitting on the surface. Otherwise, it can dry with bulky glue sections that will interfere with making a clean seam for the bangle.

Try using different lace trims, such as cotton, to mix with metallic lace for a more eclectic look.

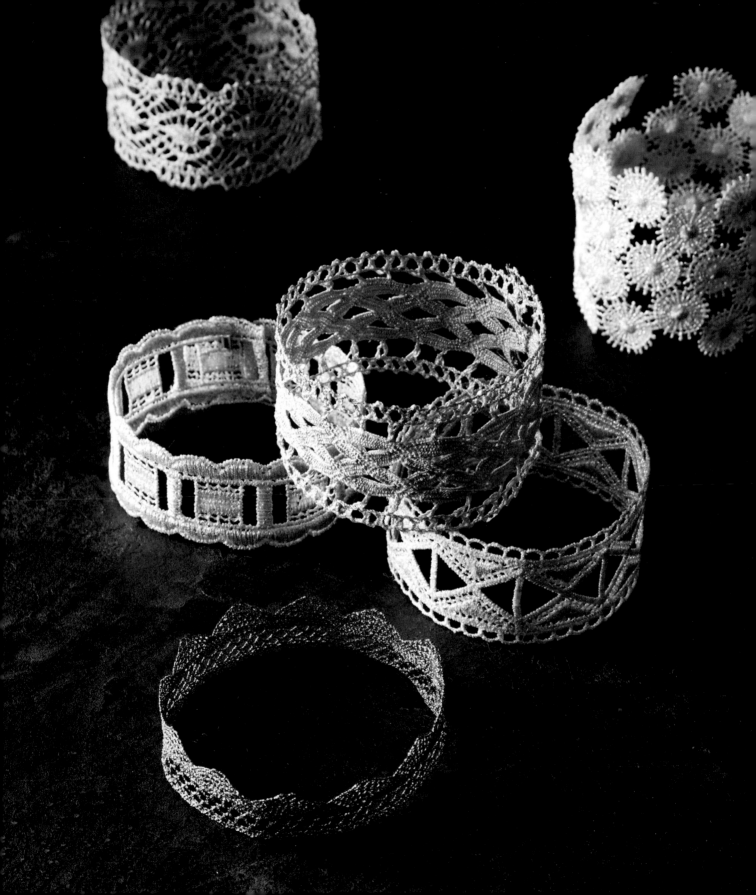

1 In the bowl, mix 1 capful of liquid dye with 4 cups of warm water. Place the lace motif in the dye bath and stir well. Let it set for 1 hour. Rinse the lace motif and let it dry completely. Once the motif is dry, iron it so that it is completely flat.

2 Slip a bead onto an eye-head pin. Using wire snips, trim the pin, leaving about ⅜ inch. Using round-nose pliers, make a loop with the extra wire (see page 13). This leaves you with a metal loop on either side of the bead. Repeat with the second bead.

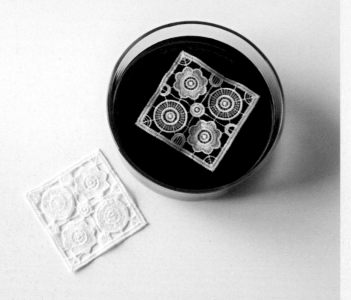

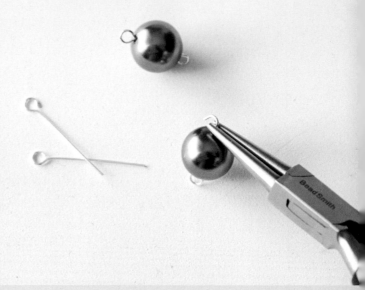

3 Attach a jump ring (see page 13) to both ends of each piece of chain. Secure tightly. Attach the clasp to one jump ring, and connect it to the other piece of chain.

4 Attach the beads to either side of the chain, connecting the jump rings at the end of the chain with a loop on one side of the bead. Secure tightly. Attach another jump ring to the loop on the other side of the bead. Attach that jump ring to the top edge of the lace motif about ¼ inch from each side. Repeat to attach the other side of the motif to the chain.

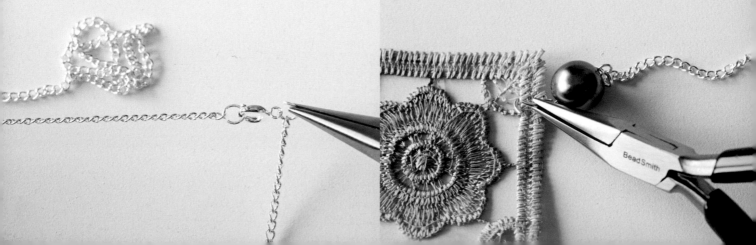

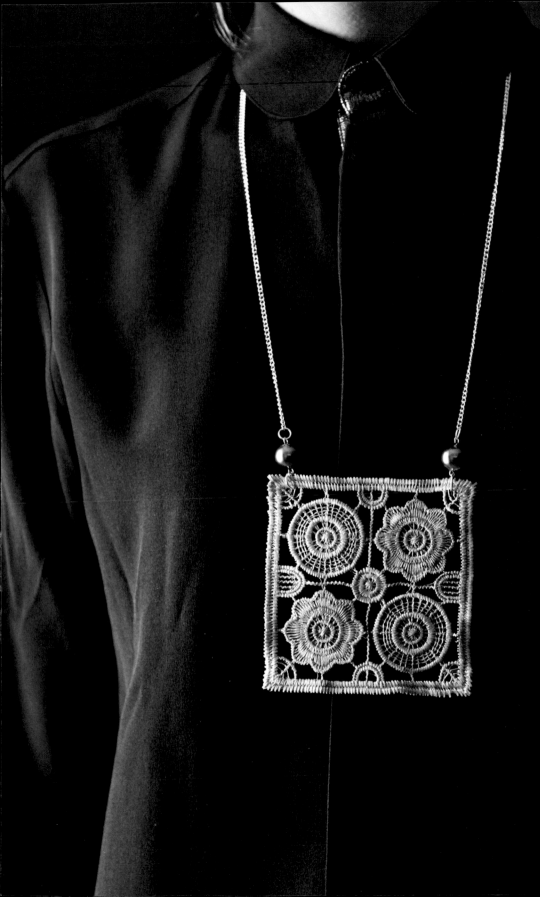

LACE
RECIPE 3:
LACE BIB
NECKLACE

MATERIALS

RIT liquid dye (shown here: Denim Blue)

Lace motif, approximately 3½ inches wide and 3½ inches tall

2 pearl beads about ⅜ inches in diameter

2 eye-head pins

Six 6 mm jump rings

Two 12-inch lengths of chain

Spring ring clasp

TOOLS

Large glass bowl or other dye-safe container

Iron

Wire snips

Round-nose and flat-nose pliers

LEATHER

Leather can be used in many different ways and is favored by everyone from classic Italian designers to indie makers. Today, leather is a staple on the runway and in the home, but since pre-historic times, man has preserved leather with smoke, grease, and bark extracts and used it to make clothing and create shelter; in Egypt, pieces of leather have been found that date back to 1300 BC. These modern-day projects use simple cattle leathers and suede string, but if you prefer, you can work with synthetic leather—it's the look that counts, not the origin of the materials.

TIP: If you prefer not to work with materials made from animals, you can use artificial leather made from vinyl (polyurethane), often referred to as pleather, leatherette, and faux leather. You can purchase artificial leather in both sheets and cords.

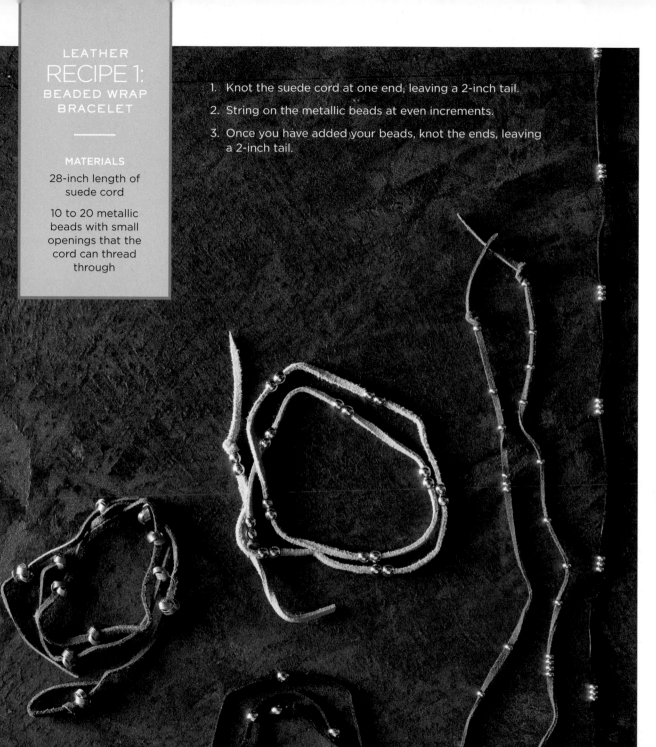

LEATHER
RECIPE 1:
BEADED WRAP
BRACELET

————————

MATERIALS

28-inch length of
suede cord

10 to 20 metallic
beads with small
openings that the
cord can thread
through

1. Knot the suede cord at one end, leaving a 2-inch tail.

2. String on the metallic beads at even increments.

3. Once you have added your beads, knot the ends, leaving
 a 2-inch tail.

RECIPE 2:
BRAIDED LEATHER BRACELET

MATERIALS

Leather tape in assorted natural colors, 10 to 12 inches each

Waxed cotton cord in neon colors, 7 inches each

TOOLS

Japanese screw punch

Scissors

1 Choose three strands of the same color leather tape and lay them next to one another.

2 Punch a hole in each strand in the same location. (The width of the leather will determine which setting your hole punch should be on.) The hole should be ⅛ to ¼ inch from the top.

3 String the cord through the holes, tie off in a basic knot, then begin loosely braiding.

4 Braid the strands of leather tape until your reach the desired length; trim the bracelet to fit around your wrist. Punch the other end exactly as you did the start of the braid, add cord, tie the cord off in a basic knot, and then tie the cord ends together to finish.

NOTES

When braiding, you will have the most success doing so loosely, especially when you have stiff or thick leather. Too tight a braid will curl or contort the leathers in ways that will interfere with the design and comfort when wearing the bracelet.

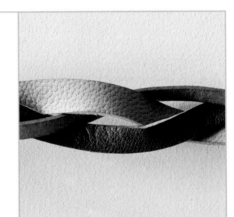

Use contrasting leathers when braiding to create more visual interest.

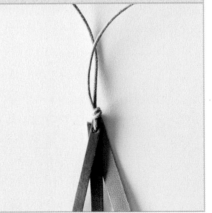

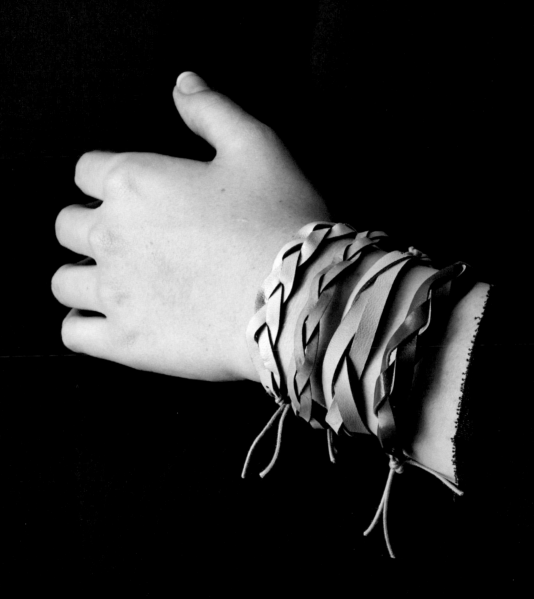

Align the piece of leather on the cutting mat so that you have a square edge. Measure and cut three rectangles, ½ inch by 2 inches.

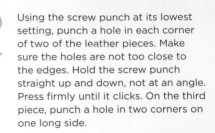

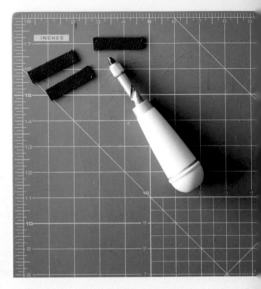

Using the screw punch at its lowest setting, punch a hole in each corner of two of the leather pieces. Make sure the holes are not too close to the edges. Hold the screw punch straight up and down, not at an angle. Press firmly until it clicks. On the third piece, punch a hole in two corners on one long side.

Attach the leather pieces using pliers and four of the 6 mm jump rings (see page 13).

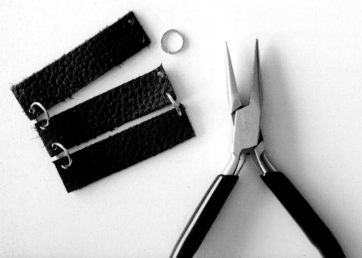

Attach a 4 mm jump ring to each end of the two pieces of chain. Attach one end of each chain to the leather pendant using a 6 mm jump ring. Then attach the clasp to the other end of each chain.

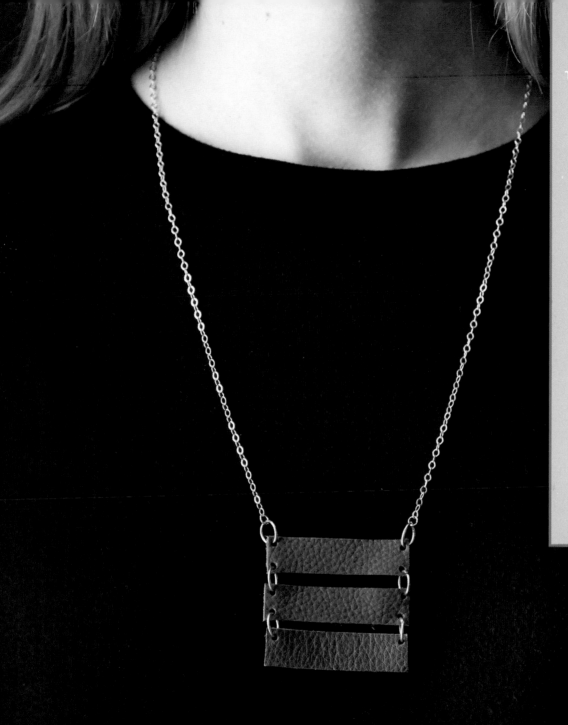

LEATHER
RECIPE 3:
TIERED LEATHER NECKLACE

MATERIALS

Leather yardage (approximately 4 inches by 4 inches)

Six 6 mm gold-colored jump rings

Four 4 mm gold-colored jump rings

2 pieces of gold chain (approximately 12 inches each)

1 gold-colored lobster clasp

TOOLS

Self-healing mat

Ruler

X-Acto knife or sharp scissors

Japanese screw punch

Round-nose and flat-nose pliers

METAL CHAINS

From the most delicate, hand-forged 24-carat-gold chain to the chunkiest sterling silver version, chains are an essential component in jewelry design. Chains date back at least as far as 2500 BC; we can credit the ancient Egyptians for threading together links of gold and silver. These projects combine chains with other materials to create a contrast in texture; I love the juxtaposition of the hard metal links and the velvet ribbon in the Ribbon Woven Chain Bracelet.

TIPS: You will often see a chain labeled "soldered" or "unsoldered," which means that when the chain was created, the individual links were either soldered together or merely pressed back together.

There are many styles of jewelry chain, including cable chain, rope chain, Byzantine chain, box chain, herringbone chain, wheat chain, omega chain, and bead chain.

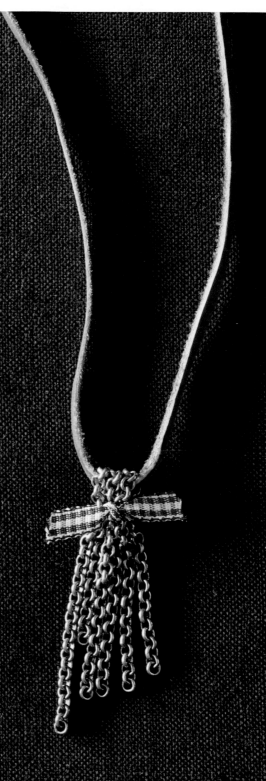

MATERIALS

12 inches of 4 mm chain in an antique brass finish

1 yard of suede cording

4 inches of ribbon

TOOLS

Metal cutters

Scissors

1. Cut the chain into three 4-inch sections. Fold the chain sections over the center of the suede cording.

2. Tie the ribbon tightly in a knot around the chain sections right at the base of the suede, creating a chain tassel. Cut the excess ribbon to the desired length.

3. Tie the ends of the cord in a knot or a bow to wear at the desired length.

RECIPE 2:
RIBBON WOVEN CHAIN BRACELET

MATERIALS

1 yard of velvet or grosgrain ribbon

4-inch large chain

1 medium- to large-hole bead

1 | Knot the ribbon approximately 9 inches from the end, onto an end link of the chain.

2 | Weave the long end of the ribbon through the links of the chain. With the chain stretched out to its maximum length, tie the ribbon to the end of the chain with another knot.

3 | String the bead onto the longer piece of ribbon and push it down to rest next to the knot tied at the end of the chain. You can trim the excess ribbon down for a shorter tail or leave it long to wrap around your wrist multiple times.

NOTES

Weave the ribbon through one link at a time, rotating it so that the velvet side is always facing up. Be prepared to work with the ribbon and chain to ensure that the pretty side of the ribbon is showing at all times.

Consider using different chains with different ribbons to create a grouping of beautiful textured bracelets.

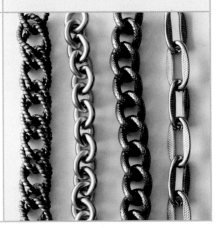

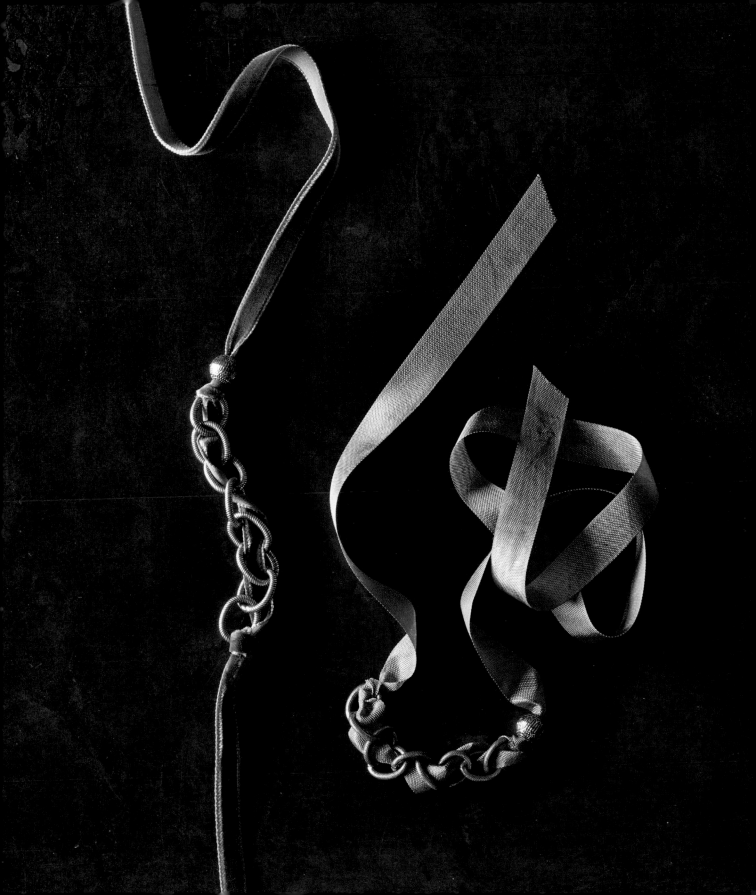

Cut the 20-gauge wire into three 4-inch pieces. Cut the medium-weight chain into two pieces, one 4 inches long and one 14 inches long.

2 Use each piece of wire to string an entire color-blocked section of beads and, using round-nose pliers, make wire loops (see page 13) on either side of the beaded section. The wire is very delicate and may curve slightly when you bend it. Gently unbend it so that it lies flat and straight when you're putting the necklace together.

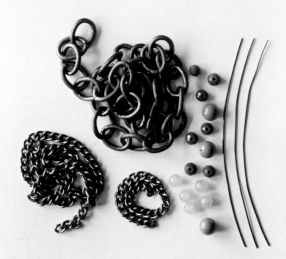

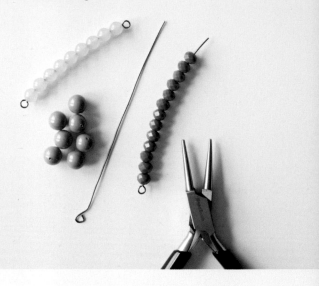

3 Attach the two pieces of medium-weight chain to a beaded section using jump rings (see page 13). Secure tightly.

4 Attach the remaining beaded sections to the ends of the medium-weight chain using jump rings, then attach the heavy chain to the ends of the beaded sections.

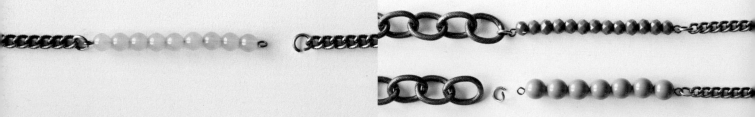

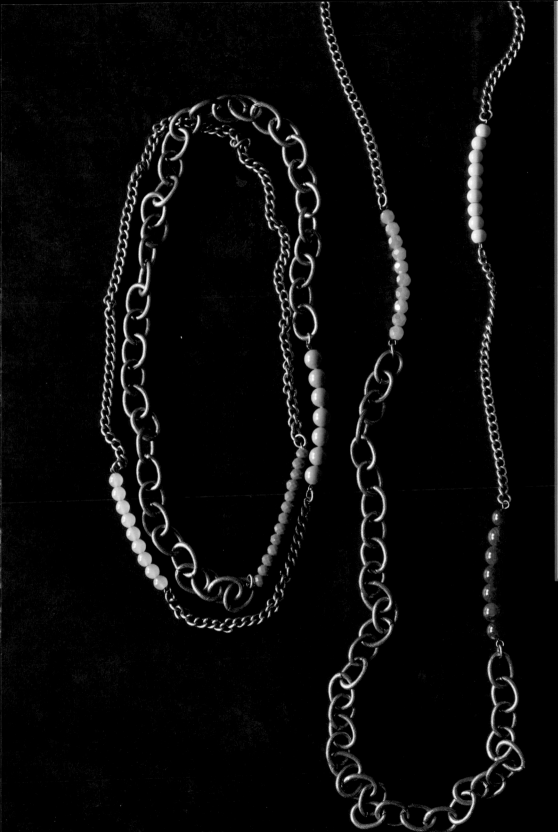

METAL CHAINS
RECIPE 3:
TRIPLE BEAD CHAIN NECKLACE

MATERIALS

12 inches of 20-gauge craft wire

18-inch medium-weight textured chain in an antique silver finish

Seven 8 mm brightly colored round beads

Nine 6 mm pastel-colored round beads

Thirteen 5 mm faceted rondelle beads in a darker color

Six 6 mm jump rings in an antique silver finish

18-inch heavy-weight textured chain in an antique silver finish

TOOLS

Wire snips

Round-nose and flat-nose pliers

METAL HEXAGONS

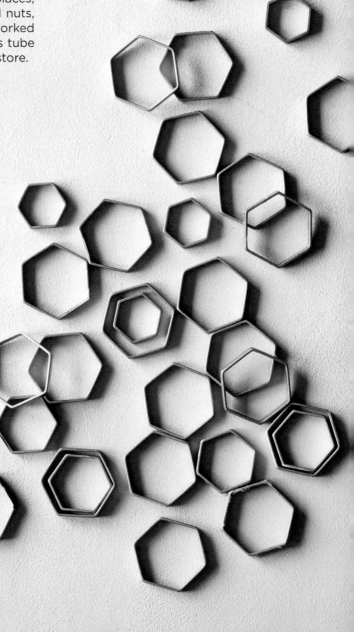

Hexagon tubing is a staple at the hardware store, but the shape is a classic motif with ancient roots. *Hexa* means "six" in Greek; the number six has long been seen as mystical (some even consider it to be the perfect number), and the six-sided hexagon is prevalent in geometry and nature, revered for its efficiency (think of a bee's honeycomb). Today, hexagons can be found in a variety of places, such as furniture and lighting, hardware, turtle shells, metal nuts, ice crystals, gazebos, and ceramic tiles. For these projects I worked with cut hexagon tubing, often referred to as hexagon brass tube outlines, which can be found on Etsy or at a jewelry supply store.

TIP: If you buy hexagon brass tubes online (see Resources), you will often have the option of choosing vintage or new pieces. Both will work for these projects.

RECIPE 1:
STACKABLE GEOMETRIC RINGS

MATERIALS

Hexagon brass tube outlines in the wearer's ring size

Nail polish in a color of your choice

1. Paint one side of a hexagon brass tube outline with nail polish until it is opaque. You can also alternate blank and painted sides, paint multiple colors on one outline, or paint dots for a unique look. Try stacking multiple rings, too.

2. Let dry for 2 hours before wearing.

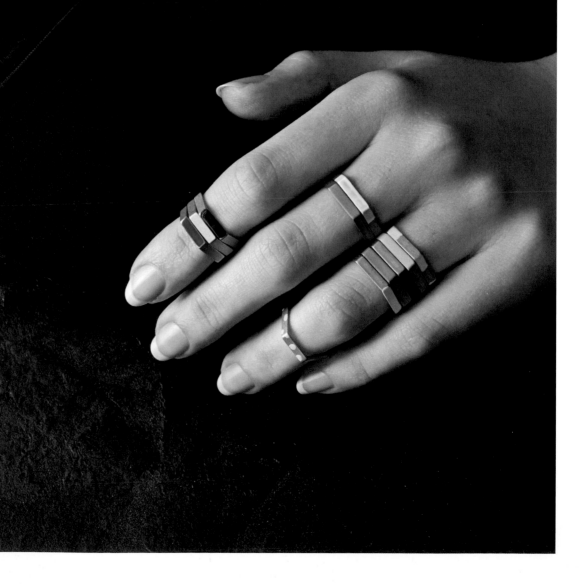

RECIPE 2:
TRIO PENDANT

MATERIALS

Hexagon brass tube outlines in three different sizes, so they nest within one another

One 6 mm jump ring

Brass or gold chain with clasp

TOOLS

Round-nose and flat-nose pliers

1 Nest the brass hexagons, then using pliers, loop a jump ring (see page 13) around all three. Secure tightly.

2 String the pendant onto the chain.

NOTES

Mix different-sized hexagons together to create a new look or a different piece of jewelry.

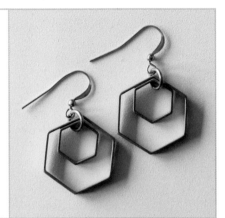

Use the nested set of hexagons as a charm. It will mix well with classic, vintage, and contemporary shapes.

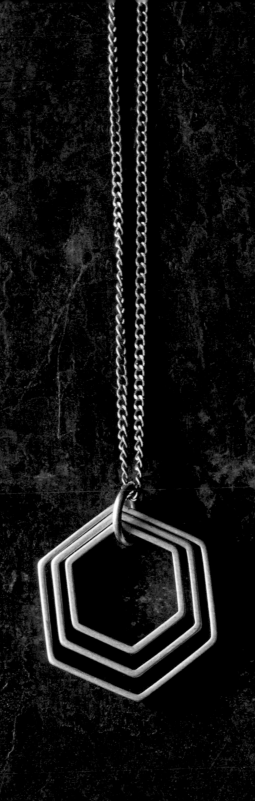

Arrange the hexagon pieces in a bib-like formation on a piece of plastic wrap.

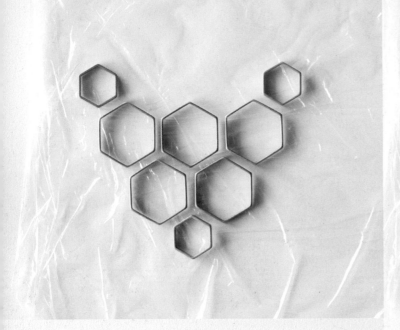

2 Working in sections of 2 to 3 hexagons, apply glue to the sides of the pieces that touch other pieces and press together. Let each section dry for 30 minutes before adding new sections. Work from one side of the pendant to the other. When all sections have been glued together, let dry for 1 hour, lying flat.

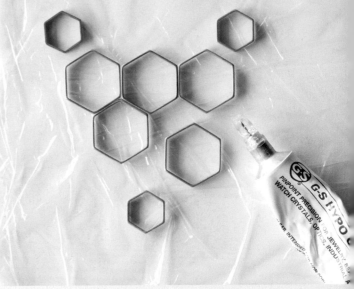

3 Wrap the wire around the touching sides of the upper left and upper right pieces to reinforce the structure. (You can also wrap wire around the remaining joints for added security or an extra element of design.)

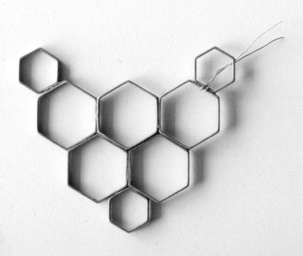

4 Attach the outer top hexagons to the chain using pliers and jump rings (see page 13). Secure tightly.

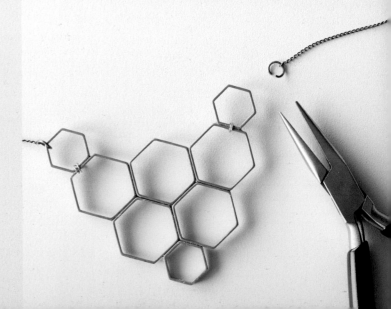

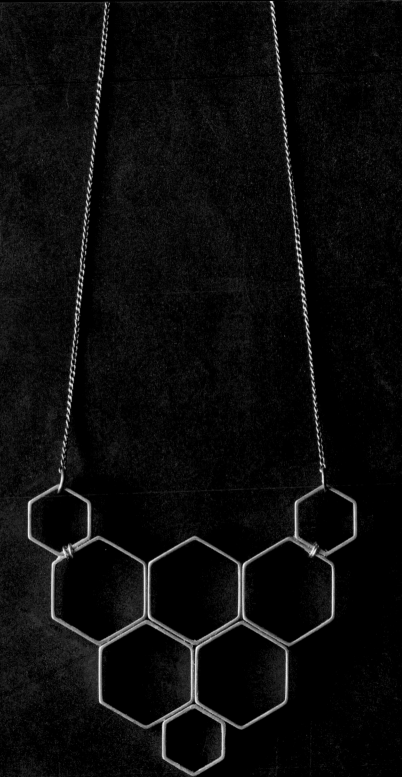

METAL HEXAGONS

RECIPE 3:
HONEYCOMB STATEMENT NECKLACE

MATERIALS

8 hexagon brass pieces, 5 large, 3 small

Two to six 2-inch pieces of 28-gauge brass wire

2 brass jump rings

Brass chain

TOOLS

Plastic wrap

G-S Hypo Cement or other strong glue

Round-nose and flat-nose pliers

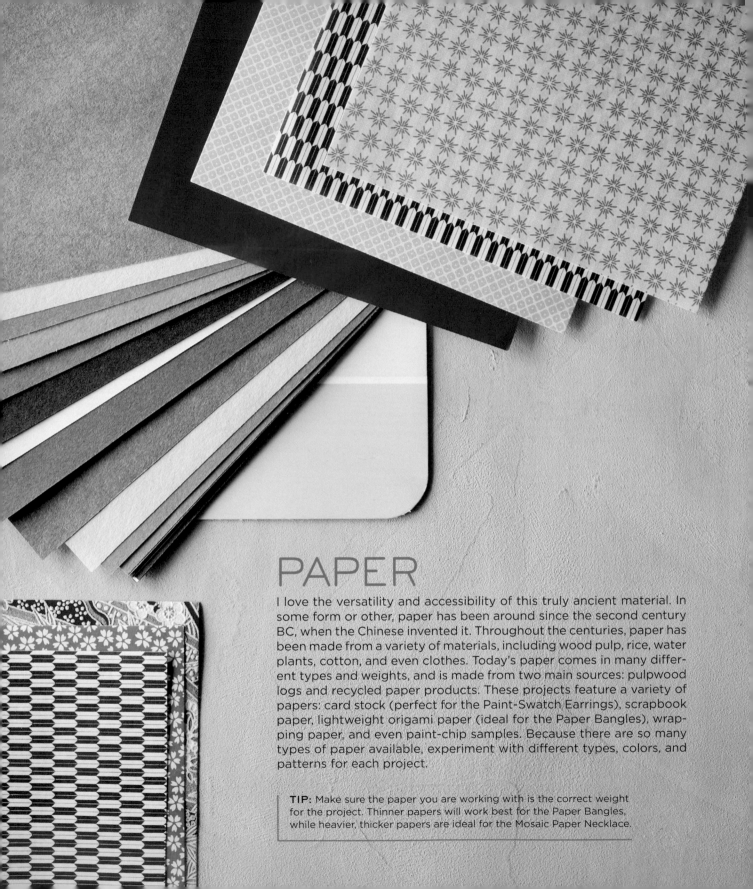

PAPER

I love the versatility and accessibility of this truly ancient material. In some form or other, paper has been around since the second century BC, when the Chinese invented it. Throughout the centuries, paper has been made from a variety of materials, including wood pulp, rice, water plants, cotton, and even clothes. Today's paper comes in many different types and weights, and is made from two main sources: pulpwood logs and recycled paper products. These projects feature a variety of papers: card stock (perfect for the Paint-Swatch Earrings), scrapbook paper, lightweight origami paper (ideal for the Paper Bangles), wrapping paper, and even paint-chip samples. Because there are so many types of paper available, experiment with different types, colors, and patterns for each project.

TIP: Make sure the paper you are working with is the correct weight for the project. Thinner papers will work best for the Paper Bangles, while heavier, thicker papers are ideal for the Mosaic Paper Necklace.

RECIPE 1:
PAPER BANGLES

MATERIALS

Paper towel roll for
3 bracelets:
2½ inches, 1½ inches,
and 1 inch (you can
make the cuffs a bit
bigger if you like)

Sheets of thin paper,
such as wrapping or
origami paper, in a
variety of patterns
and solids

TOOLS

White craft glue

Scissors

6 binder clips

1. Cut the paper towel roll in half, and then cut one of the halves again. This will give you three bracelets, one larger, two smaller. Cut out a 1½-inch section to form a cuff shape.

2. Cut two strips of paper to match the width of each cuff. The strip for the outside of the cuff should be longer than the strip for the inside of the cuff.

3. Coat the back of the paper strip for the outside of the cuff with glue and begin adhering it to the cuff, anchoring the strip with a finger as you work and overlapping the cuff ends slightly. Repeat with the inside of each bangle. Trim any excess paper.

4. Once each bangle is completely covered, dab glue at the ends and secure each cuff end with a binder clip to dry overnight.

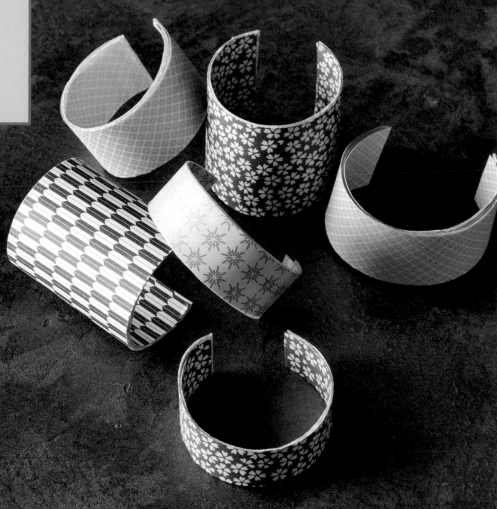

MATERIALS

Paint swatch strips

Two 6 mm silver
jump rings

Earring wire blanks

TOOLS

Japanese screw
punch

Self-healing mat

Scissors

Round-nose and
flat-nose pliers

1 Using the screw punch at the smallest setting, place the full paint swatch (we used the ones that have three colors on one strip) on the self-healing mat and punch four holes along one end in each of the three colors.

2 Cut each paint swatch into four strips. Each strip should have a hole at the top.

3 Select three strips and loop them onto a jump ring (see page 13). Secure tightly. Repeat for the second earring.

4 Using pliers, attach the jump rings to the earring blanks.

NOTES

Make sure you punch the holes in the paint swatches before you cut them apart; otherwise, they can become bent or twisted from the screw punch.

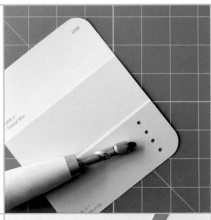

Cut different widths of strips and/or mix colors for a different look.

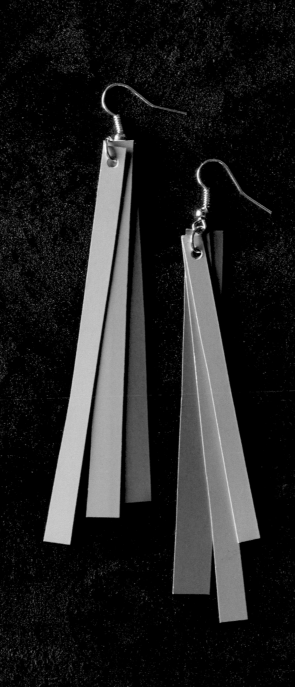

Photocopy the template, enlarging it by 50 percent. Cut the eleven paper tiles out of heavyweight patterned paper.

2 Using a micro punch, punch a hole where indicated on the templates.

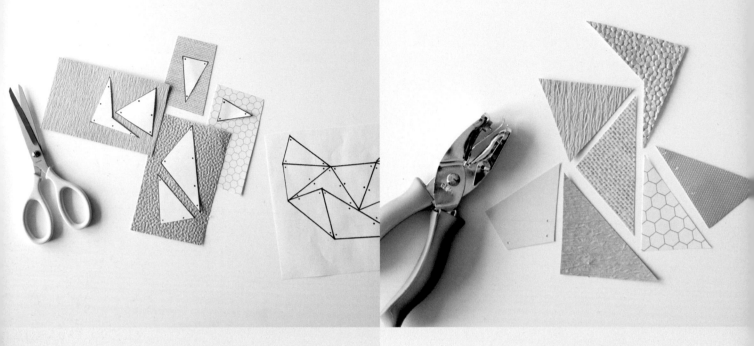

3 Using pliers, attach the pieces using jump rings (see page 13). Secure tightly.

4 Thread the cord through a jump ring on an end tile and knot the ends together. Repeat with the remaining cord and end tile. To wear, loosely tie the ends.

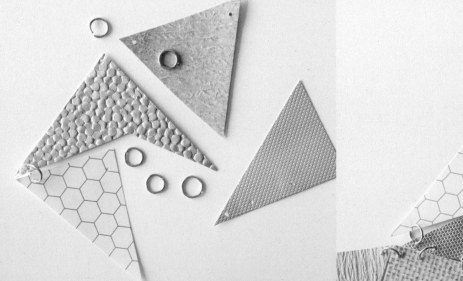

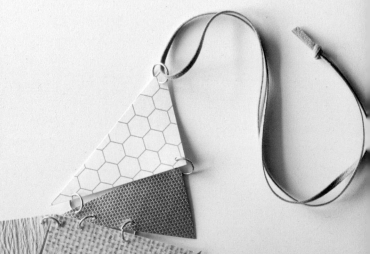

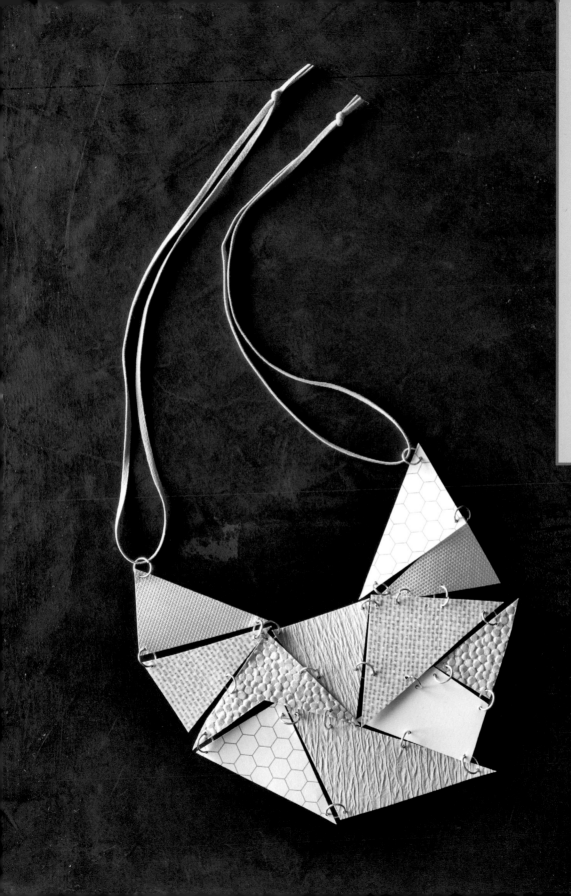

PAPER

RECIPE 3:
MOSAIC PAPER NECKLACE

MATERIALS

Heavyweight
patterned paper

Enlarged photocopy
of template
(page 223)

Twenty-three 6 mm
jump rings

Colored cotton suede
cord, cut in half,
30 inches total

TOOLS

Photocopier

Scissors

Micro punch

Round-nose and
flat-nose pliers

PEARLS

Pearls, once the most expensive jewels in the world, are now much more accessible. Before the beginning of the twentieth century, pearls were gathered from pearl oysters (or pearl mussels) found on the ocean floor or river bottom by divers who often dove to depths of more than 100 feet on a single breath! Today, however, pearls largely come from cultured-pearl farms, which use a process widely popularized and promoted by Japanese entrepreneur Kokichi Mikimoto, and freshwater pearls are harvested in several areas of the United States. These projects use a variety of cultured and freshwater pearls, as well as beads that look like pearls, to capture that luminous, iridescent quality that can be dressed up or down.

TIP: Be sure to take care of natural pearls; keep them away from perfumes (especially those made with alcohol), don't moisturize any skin that they will touch, and clean them only with mild soap and water.

RECIPE 1:
RUSTIC CORD BRACELET

MATERIALS

2 strands of linen or hemp cord, each 15 inches long

8 to 12 pearl beads, plus 1 extra bead

TOOLS

Scissors

1. Hold the cords together and fold them in half; knot them together about ½ inch below the fold.

2. String a pearl onto each of the four individual strands, then knot the strands together (refer to the photo for the spacing). Repeat until the bracelet is the desired length. Reserve one bead for the next step.

3. Take two of the loose strands of cord through the beginning loop and the remaining bead and knot with the remaining two loose strands of cord to secure. Trim the ends.

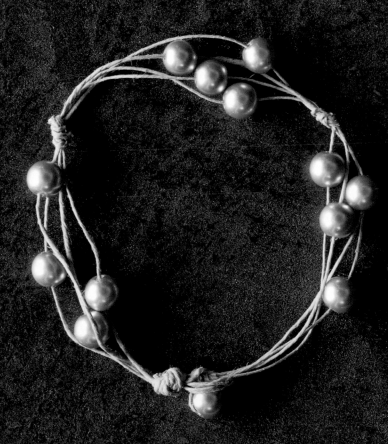

RECIPE 2:
PEARL RIBBON NECKLACE

MATERIALS

20 inches of clear beading cord

2 yards of silk ribbon, 1 inch thick

40 pearl beads, ½ inch in diameter

TOOLS

Magna-Tac 809 or other fabric glue

Beading needle

1 Hold the beading cord together with the ribbon, placing the cord in the center of the length of ribbon. Secure one end of the cord to the ribbon with a dab of glue. Tie the ribbon and that end of the cord together with an overhand knot, covering the cord with the ribbon knot.

2 Thread the beading needle onto the cord, and place a bead on the cord. Fold the ribbon in half widthwise and draw the needle and cord through the ribbon about ½ inch from the ribbon knot, folding the ribbon over the bead.

3 Place another bead on the cord, and then pull the cord through the ribbon again, folding it over the bead. Repeat this action, alternating beads and ribbon, until you have used all of the beads.

4 Secure the cord with another overhand knot. Tie the loose ribbon ends into a bow to wear the necklace at the desired length.

NOTES

Work the ribbon with the bead to secure the right layered look. A hand-dyed silk ribbon will be softer and less structured than a grosgrain ribbon and will require more coaxing as you thread the bead onto the ribbon.

Use a different color, texture, or width of ribbon to give this necklace a different look.

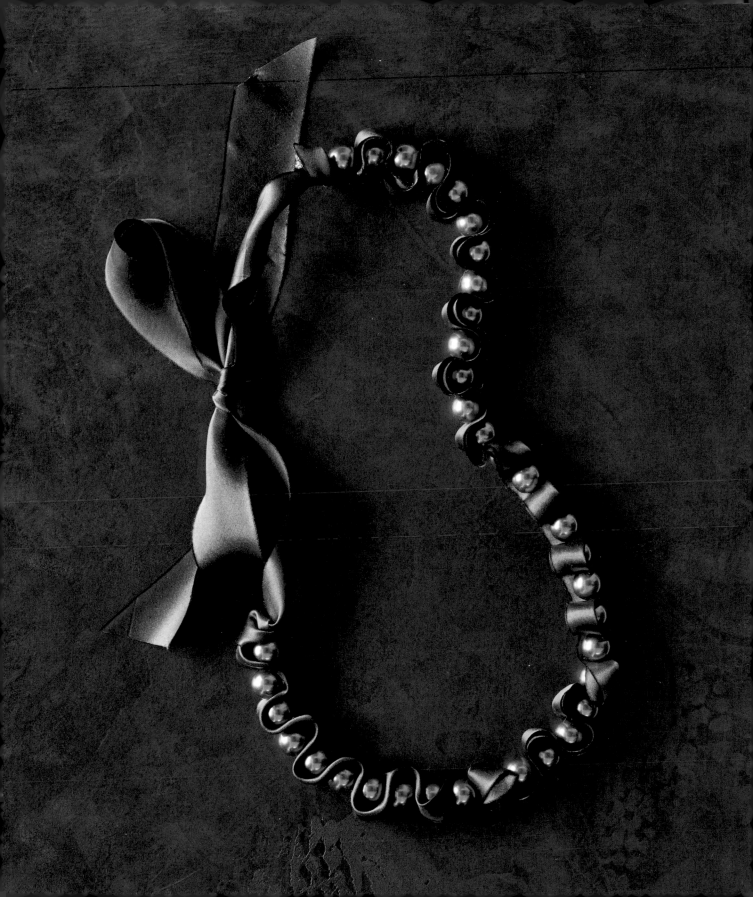

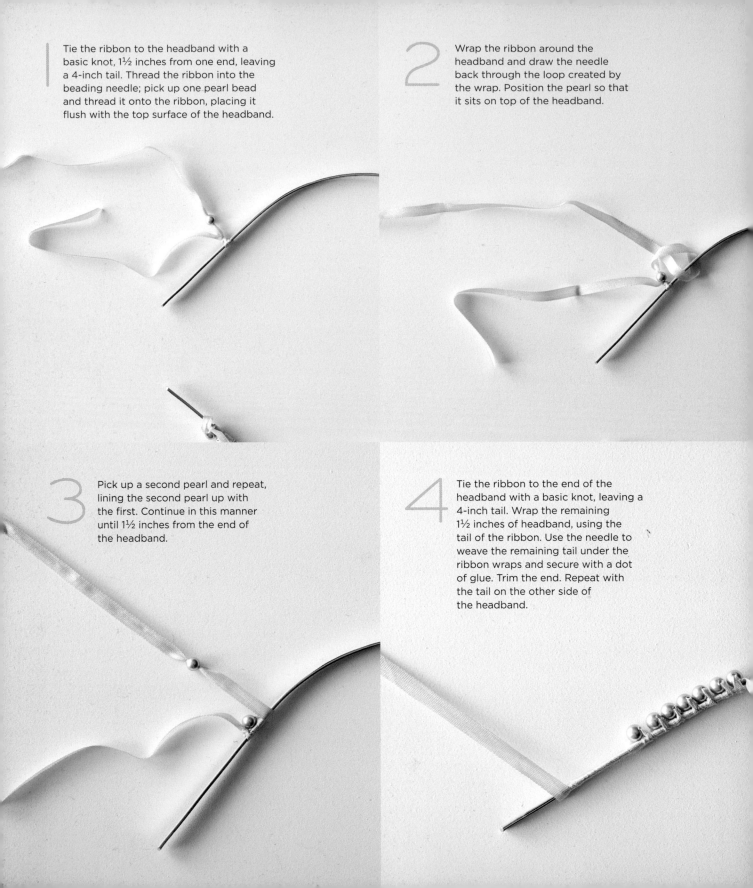

1 Tie the ribbon to the headband with a basic knot, 1½ inches from one end, leaving a 4-inch tail. Thread the ribbon into the beading needle; pick up one pearl bead and thread it onto the ribbon, placing it flush with the top surface of the headband.

2 Wrap the ribbon around the headband and draw the needle back through the loop created by the wrap. Position the pearl so that it sits on top of the headband.

3 Pick up a second pearl and repeat, lining the second pearl up with the first. Continue in this manner until 1½ inches from the end of the headband.

4 Tie the ribbon to the end of the headband with a basic knot, leaving a 4-inch tail. Wrap the remaining 1½ inches of headband, using the tail of the ribbon. Use the needle to weave the remaining tail under the ribbon wraps and secure with a dot of glue. Trim the end. Repeat with the tail on the other side of the headband.

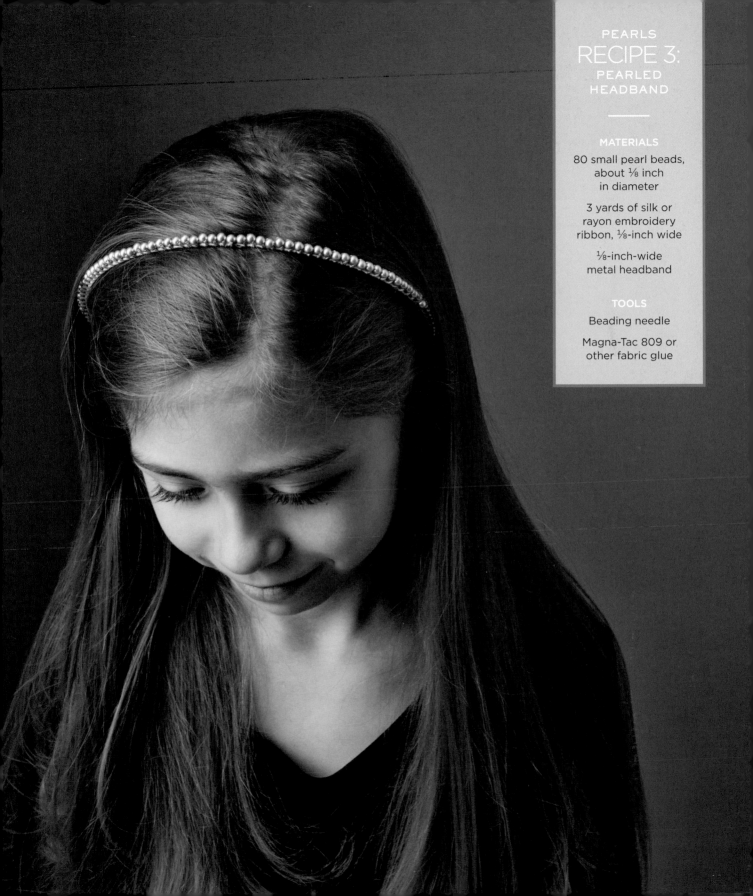

RECIPE 3:
PEARLED HEADBAND

MATERIALS

80 small pearl beads, about ⅛ inch in diameter

3 yards of silk or rayon embroidery ribbon, ⅛-inch wide

⅛-inch-wide metal headband

TOOLS

Beading needle

Magna-Tac 809 or other fabric glue

PINECONES

A cone is the reproductive part of many types of evergreen trees (also known as conifers), including arborvitaes, junipers, pines, and spruces. Each year, I gather the pinecones that have fallen in our yard and place them in a bowl in our foyer, a reminder of the growth and renewal that come with each passing season. These recipes use hemlock pinecones, which are small and easy to work with and wear, and elevate this simple material to a level of elegance and sophistication. The Woodland Crown would even make the perfect headband for a woodland wedding!

TIP: Pinecones are a natural material, so treat them gently. Avoid exposing them to intense heat and sunlight for extended periods, and if you are using pinecones you gathered on a walk, clean them to remove any obvious debris and sap. To clean pinecones, soak them in a bath of water with white vinegar for 30 minutes and then air-dry for 2 days. This will kill bugs and get sap out.

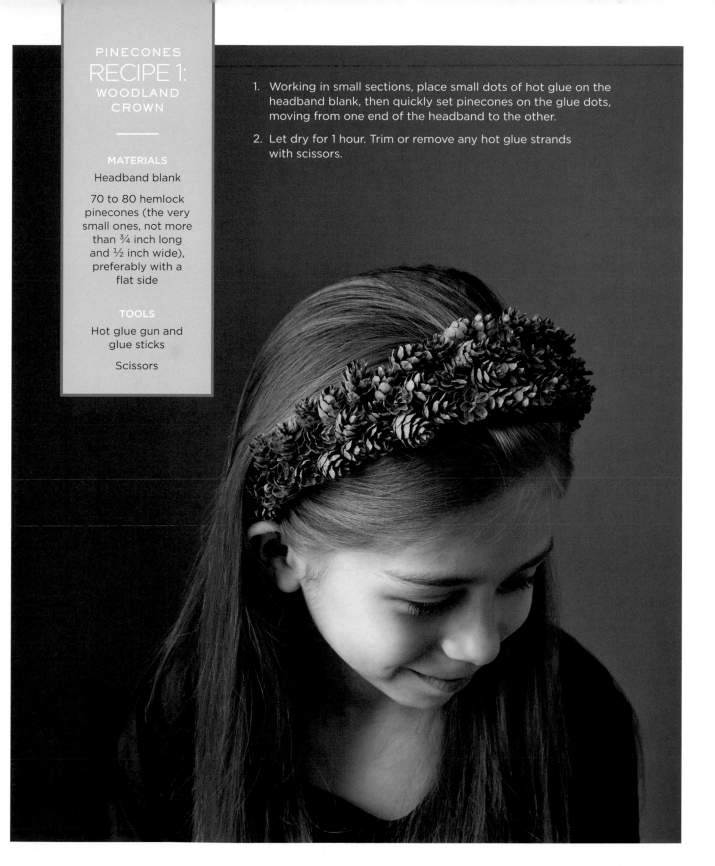

PINECONES
RECIPE 1:
WOODLAND CROWN

MATERIALS

Headband blank

70 to 80 hemlock pinecones (the very small ones, not more than ¾ inch long and ½ inch wide), preferably with a flat side

TOOLS

Hot glue gun and glue sticks

Scissors

1. Working in small sections, place small dots of hot glue on the headband blank, then quickly set pinecones on the glue dots, moving from one end of the headband to the other.

2. Let dry for 1 hour. Trim or remove any hot glue strands with scissors.

MATERIALS

20-inch gold chain

1 yellow gold or metal end cap

1 medium pinecone (1 to 1½ inches)

2 small jump rings

1 spring ring clasp

TOOLS

Hot glue gun and glue sticks

Scissors

Round-nose and flat nose pliers

1 Thread the chain through the end cap, centering it. Glue the chain to the end cap so that it becomes one unit. Let dry for 30 minutes.

2 Trim the base of the pinecone with scissors so that the bottom will fit snugly into the end cap.

3 Glue the base of the pinecone to the inside cup of the end cap and let dry for 30 minutes. Trim any hot glue strands with scissors.

4 Attach the clasp to the chain using pliers and jump rings on either end of the chain.

NOTES

When putting the pinecone, chain, and cap together, you can also sandwich the middle (where you want the pinecone to fall) of the chain between the cap and the pinecone and glue all three pieces together.

Select an end cap that is fairly flat so it will fit on the pinecone with minimal trimming required.

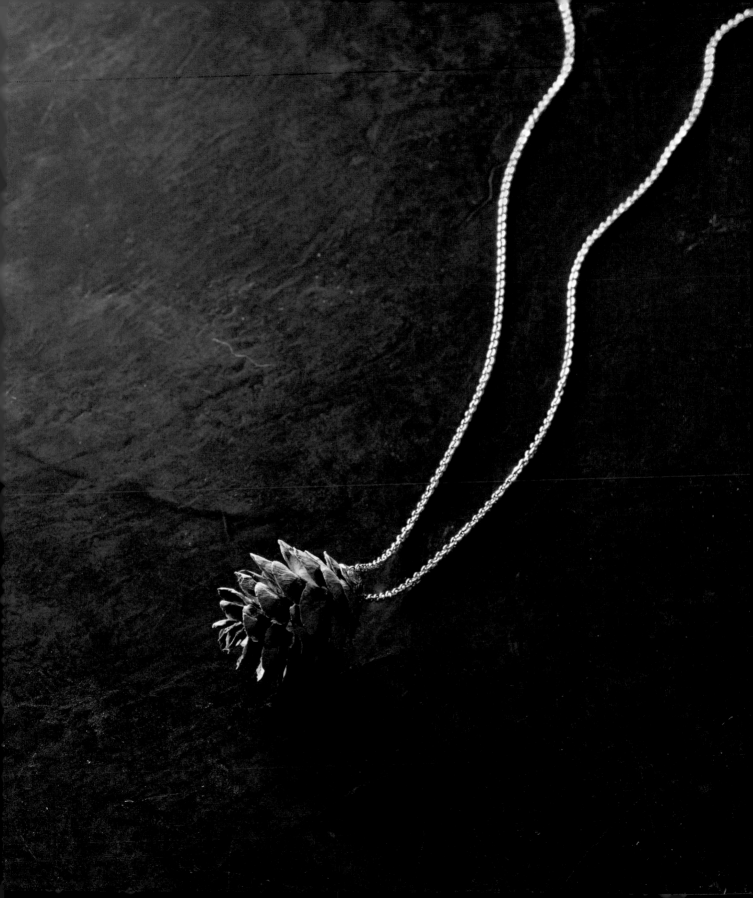

1 | Arrange the pinecones and dried sprigs of greenery and glue them together. Start with the greens, and then glue the pinecones.

2 | Place a twig under the arrangement as a base and attach with hot glue. Secure the grouping with 6 inches of the cotton cord, wrapping it around the base. Knot the cord.

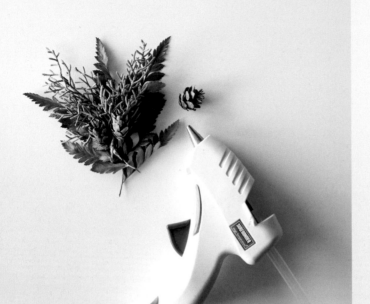

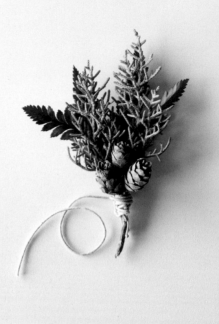

3 | Lay the felt so that one of the corners is pointing up. Place the bouquet on the fabric and fold the bottom corner up, then take the right corner and fold it over; finish by taking the left corner and wrapping it around the boutonniere. Use hot glue to secure the felt wrapping to the bouquet in the back.

4 | Glue the pin back to the back of the fabric. Let dry for 5 minutes. With the pin back open, wrap the remaining cord around the base of the boutonniere and the pin back, which will help to secure it. Knot the cord in the back and dab it with a bit of hot glue. Trim any excess cord.

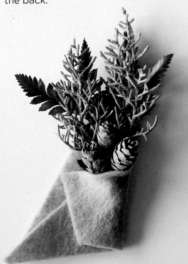

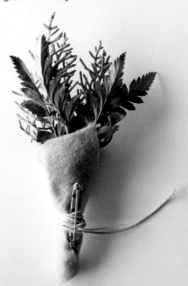

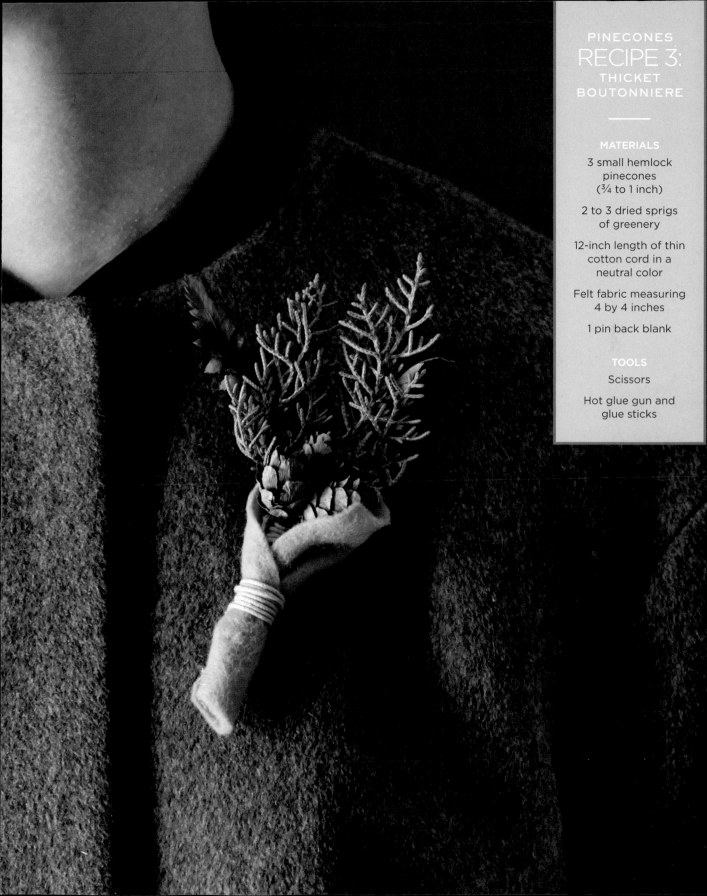

PINECONES
RECIPE 3:
THICKET
BOUTONNIERE

MATERIALS

3 small hemlock
pinecones
(¾ to 1 inch)

2 to 3 dried sprigs
of greenery

12-inch length of thin
cotton cord in a
neutral color

Felt fabric measuring
4 by 4 inches

1 pin back blank

TOOLS

Scissors

Hot glue gun and
glue sticks

POLYMER CLAY

In 1939 German doll maker Käthe Kruse rejected polymer clay for use in her factory, instead giving it to her daughter Fifi to play with; it was later sold to Eberhard Faber and marketed under the name FIMO (from Fifi's Modeling Compound). Polymer clay has a bit of magic to it: at first glance, it may seem ho-hum, but its simplicity makes it quite versatile and sophisticated, as seen in the Gold Geo-Faceted Rings. It is a good alternative to other types of clay (like red clay) because you don't need a kiln to dry the finished item—you need only a home oven to transform your kitchen into a design studio. Note: I prefer to use Sculpey polymer clay, because it dries with a nice matte finish.

TIPS: The work surface and your hands must be superclean, because polymer clay picks up everything it touches. If you are working with light and dark colors for one project, make sure your hands are clean after working with the darker color before handling the lighter color. You do not want residual color to come off from your hands. Keep paper towels or wet wipes nearby.

Baking ovens can be calibrated differently. Therefore, be sure to keep an eye on the pieces as they are baking to be sure they are cooking correctly and evenly.

RECIPE 1:

GOLD GEO-FACETED RINGS

MATERIALS

One 2-ounce package of Sculpey polymer clay in Spring Lilac

Acrylic paint in metallic gold

3 adjustable metal ring blanks with ½-inch-diameter flat surface

TOOLS

X-Acto knife

Parchment paper

Cookie sheet

Paintbrush (size 6)

G-S Hypo Cement

1. Preheat the oven to 275°F. Cut a quarter-sized piece of polymer clay and roll it into a ball. Press it slightly to create a flat base, then place it on a parchment-lined cookie sheet. Repeat to create 2 more balls.

2. Slice sections off the balls to create flat surfaces.

3. Place the cut balls in the oven and bake until they feel hard and the surface looks matte, about 90 minutes. (For a more antiqued look, leave the clay pieces in the oven longer than the specified time—this will create brown spots, which can give a more vintage-looking, weathered patina.) Be careful to keep an eye on the oven so they don't burn. Remove them from the oven and place on a wire rack. Let them cool for 20 minutes.

4. Paint adjacent flat surfaces. Once dry, apply a small dot of cement to each ring base and adhere the faceted shapes.

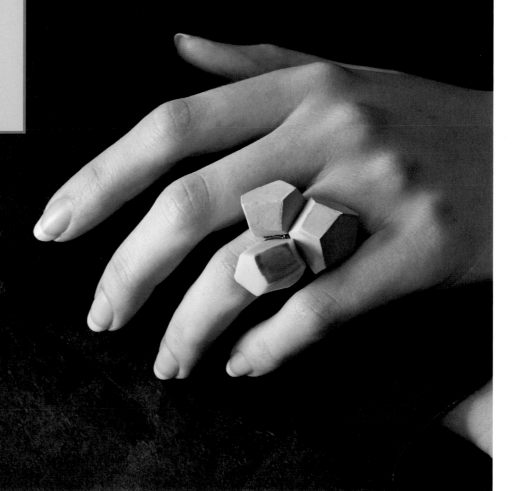

RECIPE 2:
COLOR-BLOCKED BEADS

MATERIALS

One 2-ounce package of Sculpey polymer clay in each of the following colors: Plum, Silver, Ballerina, and Blue Pearl

32-inch navy-blue leather cord or string

TOOLS

X-Acto knife

Parchment paper

Cookie sheet

Wooden skewer

150-grit dust-free sandpaper

1 Preheat the oven to 275°F. Cut off a brick of polymer clay (small packages of polymer clay are scored to be divided) and roll it into a tube about 6 inches long with a diameter of about ⅜ inch. Place the tube on a parchment-lined cookie sheet. Cut the tube into different lengths using an X-Acto knife. Repeat with each color.

2 Slowly push a skewer all the way through the center of each bead. Remove the skewer.

3 Place the beads in the oven and bake until they feel hard and the surface looks matte, about 90 minutes. If you're not sure whether they're done, take the beads out of the oven and let them cool for 20 minutes. If they are not completely hard, just stick them back in the oven.

4 Once the beads are fully baked, remove them from the oven and let cool. Then lightly brush each bead with sandpaper (to remove any slight imperfections and create a smooth, honed look). Slide each bead onto the leather cord, then tie the two ends in a knot to wear the necklace at the desired length.

NOTES

Gently spear the clay pieces with a skewer. Make a clear, smooth hole through each bead. You can also dust the skewer (and your fingers) with cornstarch to help the skewer slide with greater ease and to keep you from transferring fingerprints to the bead as you apply pressure to the skewer. However, be careful not to get the cornstarch on the outer surface of the darker pieces.

Use a single bead on a simple silver chain for a minimalist, modern look.

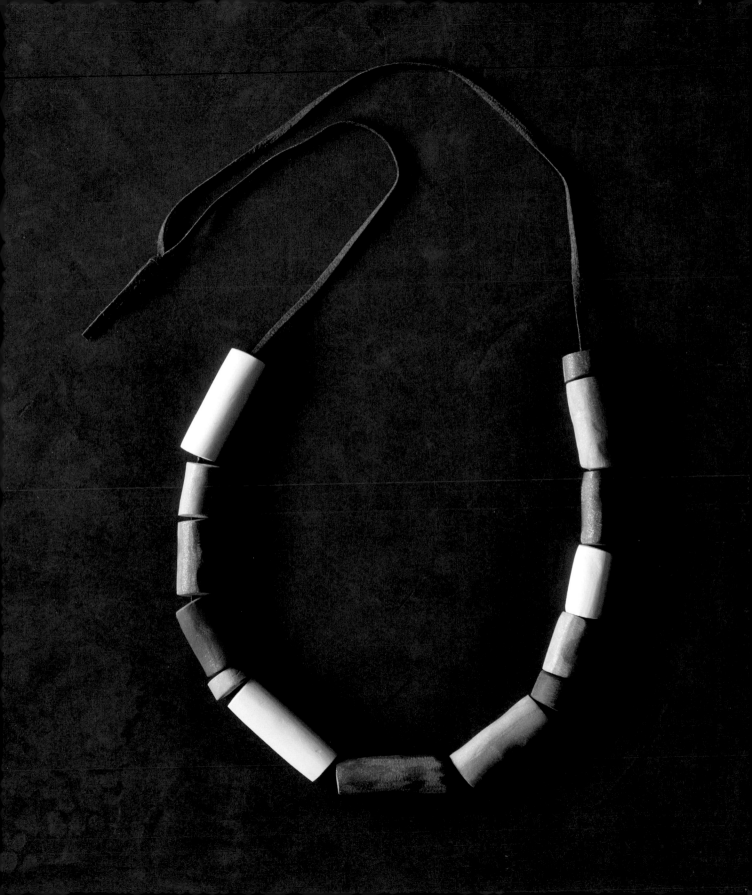

Preheat the oven to 275°F. Cut small to medium pieces from a brick of polymer clay and roll them into round beads (varying in size from a dime to a quarter). Place the beads on a parchment-lined cookie sheet.

2 Slowly push a wooden skewer through each bead.

3 Place the beads in the oven and bake until they feel hard and have a matte appearance, about 90 minutes. Keep in mind that polymer clay won't completely harden until it cools. If a piece still feels soft after 90 minutes of baking, remove it from the oven and let it cool. Do not bake for more than 2 hours.

4 While the beads cool for 30 minutes, start making a pom-pom (see page 14). Using a large-eye beading needle, thread the cord through the center of the pom-pom, catching the string that anchors the nest. Then string the clay beads, alternating color and size. Knot at the top to secure.

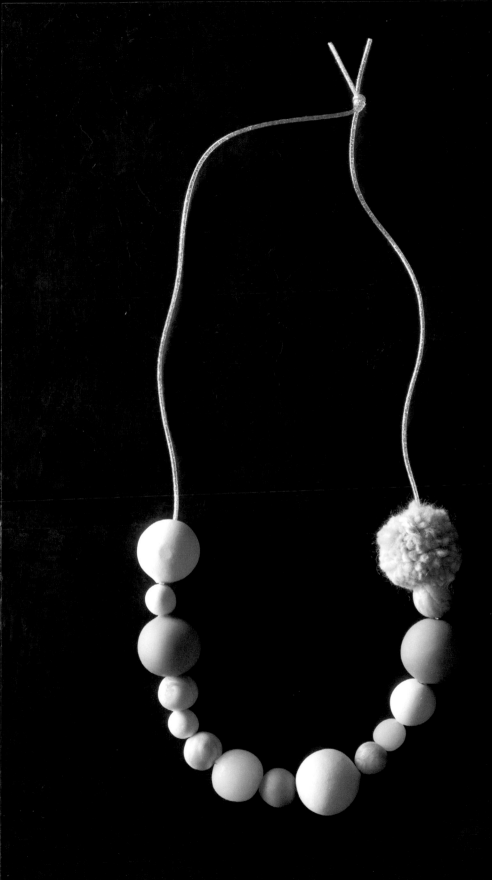

POLYMER CLAY
RECIPE 3:
POM-POM BAUBLE
NECKLACE

MATERIALS
One 2-ounce package
of Sculpey polymer
clay in each of the
following colors:
Beige, Pearl, and
White Translucent

30 inches of plastic
sparkle cord or
gift-wrapping cord
(pictured here: gold)

Leftover bulky
oatmeal-colored
wool yarn

TOOLS
X-Acto knife

Parchment paper

Cookie sheet

Wooden skewer

Scissors

Large-eye beading
needle (any size)

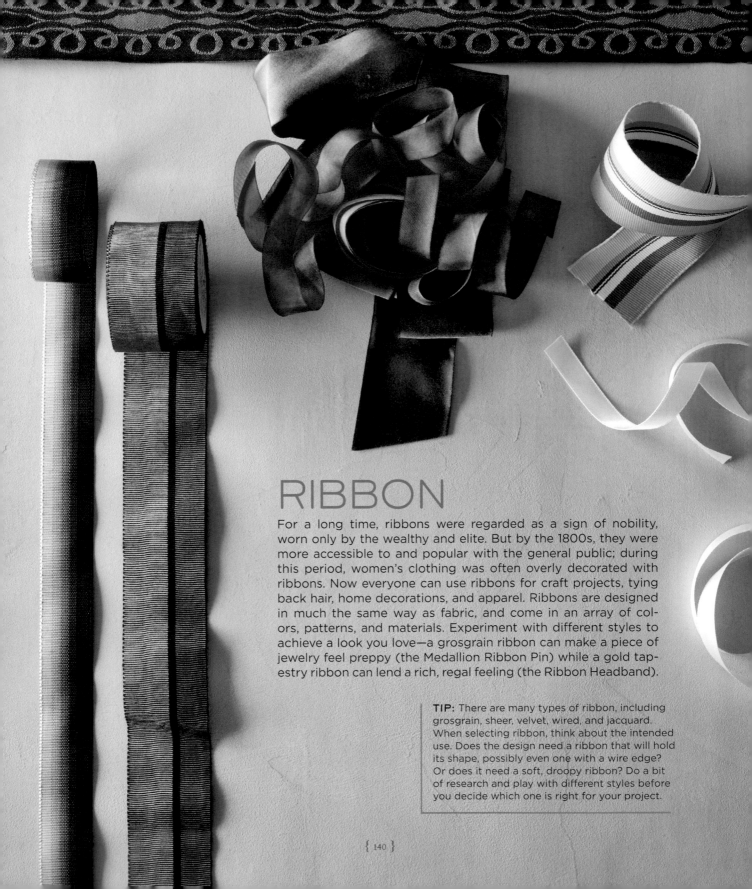

RIBBON

For a long time, ribbons were regarded as a sign of nobility, worn only by the wealthy and elite. But by the 1800s, they were more accessible to and popular with the general public; during this period, women's clothing was often overly decorated with ribbons. Now everyone can use ribbons for craft projects, tying back hair, home decorations, and apparel. Ribbons are designed in much the same way as fabric, and come in an array of colors, patterns, and materials. Experiment with different styles to achieve a look you love—a grosgrain ribbon can make a piece of jewelry feel preppy (the Medallion Ribbon Pin) while a gold tapestry ribbon can lend a rich, regal feeling (the Ribbon Headband).

TIP: There are many types of ribbon, including grosgrain, sheer, velvet, wired, and jacquard. When selecting ribbon, think about the intended use. Does the design need a ribbon that will hold its shape, possibly even one with a wire edge? Or does it need a soft, droopy ribbon? Do a bit of research and play with different styles before you decide which one is right for your project.

RECIPE 1:

RIBBON HEADBAND

MATERIALS

½ yard of decorative ribbon, 3 different types, each no wider than ½ inch

2 inches of elastic to match the width of the widest ribbon

TOOLS

Scissors

Fray Check (optional)

Sewing needle and thread

1. Cut the ribbons so that they fit around your head, allowing for a 3-inch space between the ends of the ribbon.

2. If desired, apply Fray Check along the edges of the ribbons to prevent them from fraying.

3. Sew both ends of the ribbons to the ends of the elastic to secure.

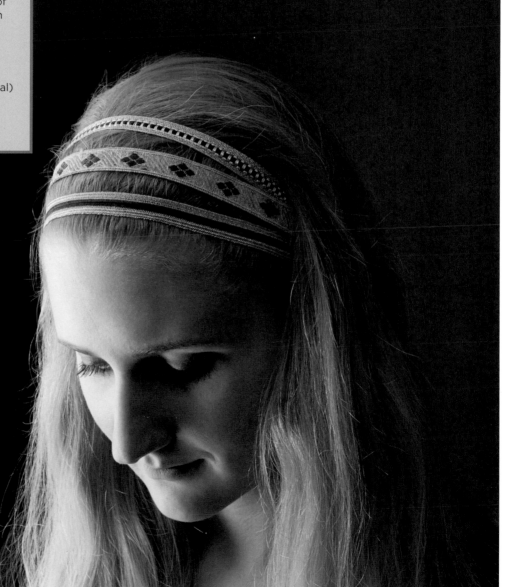

RECIPE 2:
MEDALLION RIBBON PIN

———

MATERIALS

1 yard of a lightweight
grosgrain ribbon,
1 inch wide

TOOLS

Scissors

Sewing needle
and thread

Iron

Hot glue gun and
glue sticks

Blank pin back

1 Fold the ribbon accordion-style, holding the folds in a stack as you work. The folds should be about 1 inch long, and you should have about ten folds. Finish with a fold that faces in the same direction as the first fold. Trim any excess length.

2 Thread the needle and pull it through the center of the stack a third up from the bottom, leaving a 4-inch tail at either end.

3 Bring the ends of the thread together and knot them. Fan the folds to make a circle. Adjust the folds so that they are evenly spaced.

4 Using an iron, press the right side of the medallion, flattening the folds in one direction. Glue a flat pin back to the underside of the medallion. Let dry for 1 hour.

NOTES

Iron the entire pin when you have finished assembling it. This will ensure that it lies flat. There is no need to iron each fold individually.

To create a different look, use a solid grosgrain ribbon. To embellish it further, hot-glue a button, a bead, or a charm in the center.

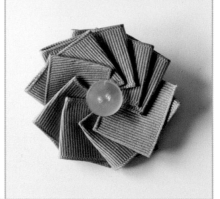

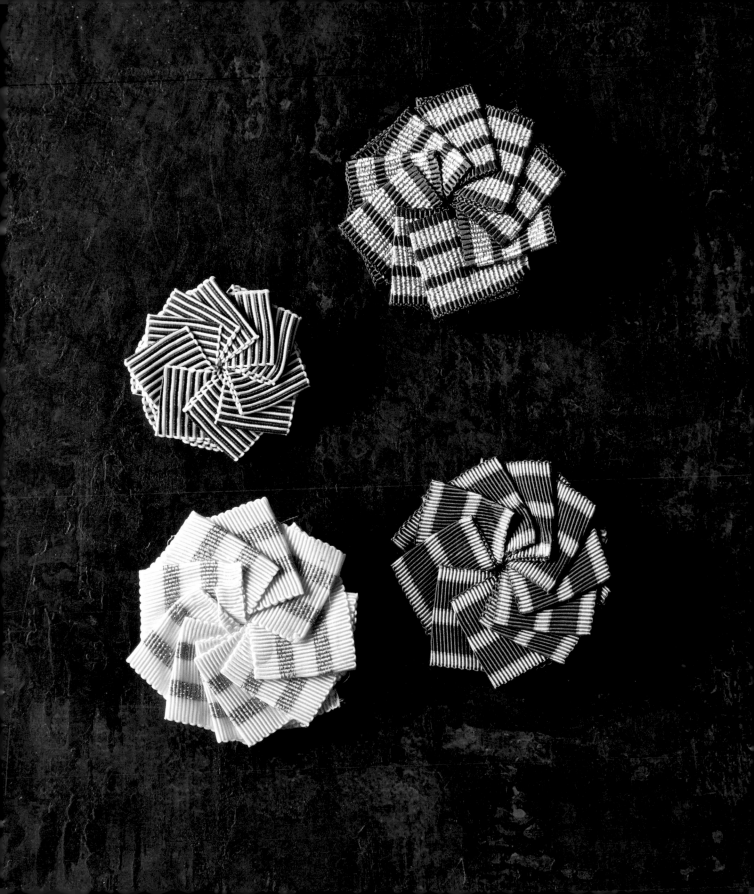

Cut color A into 6-foot lengths; cut color B into 4-foot lengths. Hold the two lengths of color A (here, the blue) together and tie an overhand knot 20 inches from the end. Glue the ends of color B (here, the white) to the inside of the knot, positioning them perpendicular to the color A lengths.

2 Weave the ribbon: fold the color A lengths over the center knot, laying them parallel to each other. Weave one length of color B over and under one length of color A. Weave the second length of color B under and then over the second length of color A to complete the woven square. Repeat this step until the woven piece measures about 7 inches in length.

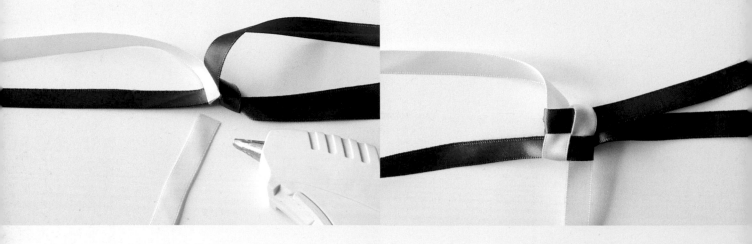

3 Secure the ends of color B to the end of the woven piece with a dab of glue. Trim the excess color B ribbon after the glue has dried.

4 With the remaining length of color A, tie an overhand knot close to the end of the woven piece, covering the glued, trimmed edges of color B, then trim color A to 20 inches to match the length of color A on the other side of the woven piece. Tie the loose ribbon ends in a bow to wear the necklace at the desired length.

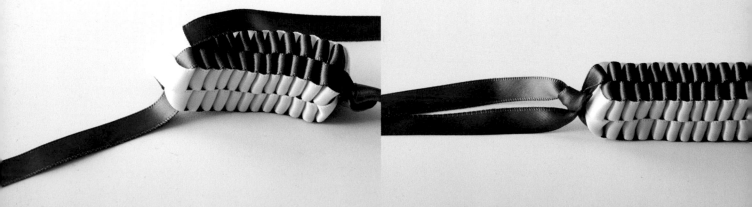

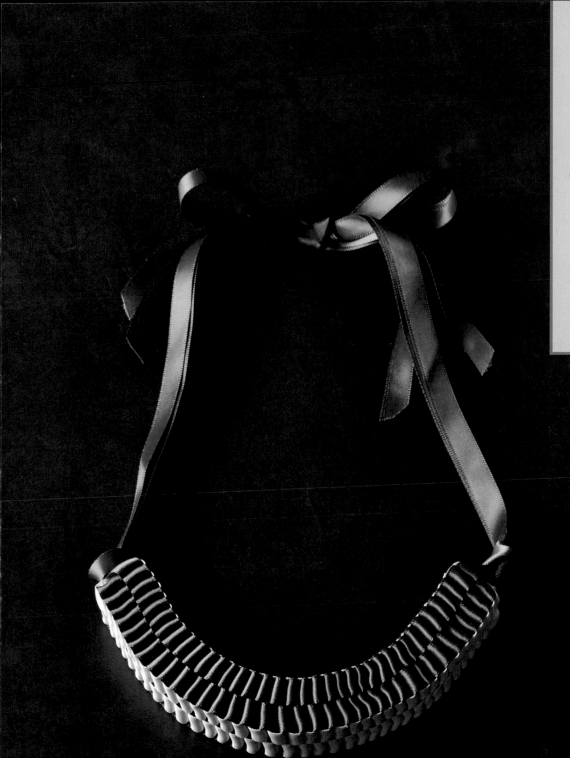

RIBBON
RECIPE 3:
WOVEN RIBBON NECKLACE

MATERIALS

12 feet of ⅜-inch-wide ribbon (color A)

8 feet of ⅜-inch-wide ribbon in a contrasting color (color B)

TOOLS

Fabric scissors

Hot glue gun and glue sticks

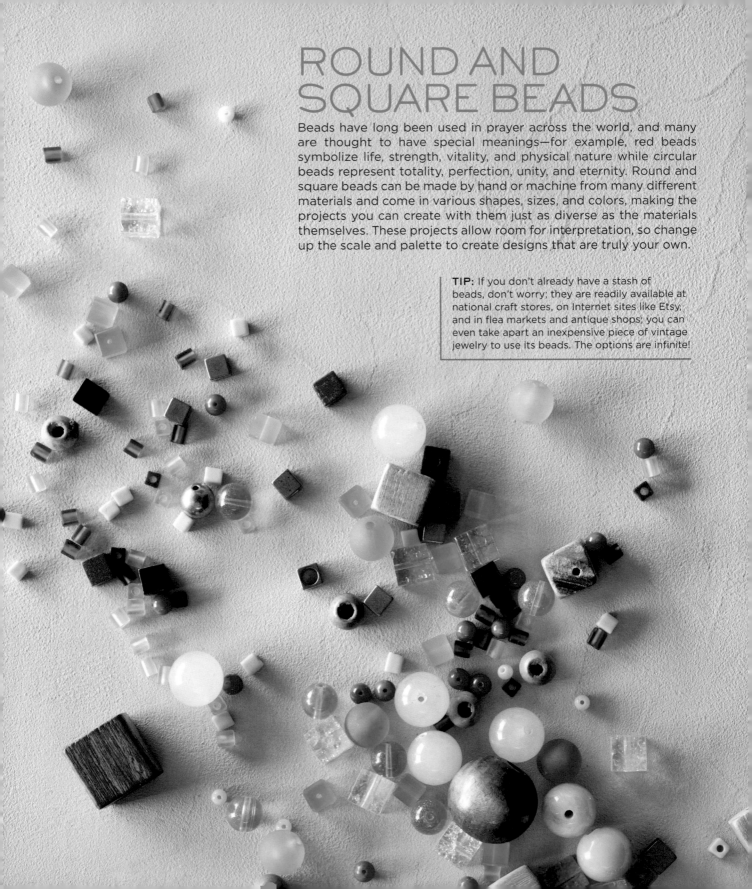

ROUND AND
SQUARE BEADS

Beads have long been used in prayer across the world, and many are thought to have special meanings—for example, red beads symbolize life, strength, vitality, and physical nature while circular beads represent totality, perfection, unity, and eternity. Round and square beads can be made by hand or machine from many different materials and come in various shapes, sizes, and colors, making the projects you can create with them just as diverse as the materials themselves. These projects allow room for interpretation, so change up the scale and palette to create designs that are truly your own.

TIP: If you don't already have a stash of beads, don't worry; they are readily available at national craft stores, on Internet sites like Etsy, and in flea markets and antique shops; you can even take apart an inexpensive piece of vintage jewelry to use its beads. The options are infinite!

ROUND AND SQUARE BEADS
RECIPE 1:
FOLK-BEAD EARRINGS

MATERIALS

Earring blanks, hoop style, 1 to 2 inches in diameter

Round or square seed beads, up to 5/0 or 6/0, enough to cover 2 inches of earring wire

1. Thread beads onto an earring hoop, covering about 1½ inches (add or subtract as desired).

2. Repeat for the second earring.

RECIPE 2:
SQUARE AND
ROUND BEADS ON
CORD

MATERIALS

¼-inch wood beads
in assorted round
and square shapes
and colors
(approximately 75)

1 yard of leather cord

1 small lobster clasp

TOOLS

Scissors

1 String about four round beads onto the cord, leaving 4 inches of the cord uncovered. Form a loop with the uncovered cord and secure it with a knot; tuck the tail into the bead.

2 Tie an overhand knot close to the other end of the line of beads.

3 Continue threading beads and knotting as in step 2, alternating the bead shape and color as desired. Alternate the number of beads as well, threading sections with as few as three beads and as many as ten.

4 When the cord has been covered, finish by simply knotting the clasp to the end of the cord. Trim any excess cord with scissors.

NOTES

Think of the cord as a design element—you can select a color that matches your beads or go for more contrast.

Place the beads on a piece of felt when working. They'll be easier to handle, and the felt will ensure that they won't roll away.

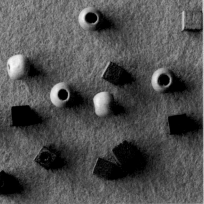

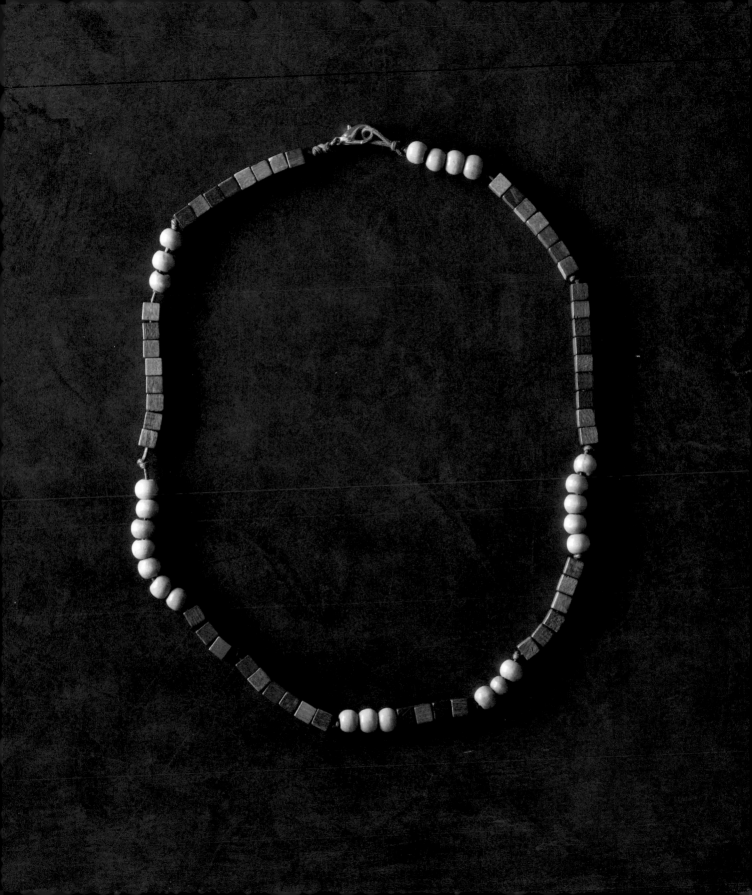

1

Using a bead needle, thread a 20-inch piece of beading cord with 8 inches of beads. Loop the thread back through the beads about 2 inches and trim. Then repeat with the tail at the beginning of the strand. Set aside. Using the other cord, string a 10-inch-long strand of beads.

2

Place and secure a crimp bead at the base of each loop at both ends of the strand of beads to hold them in place with flat-nose pliers. Repeat with the second strand of beads.

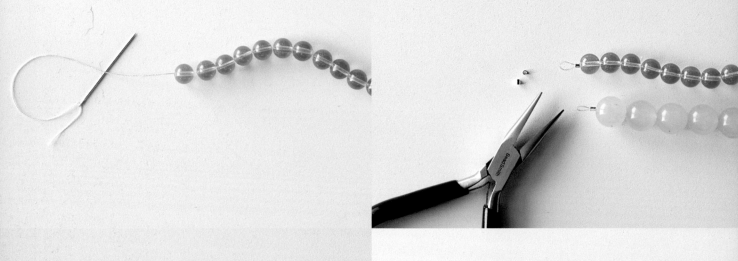

3

Using pliers, attach a jump ring (see page 13) to each of the four loops. Secure tightly.

4

Align the two strands of beads. Thread one ribbon through the jump rings for the shorter and the longer strands of beads and repeat with the second ribbon on the other end of the strands. Tie a bow to create the desired length.

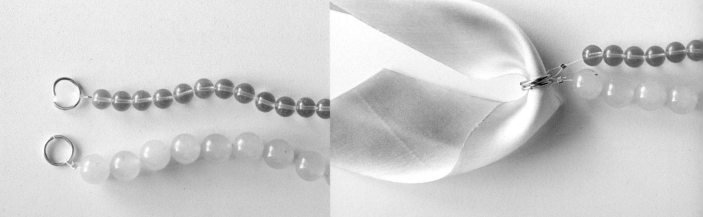

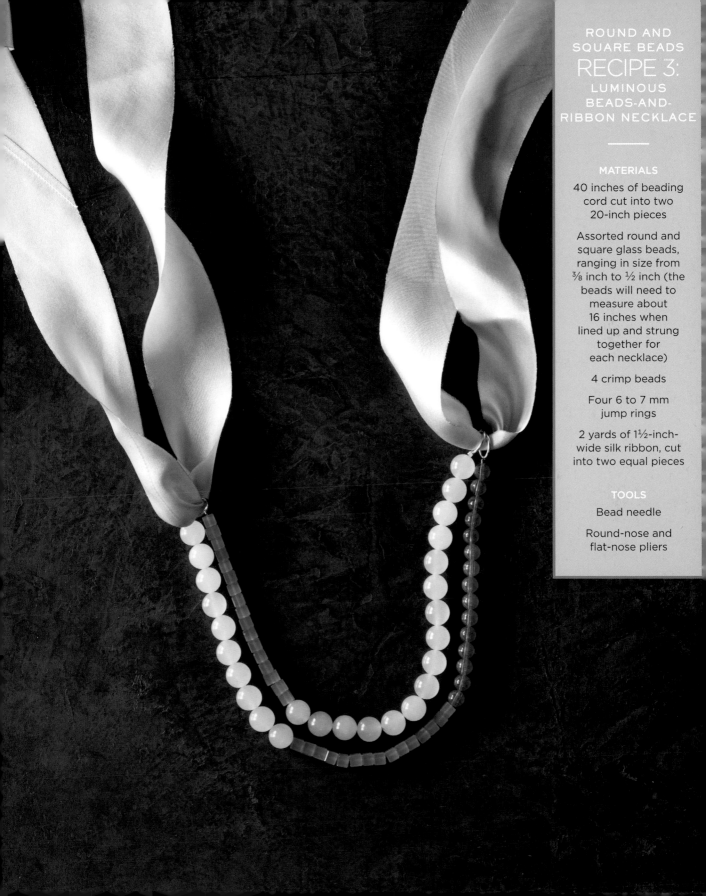

ROUND AND SQUARE BEADS
RECIPE 3:
LUMINOUS BEADS-AND-RIBBON NECKLACE

MATERIALS

40 inches of beading cord cut into two 20-inch pieces

Assorted round and square glass beads, ranging in size from ⅜ inch to ½ inch (the beads will need to measure about 16 inches when lined up and strung together for each necklace)

4 crimp beads

Four 6 to 7 mm jump rings

2 yards of 1½-inch-wide silk ribbon, cut into two equal pieces

TOOLS

Bead needle

Round-nose and flat-nose pliers

SEQUINS

We all love a bit of bling, but while some of us want to make a big statement, others just want a touch of flash. Sequins, also known as spangles, paillettes, or diamantés, are extremely versatile and can add just the right hint of sparkle to almost any ensemble. Gold sequins are believed to have been used as decoration on clothing in the Indus Valley as early as 2500 BC, but the French transformed the sequin into what we know and use today. Sequins were originally made from shiny metals, but these days, they're most often made from plastic. These projects use sequins in pared-down, simple, but fun ways that catch the eye.

TIP: Sequins can be stitched flat to fabric so they don't move, but they can also be stitched at only one point so they dangle and catch more light. They can also be stacked, as they are in the Structured Earrings, for a more minimalist look. Be creative, and the results may surprise you!

SEQUINS
RECIPE 1:
STRUCTURED EARRINGS

MATERIALS

Sequins, about ¼ inch in diameter (20 to 50)

2 head pins, each about 4 inches long

TOOLS

Flat-nose pliers

Wire snips

1. Slip the sequins onto a head pin, forming a stack about 1½ inches tall. You can vary the height of the stack as desired.

2. Using pliers, bend the other end of the head pin in two places to form a narrow U shape. For a shorter earring, trim the head pin with wire snips.

MATERIALS

¾- to 1⅛-inch-diameter wood bead

10-inch-long piece of prestrung sequin trim

Adjustable metal ring blank with ½-inch-diameter flat surface

TOOLS

Hot glue gun and glue sticks

1 Apply a dab of glue to the top of the dowel cap and secure the end of the sequin trim.

2 Working in small sections, wrap the sequins in a spiral around the entire ball. Add one or two dabs of glue as you wrap the sequins to secure.

3 Trim the sequins and secure the end with glue, covering the hole at the base of the dowel cap. Allow to dry for 5 minutes.

4 Glue the ball to the ring base. Allow to dry for 30 minutes.

NOTES

Working in small sections when gluing and wrapping prevents the glue from drying before you put the sequins in place and makes it easier to keep the sequins straight.

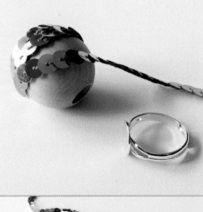

You can wrap all kinds of shapes and materials with sequins to make many different rings. For example, you can use square beads, flat discs, and Styrofoam balls.

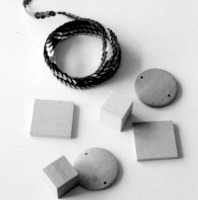

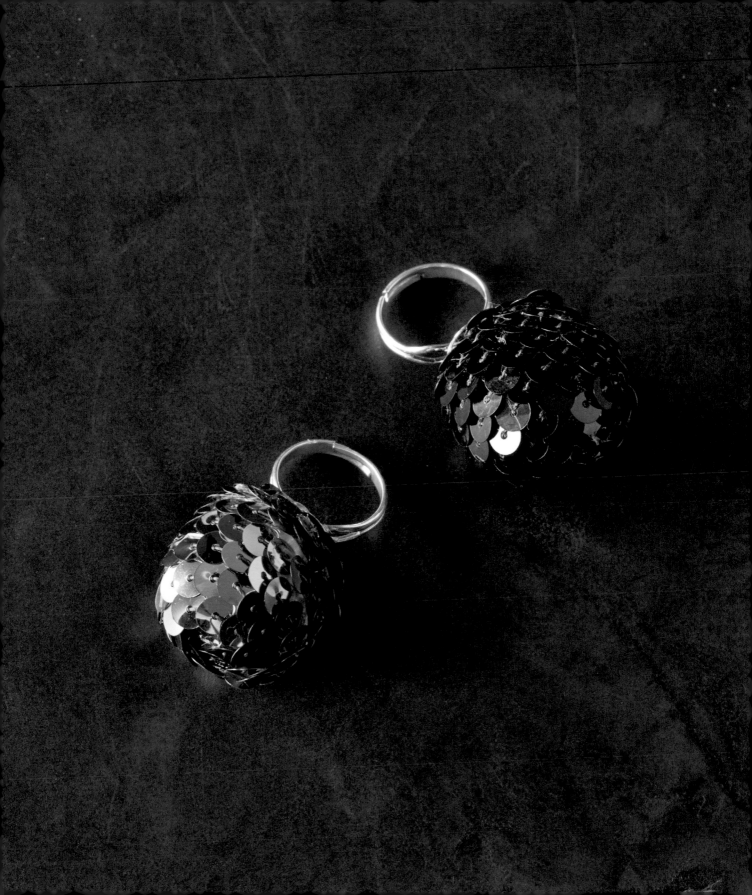

1 Trim the felt so that it is at least 7½ inches long and the same width as the trim. To ensure a straight edge, cut the felt using a rotary cutter and a metal ruler on a self-healing mat. For a shorter bracelet, subtract 1 inch in length from both the sequin trim and the felt piece. Set aside the felt.

2 Place half of the snap to the right side of the sequin trim, leaving ¼ inch of trim at the edge. Attach the other half to the right side of the other end of the trim, leaving 1 inch of trim at the edge. Push the prongs of the magnetic snap through the trim and flatten/secure them with the pliers on the wrong side of the fabric.

3 Position the felt on the wrong side of the trim so that the snap with ¼ inch of trim remains exposed. The felt should cover the prong side of the other snap but leave the 1 inch of trim beyond the snap exposed. Glue the felt in place.

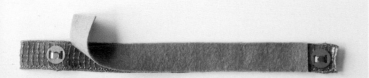

4 Fold over the exposed snap and trim and glue them to the felt lining of the cuff. Allow the cuff to dry.

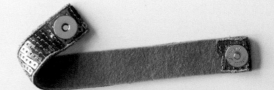

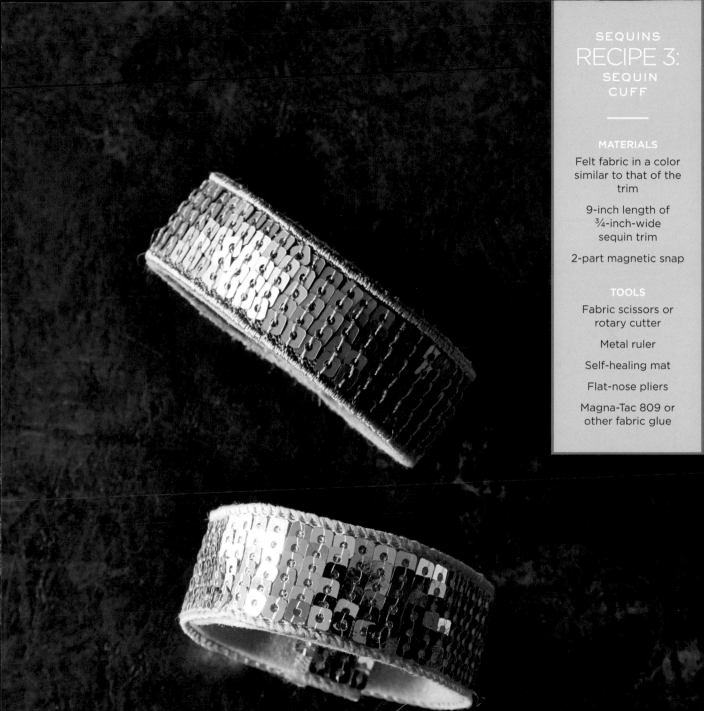

MATERIALS

Felt fabric in a color
similar to that of the
trim

9-inch length of
¾-inch-wide
sequin trim

2-part magnetic snap

TOOLS

Fabric scissors or
rotary cutter

Metal ruler

Self-healing mat

Flat-nose pliers

Magna-Tac 809 or
other fabric glue

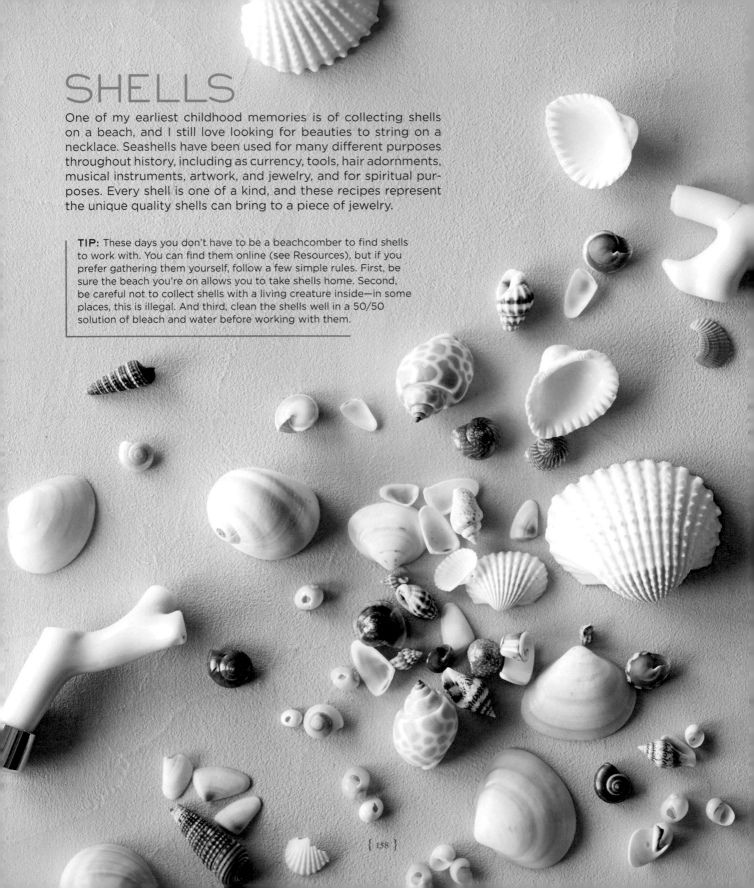

SHELLS

One of my earliest childhood memories is of collecting shells on a beach, and I still love looking for beauties to string on a necklace. Seashells have been used for many different purposes throughout history, including as currency, tools, hair adornments, musical instruments, artwork, and jewelry, and for spiritual purposes. Every shell is one of a kind, and these recipes represent the unique quality shells can bring to a piece of jewelry.

TIP: These days you don't have to be a beachcomber to find shells to work with. You can find them online (see Resources), but if you prefer gathering them yourself, follow a few simple rules. First, be sure the beach you're on allows you to take shells home. Second, be careful not to collect shells with a living creature inside—in some places, this is illegal. And third, clean the shells well in a 50/50 solution of bleach and water before working with them.

SHELLS
RECIPE 1:
BROKEN-CORAL PENDANT

MATERIALS

Broken coral piece with smooth edges (no shards or sharp edges)

Ringed end cap sized to fit the coral

30 inches of thin leather cord

TOOLS

E-6000 craft adhesive

Plastic wrap

Scissors

1. Affix the broken coral piece to the end cap using adhesive; hold firm for 2 minutes, and let dry on a flat surface covered with plastic wrap for a minimum of 30 minutes.

2. String the coral pendant onto the leather cord.

3. Trim the cord to the desired length of necklace and knot the ends to secure.

RECIPE 2:
KNOTTED SHELL ANKLET

MATERIALS

14 inches of thin cotton cording

6 to 8 small shells with holes

Lobster clasp with attached ring

TOOLS

Magna-Tac 809

1 String the shells onto the cotton cording one at a time, knotting each shell as you go. Allow a space of 1 to 2 inches between shells.

2 Knot the clasp hardware at either end once the desired anklet length is reached. Add a small dot of craft glue at each knot to reinforce.

NOTES

Organize a pattern of shells before beginning. I used small shells, but you can vary the size and scale. However, small shells generally will be less intrusive than larger shells (especially with gladiator sandals or sandals with ankle straps).

To secure each shell, place it on the string where you want it and knot securely with the string to hold it in place. You will want to add a knot on each side to keep it secure.

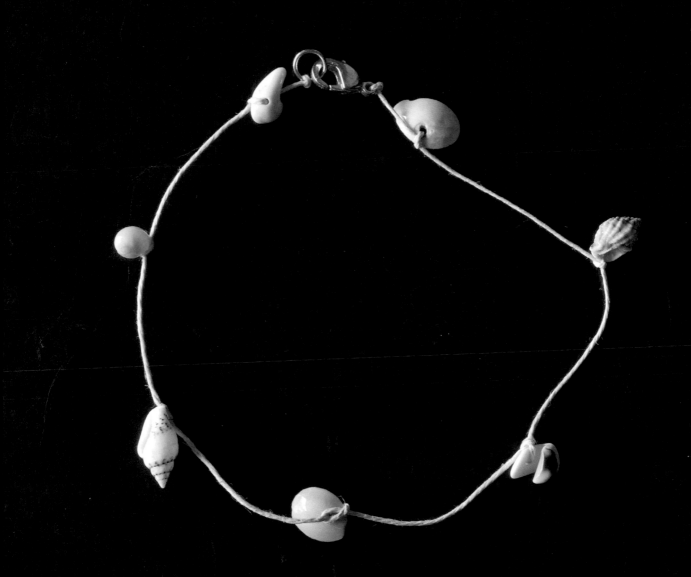

Photocopy the template, enlarging it by 60 percent. Using scissors, cut out the template, then trace it twice onto the linen fabric with a fabric pencil or pen. Using fabric scissors, cut out the bib pieces.

2 Position a ribbon 1 inch below the top inner edge of one piece of the bib, and secure it with hot glue. Repeat on the other side with the second piece of ribbon.

3 Lay the other bib piece on top of the piece with the ribbons attached. Sew a ¼-inch seam along the entire outer edge of the bib. Then turn right side out so that you don't see the seam.

4 Before you begin, arrange the shells as desired on the bib template. Then, starting at the top right edge, begin to transfer the shells from the template to the bib and secure them with hot glue, making sure to cover ½ inch of the grosgrain ribbon. Work around the bib in quadrants. Finish the necklace by hot gluing the top of the two bib pieces together. Gently apply clear nail polish or Fray Check over the inner edge of the bib to keep the fabric from fraying.

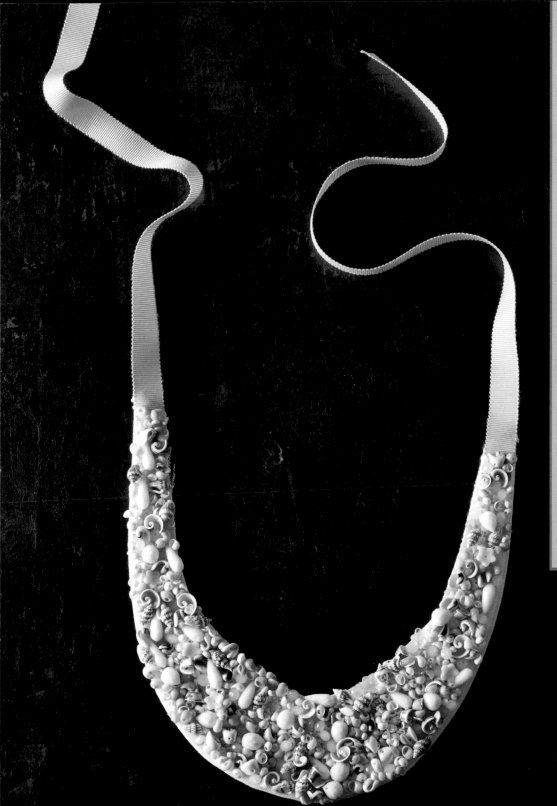

MATERIALS

Enlarged photocopy
of template
(page 223)

Two 12-inch squares
of heavy linen fabric

Two 12-inch lengths
of ½-inch-wide
grosgrain ribbon

75 to 100 assorted
small shells

TOOLS

Photocopier

Scissors

Fabric pencil or pen

Fabric scissors

Hot glue gun and
glue sticks

Sewing needle
and thread or
sewing machine

Clear nail polish or
Fray Check

SHRINK PLASTIC

When you hear "shrink plastic," you may think of Shrinky Dinks (invented by two housewives in 1973) and grade-school arts and crafts, but today many adults use this versatile material to make jewelry and more. Shrink plastic is a commercial-grade plastic sheet that you decorate, then heat in the oven or toaster oven or using an embossing tool, which shrinks the image or collage into a miniature version. It is an incredibly simple, fun material to work with, and can yield some interesting pieces—you probably wouldn't even guess that the Tribal Statement Necklace was made using shrink plastic.

TIP: Shrink plastic can get scratched easily, so be sure to remove any rings and bracelets before getting to work. And remember that everything, from punching holes to creating designs, must be done to the shrink plastic before baking!

MATERIALS

Matte white
shrink plastic

16 inches of
coral silk cord
per necklace

TOOLS

Scissors

Standard (¼-inch)
hole punch

Cookie sheet

Parchment paper

1. Preheat the oven to 325°F.

2. Cut the shrink plastic into shapes that are significantly larger than
 the desired result. Remember, the pendants will shrink to about
 75 percent of their original size and can double in thickness. Trace
 the shape before cutting if you have trouble cutting without an
 outline. Punch a hole at the top of the pendant.

3. Cover a cookie sheet with a piece of parchment paper. Place two
 or three pendants about 2 inches apart. Cover the pieces with
 a second sheet of parchment paper and gently smooth it down
 with your hands. Bake for 3 minutes.

4. Remove the pendants from the oven and let cool for 10 minutes.
 Thread a pendant onto a silk cord and tie a knot to close.

RECIPE 2:
BANNER NECKLACE

MATERIALS
Clear shrink plastic

16-inch cable chain (with or without a clasp)

Four 4 mm jump rings

TOOLS
Scissors

Ruler

Standard (¼-inch) hole punch

Cookie sheet

Parchment paper

Nail polish in 2 or 3 colors

Round-nose and flat-nose pliers

1 Preheat the oven to 325°F.

2 Cut the shrink plastic into three triangles that have 4-inch sides. The pendants will shrink to about 75 percent of their original size and can double in thickness. Punch a hole in two corners of each triangle (be sure not to make the holes too close to the edge).

3 Place the three triangles about 2 inches apart on a parchment-lined cookie sheet. Cover them with a second layer of parchment paper and gently smooth it down with your hands. Bake for 3 minutes.

4 Remove the pendants from the oven and let cool for 10 minutes. Apply one coat of nail polish to each pendant. Let dry for 24 hours.

5 Once dry, use pliers to attach the pendants to jump rings (see page 13). Attach the two outer corners of the pendant to the chain using jump rings.

NOTES

To avoid drips, make sure you don't use too much nail polish at one time. Instead, paint and let it dry. If necessary, apply additional coats to obtain a deeper finished color.

Consider using cookie cutters to create shapes. Simply trace and cut. But remember, the piece will shrink to about 75 percent of the original shape and will double in thickness.

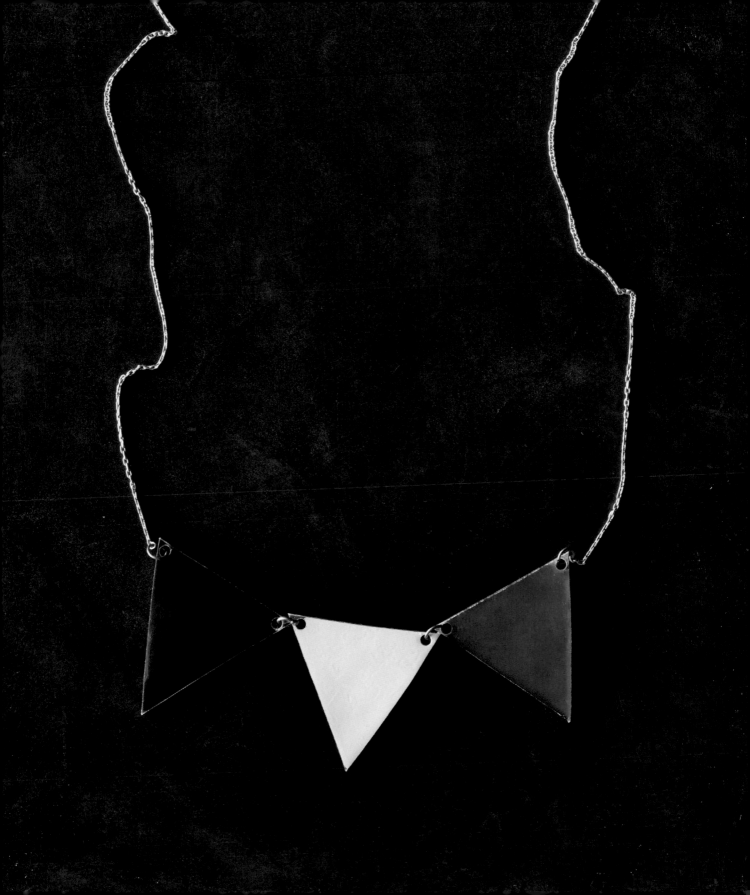

Preheat the oven to 325°F. Sketch out the shape designs in two stages. Use a pencil and a ruler to sketch two equal-sized triangles (with bases of about 5 inches), a larger triangle (with a base of about 11 inches), and two equal-sized parallelograms (with bases of about 5 inches) onto a sheet of shrink plastic. Draw different patterns on each sketched shape with a permanent marker.

2 Cut the shapes from the shrink plastic and punch holes in all corners of the smaller triangles and the parallelograms. Punch holes in the two corners at the base of the larger triangle.

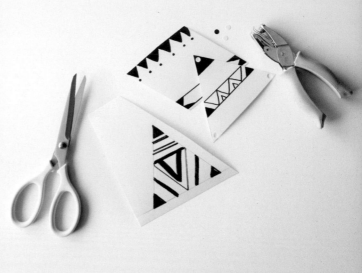

3 Cover a cookie sheet with a piece of parchment paper. Place as many pieces as you can fit on the cookie sheet with about 2 inches between them (if all the pieces do not fit, simply bake a second batch). Cover the pieces with one or two layers of parchment paper and smooth it down with your hands. Bake for 3 minutes.

4 Let the pieces cool for 10 minutes. Use pliers to connect the pieces to one another with jump rings (see page 13). Add the remaining jump rings to the top holes of the pendant, and attach them to the ends of the chain. Secure tightly.

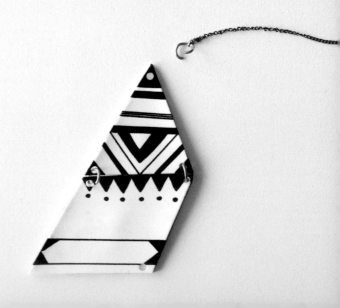

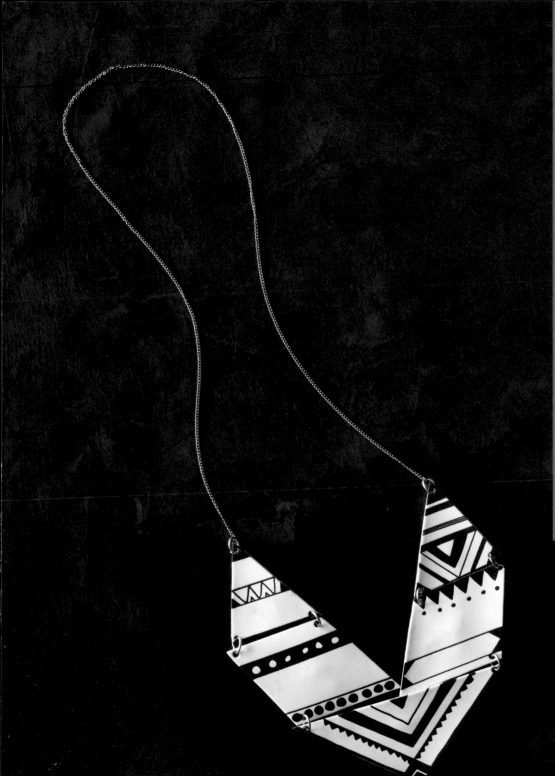

SHRINK PLASTIC
RECIPE 3:
TRIBAL
STATEMENT
NECKLACE

—————

MATERIALS

Matte white
shrink plastic

Eight 4 mm
jump rings

16 inches of cable
chain, without a clasp

TOOLS

Pencil

Ruler

Fine-tipped
permanent marker
in black

Scissors

Standard (¼-inch)
hole punch

Cookie sheet

Parchment paper

Round-nose and
flat-nose pliers

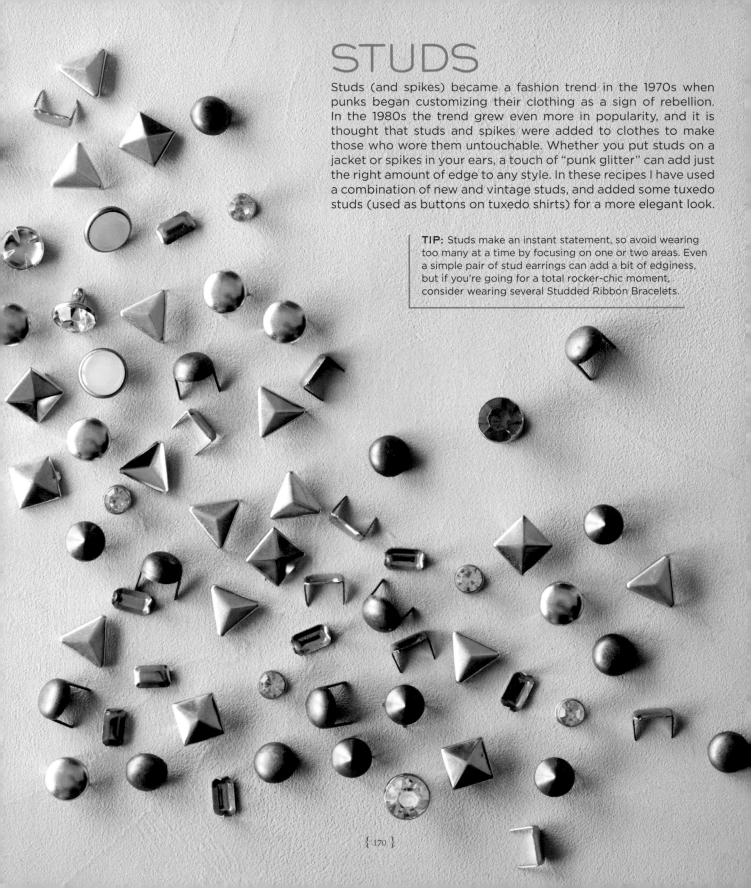

STUDS

Studs (and spikes) became a fashion trend in the 1970s when punks began customizing their clothing as a sign of rebellion. In the 1980s the trend grew even more in popularity, and it is thought that studs and spikes were added to clothes to make those who wore them untouchable. Whether you put studs on a jacket or spikes in your ears, a touch of "punk glitter" can add just the right amount of edge to any style. In these recipes I have used a combination of new and vintage studs, and added some tuxedo studs (used as buttons on tuxedo shirts) for a more elegant look.

TIP: Studs make an instant statement, so avoid wearing too many at a time by focusing on one or two areas. Even a simple pair of stud earrings can add a bit of edginess, but if you're going for a total rocker-chic moment, consider wearing several Studded Ribbon Bracelets.

RECIPE 1:
POST EARRINGS

MATERIALS
2 brass studs

2 post earring blanks
with backs

TOOLS
Wire snips or flat-
nose pliers

Hot glue gun and
glue sticks

1. Remove or fold back the stud prongs using wire snips or pliers.

2. With a small amount of glue, glue the backs of the studs to the earring post surfaces. Allow to dry for 5 minutes.

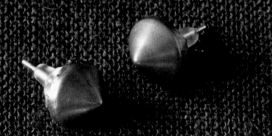

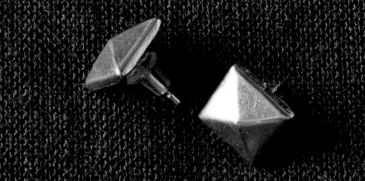

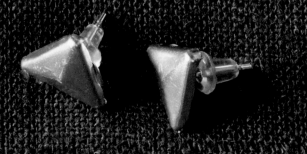

RECIPE 2:
STUDDED RIBBON BRACELET

MATERIALS

2 feet of ribbon as wide as or wider than your studs

3 to 5 pronged brass studs or rhinestone snap studs

TOOLS

Ruler

Fabric Pencil

Round-nose pliers

1 Decide on a bracelet design by choosing an arrangement of studs and where they should be attached to the ribbon.

2 Push the prongs of the brass studs through the ribbon at the desired placement sites with the top side of the stud sitting on the right (prettiest) side of the ribbon. For rhinestone snap studs, push the post through the ribbon.

3 Push the stud prongs down to lay flat against the back of the ribbon to hold each stud in place. Use pliers if necessary. For rhinestone snap studs, push the back plate onto the stud post at the back of the ribbon until it snaps into place.

4 Wrap the ribbon so that the studs sit on top of your wrist. Tie the ends with a bow or a simple knot.

NOTES

To push the studs through the ribbon, use the sharp points on the back of the stud, then fold them over with pliers to secure.

To make sure the studs are spaced evenly, mark their placement with a ruler and a fabric pencil before pushing them through your ribbon. The stud will cover the mark when pushed through the fabric.

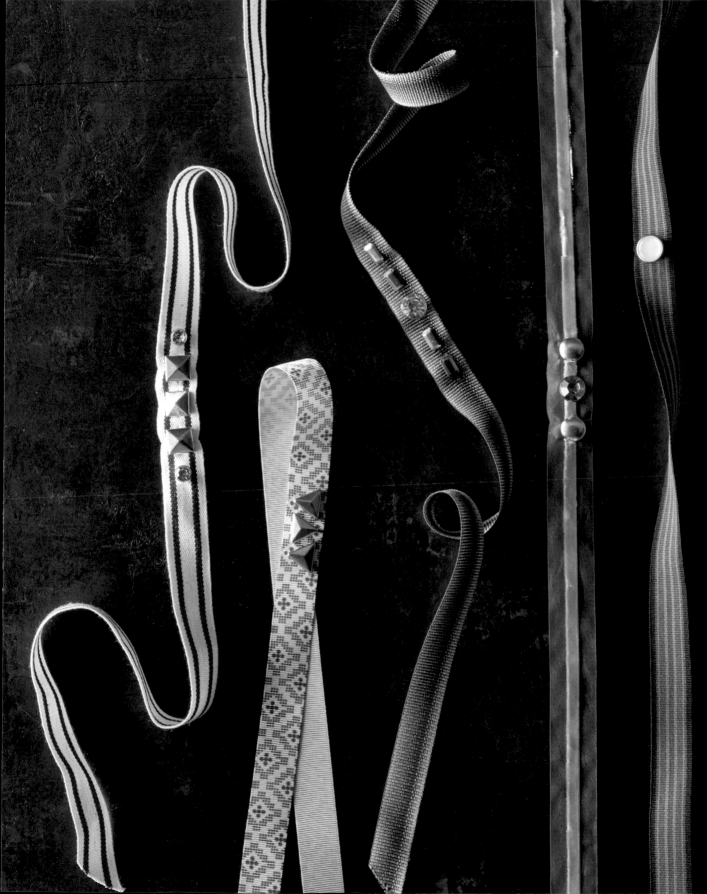

TASSELS

Tassels are a type of trim, often used in home design to finish a decorative pillow or drapes and in apparel to adorn a hemline or a handbag. They're easy to work with, yet they transform the look and feel of whatever they touch. You can make them (it's not hard!), collect them (vintage tassels have great patina), or select beautiful, ready-made tassels for a specific project. Each of these projects creates a different look using tassels, but if you want quick, fabulous jewelry, Tassel Earrings are perfect: just attach tassels to earring blanks and go!

TIP: There are lots of fun tassels on the market, and chances are you'll find many you like. However, it's not hard to make them if you prefer (see page 14). Whether you purchase the yarns or threads or use some you already have, the key is to wrap the materials around a flat edge like a ruler or a piece of cardboard.

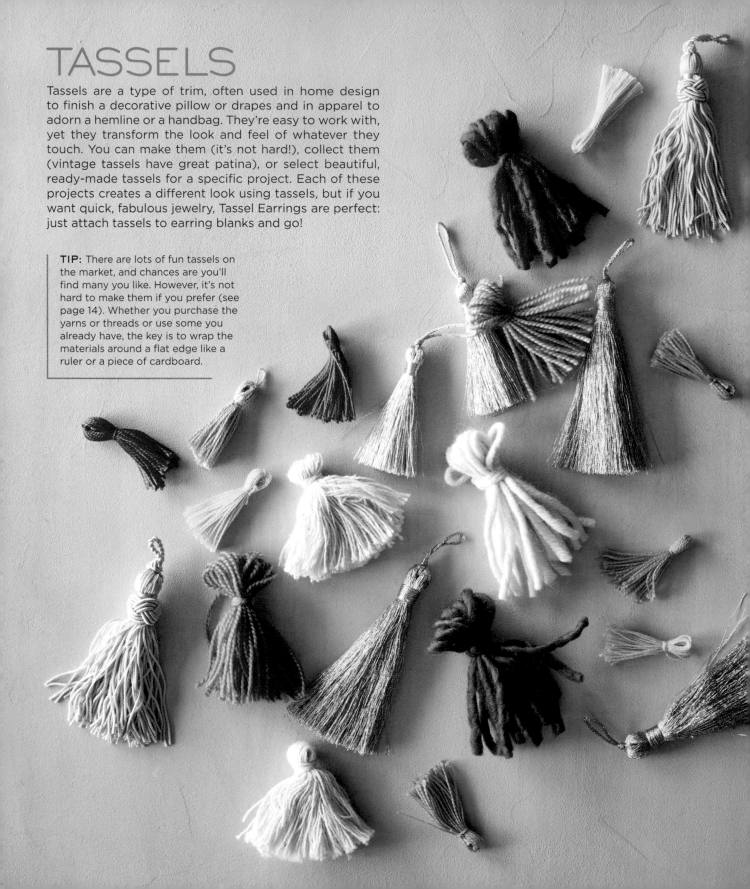

RECIPE 1:
TASSEL EARRINGS

MATERIALS

Two 6 mm jump rings

2 metallic tassels,
2 inches long

Earring wire blanks

TOOLS

Round-nose and
flat-nose pliers

1. Using pliers, open a jump ring (see page 13) and slip a tassel onto it.

2. Open the loop at the base of an earring blank and slip the jump ring onto it; close the loop. Secure tightly.

3. Repeat for the other earring.

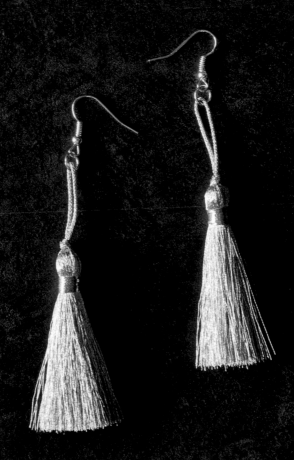

RECIPE 2:
TASSEL SWING BRACELET

MATERIALS

Embroidery thread in blue, red, yellow, and green (1 skein per color)

Twelve 6 mm jump rings

18-inch chain necklace with clasp

TOOLS

Scissors

Round-nose and flat-nose pliers

1 Make twelve tassels (see page 14), three in each color.

2 Attach a jump ring (see page 13) to each tassel by looping it through the upper tassel section. Secure tightly.

3 Attach the jump rings along the length of the chain, spacing them evenly.

4 To wear, wrap the chain twice around your wrist.

NOTES

When making a tassel, be sure to wrap it around a straight edge such as a ruler.

You can make tassels out of an array of materials, including twine, yarn, and embroidery thread.

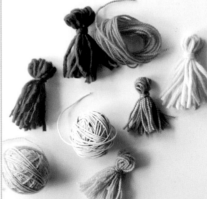

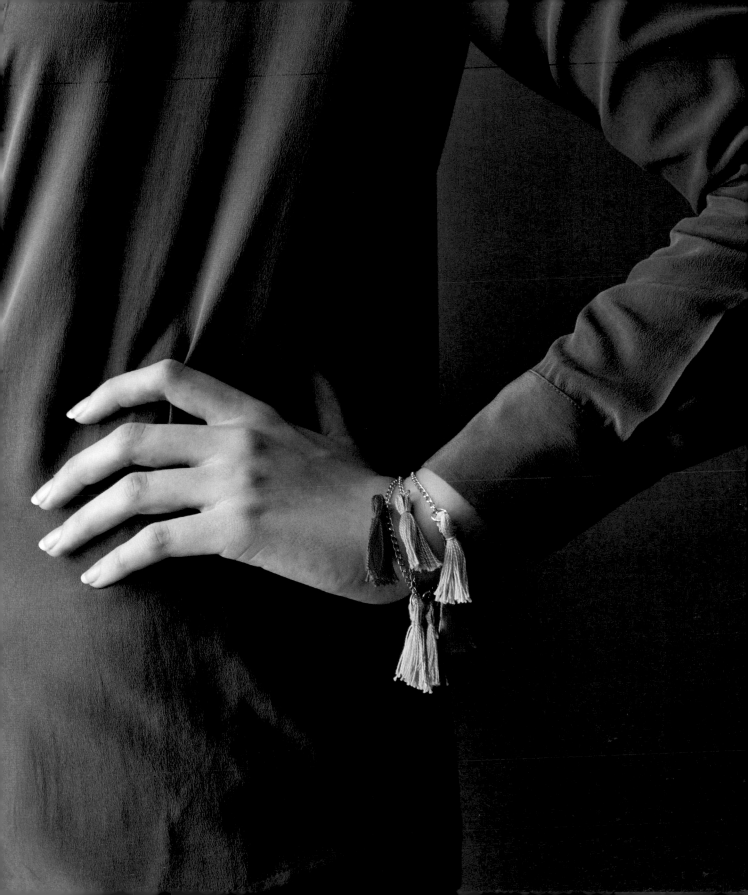

Knot the waxed cord around the cotton cord 7 inches from the center of the cotton cord. Secure the waxed cord with a dab of glue.

2 Thread the waxed cord onto the embroidery needle. Thread a tassel onto the waxed cord. Loop the waxed cord around the cotton cord, pulling the needle up through the loop you just made and securing the tassel so that it hangs from the cotton cord.

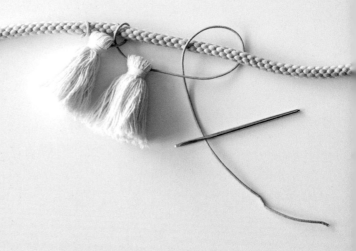

3 Repeat until you have strung all the tassels on the cotton cord. Tie the waxed cord in another knot around the cotton cord to secure. Finish with a dab of glue. When dry, trim the ends of the waxed cord.

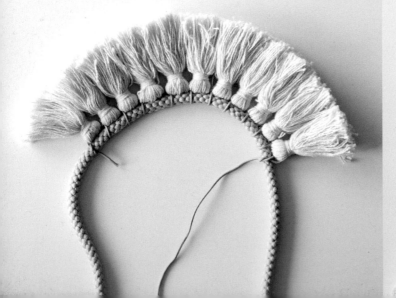

4 Trim the ends of the cotton cord to 12 inches and secure the ends inside each of the end caps by putting a dab of glue inside the end cap before inserting the cord. Make sure the cord fits snugly inside the end cap.

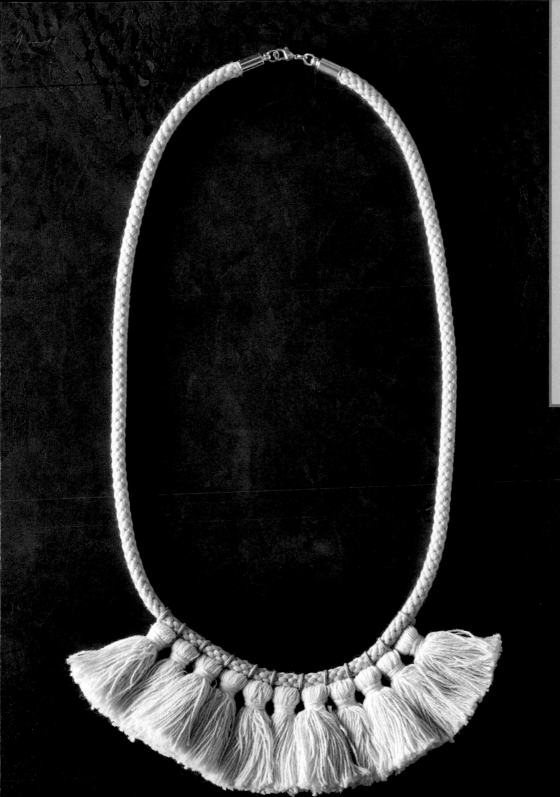

TASSELS
RECIPE 3:
NATURAL TASSEL NECKLACE

———

MATERIALS

1 yard of ⅛-inch waxed cord

1 yard of cotton cord, ¼ inch in diameter

11 purchased cotton tassels, 2 inches long

End cap and clasp set, ¼ to ½ inch in diameter

TOOLS

Magna-Tac 809 or other craft glue

Embroidery needle

T-SHIRTS

We all likely have several T-shirts in our wardrobe, whether classic white, basic black, or a memento from an alma mater or a rock concert. We have the military to thank for the T-shirt's origin—in World War I, it became part of the U.S. Navy uniform for all servicemen—and we have James Dean to thank for its status as a fashion staple. T-shirts are generally made from a jersey knit fabric, either all cotton or a synthetic blend, and the material's bit of stretch makes it perfect for these projects. T-shirts or jersey knit yardage will work for each of these recipes.

TIP: To make these projects, you can repurpose T-shirts from your wardrobe, but you can also purchase jersey knit fabric, which is easy to find in most fabric shops and comes in a wide range of colors.

RECIPE 1:
T-HEADBAND

MATERIALS

2 rectangles of
T-shirt fabric, about
8 inches by
20 inches

TOOLS

Fabric scissors

Rotary cutter
(optional)

Sewing needle
and thread

1. Lay the T-shirt rectangles on top of each other to form an X, allowing the edges of the T-shirt rectangles to roll in on themselves. Fold the rectangles over each other to link. (Trim T-shirt strips with a fabric rotary cutter for a clean edge.)

2. Sew the raw edges of the headband together, measuring around your head to determine the fit. Trim any excess fabric.

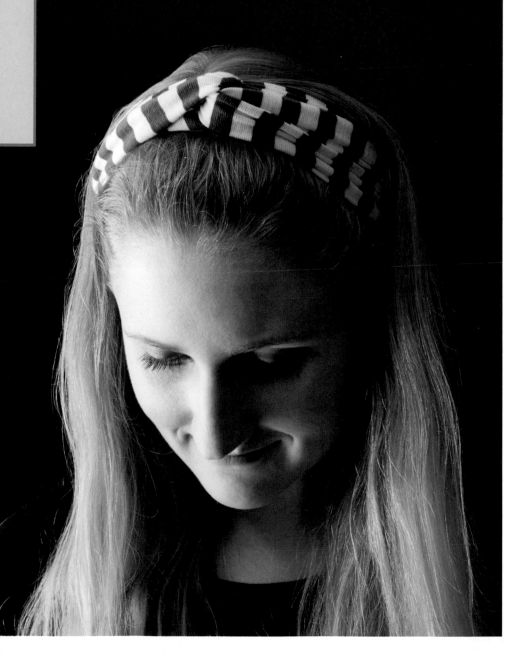

RECIPE 2:
T-WRAPPED BRACELET

MATERIALS

58-inch strip of
T-shirt fabric, about
½ inch wide

20 to 25 buttons and
beads in various sizes
and colors

TOOLS

Fabric scissors

Sewing needle
and thread to
match fabric

1 Wrap the T-shirt strip around your wrist multiple times until you are satisfied with the length. Add 2 inches to each end for knotting, and cut.

2 Sew the buttons and beads onto the T-shirt strip as desired—place them close to one another or in a more random pattern.

3 Loop one end over itself and tie the loop in an overhand knot, leaving a ½-inch loop at the end.

4 Sew a ½-inch button to the other end of the T-shirt strip. Slip it through the loop to secure around your wrist.

NOTES

Consider the closure as you sew on buttons so there is enough space between the knot and the buttons.

Adorn the bracelet with charms or beads to create a different look.

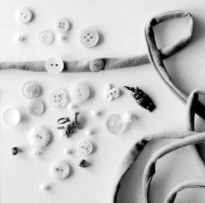

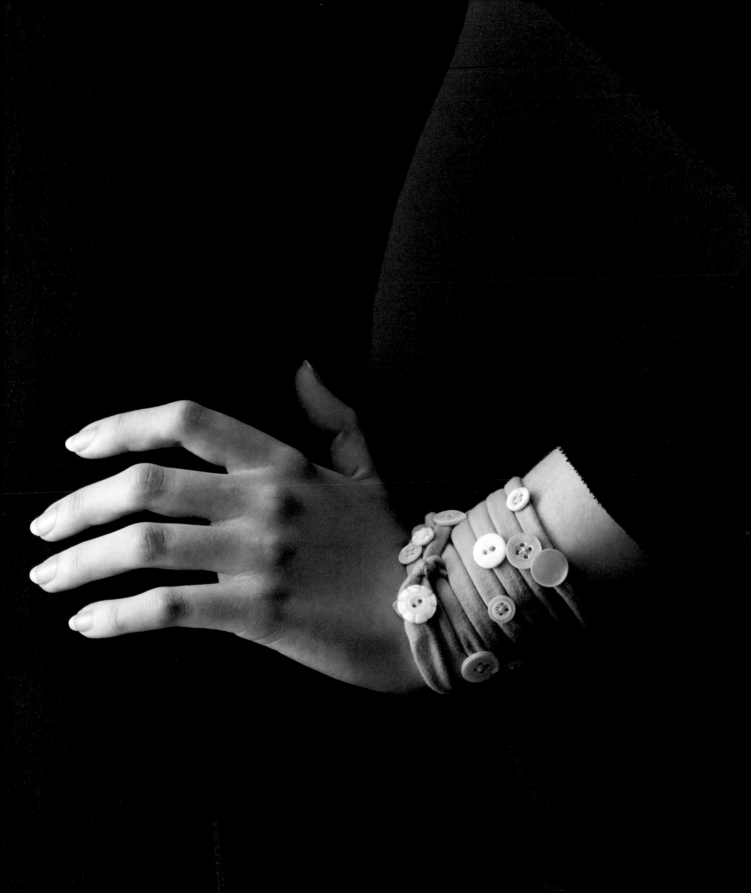

Cut a white T-shirt into two 60-inch-long strips, roughly 1½ inches wide.

2 Prepare the dye bath with 1 capful of dye and 5 cups of warm water. Allow the T-shirt strips to sit in the dye bath for 30 minutes. Then remove and rinse them. Lay them flat on paper towels or a trash bag and let them dry completely. For a darker color, use more dye concentrate. For a pale color, use less dye or let it sit for less time.

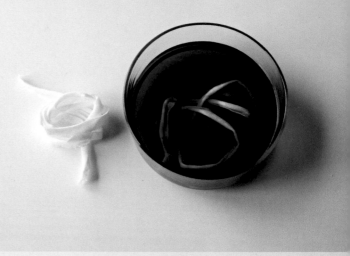

3 Thread nine small beads onto the first T-shirt strip. Make sure they sit at the center of the strip. Thread the remaining beads onto the second strip, arranging them so that there are seven large beads in the center and two small ones at either end.

4 Arrange the strips so that the strip with the small beads is the top strip. Knot the T-shirt strips together at both ends of the beads, leaving enough slack so that they arc slightly and are not pulled taut. Tie the strands in a bow to wear the necklace at the desired length.

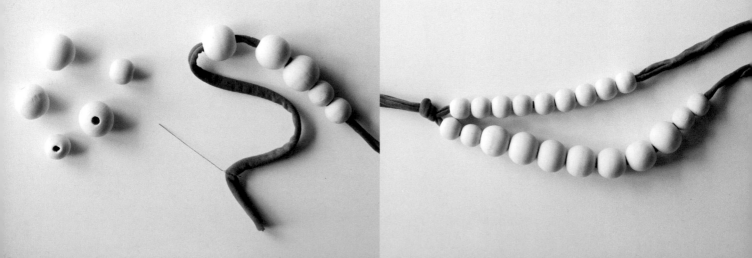

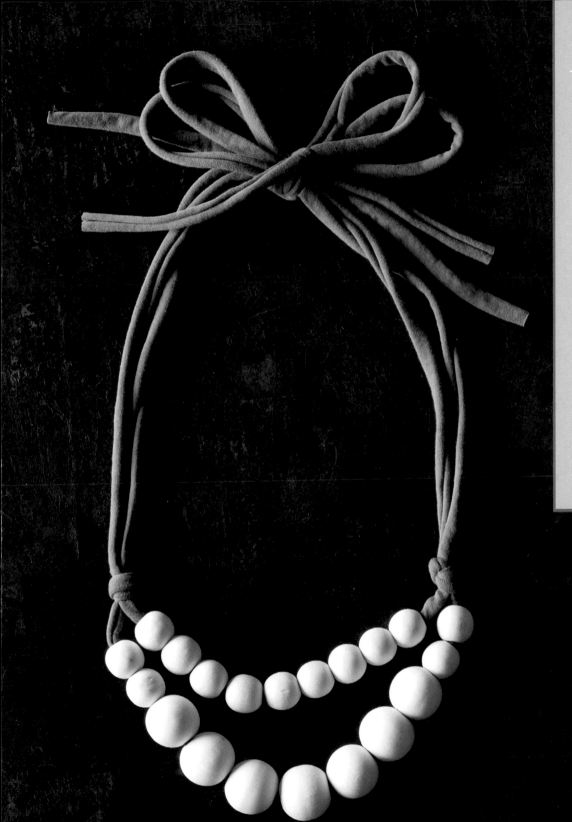

T-SHIRTS
RECIPE 3:
T-SHIRT BEADED
NECKLACE

MATERIALS

White T-shirt, men's medium, or white jersey fabric

RIT dye in desired color (pictured here: Teal)

20 wooden beads with at least a ¼-inch hole, 13 that are about ½ inch in diameter and 7 that are ¾ to 1 inch in diameter

TOOLS

Fabric scissors

Glass container for dyeing

Paper towel or trash bag

Beading needle

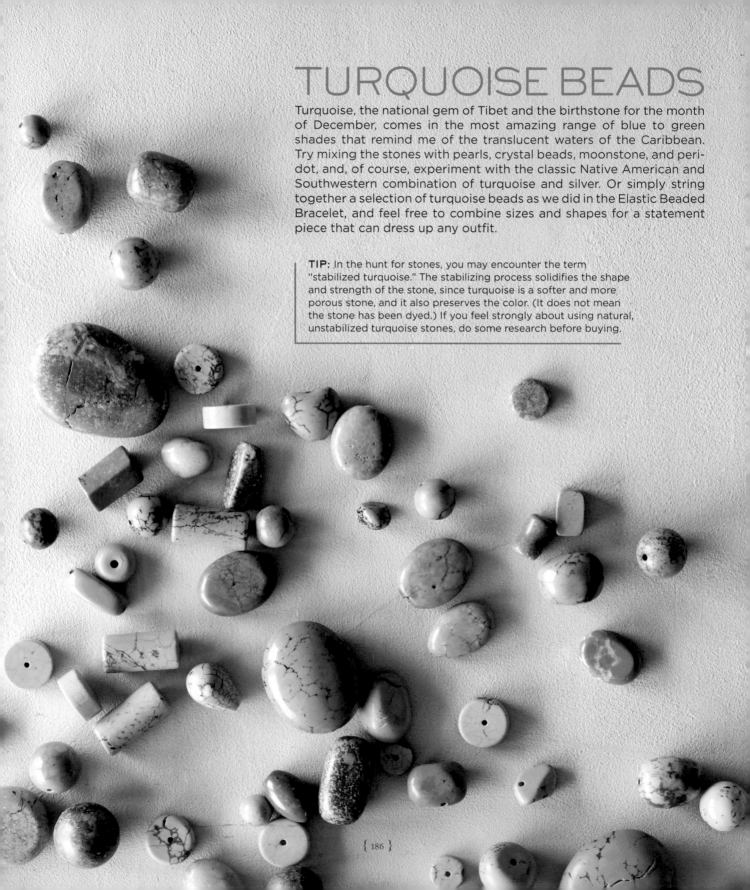

TURQUOISE BEADS

Turquoise, the national gem of Tibet and the birthstone for the month of December, comes in the most amazing range of blue to green shades that remind me of the translucent waters of the Caribbean. Try mixing the stones with pearls, crystal beads, moonstone, and peridot, and, of course, experiment with the classic Native American and Southwestern combination of turquoise and silver. Or simply string together a selection of turquoise beads as we did in the Elastic Beaded Bracelet, and feel free to combine sizes and shapes for a statement piece that can dress up any outfit.

TIP: In the hunt for stones, you may encounter the term "stabilized turquoise." The stabilizing process solidifies the shape and strength of the stone, since turquoise is a softer and more porous stone, and it also preserves the color. (It does not mean the stone has been dyed.) If you feel strongly about using natural, unstabilized turquoise stones, do some research before buying.

RECIPE 1:
ELASTIC BEADED BRACELETS

MATERIALS

Elastic cord

Turquoise beads in various shapes and sizes (approximately 15 to 35 per bracelet)

TOOLS

Scissors

Bead needle

1 to 1½ inches ⅛-inch-wide turquoise ribbon

1. Loosely wrap the elastic cord around your wrist to determine how much you need for each bracelet. Add an inch or two for tying a knot, and cut that length.

2. Lay out the beads to organize a design. Using a bead needle, thread the beads onto the cord.

3. Tie the ends of the elastic together (close to the beads) to secure. Trim any excess elastic. Tie the ribbon on top of the knot in the elastic. If the finished bracelet is too tight, stretch it out by placing it around a wide drinking glass for 2 hours.

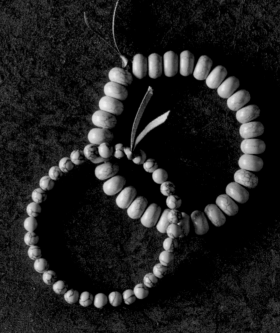

RECIPE 2:
WRAPPED WIRE RING

MATERIALS

18-inch length of 24-gauge wire (you may need more if you have a larger finger)

2 blue or turquoise beads, each in a different shape (we used one square and one round bead, each measuring ½ inch)

6-inch length of wire

TOOLS

Wire snips

Hot glue gun and glue sticks

1 Starting at one end of the 18-inch wire, wrap it around your finger four to six times to create a ring base. Make sure it is tight enough to stay on your finger but roomy enough to slide off. Coil two or three times in the center of the ring base to secure.

2 Coil the remaining wire in a circle at the top of the ring base to create a flat surface on which the beads will sit, leaving a tail of wire to string the beads through to secure them.

3 Thread the 6-inch length of wire through the two beads. Fold the wire to the underside of the beads and twist them to secure. Tightly coil the ends around in a circle to create a flat surface under the beads.

4 Place a dab of hot glue on the top of the ring base and connect the wire coil of beads to the wire coil of the base.

NOTES

The larger the bead, the more top-heavy the ring will be.

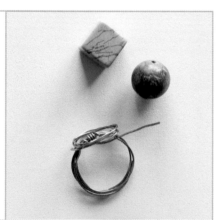

Play with various sizes, shapes, and colors of beads to create different looks.

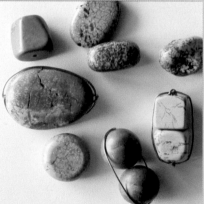

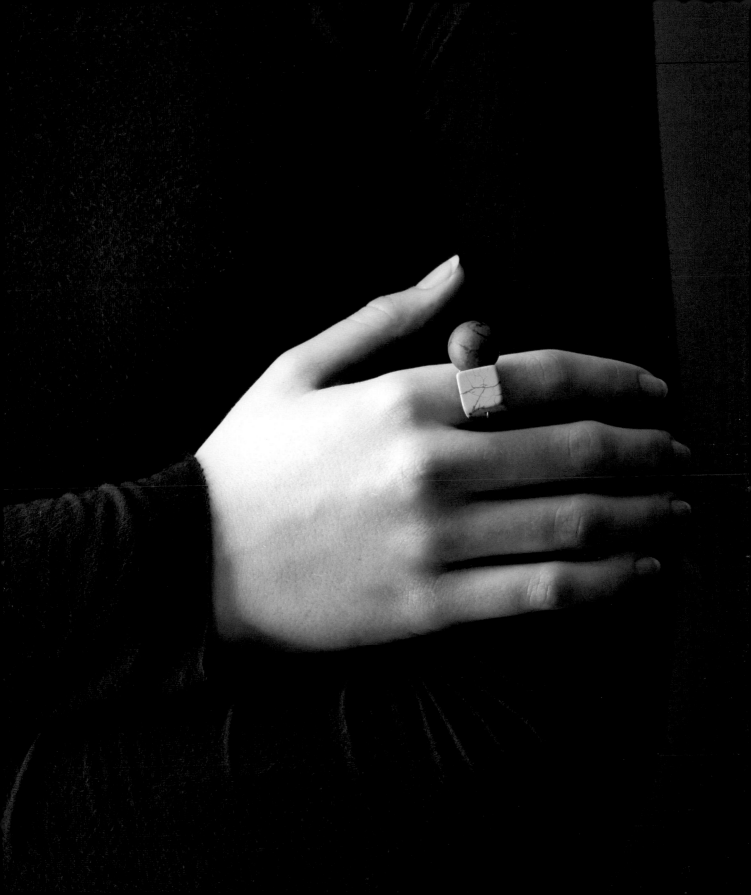

Cut ten pieces of wire measuring 4 inches long. You will have one piece of wire for each bead. Thread the wire through the beads and position the bead in the center of the wire.

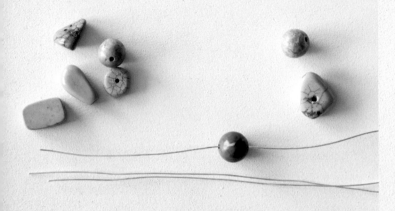

2 Bend the wire up and cross the two ends close to the bead. Loop one wire back toward the bead, creating a ¼-inch-wide loop.

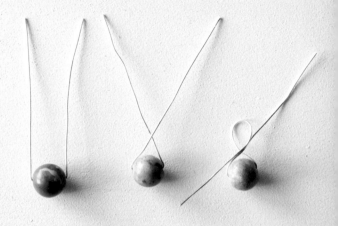

3 Wrap both wire ends around the base of the loop where the wires cross, three times. Trim the excess wire with the wire snips.

4 Thread each bead-and-wire charm onto the leather cord, knotting the cord to secure the charms in place. Space them between 1 and 2 inches apart, knotting as you go. Knot five charms on one end and five charms on the other end of the leather cord. Note: There are multiple ways to wear this necklace. One is to fold the leather cord in half and wrap it around your neck from the back, looping the charm end through the folded part of the leather cord (opposite). Another way is to loosely wrap the leather cord around your neck, leaving the charm ends hanging free.

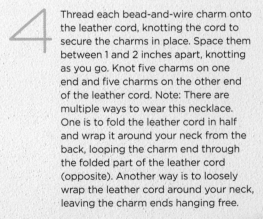

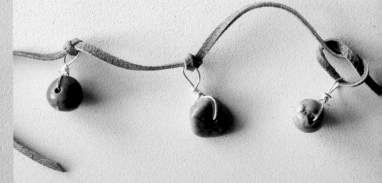

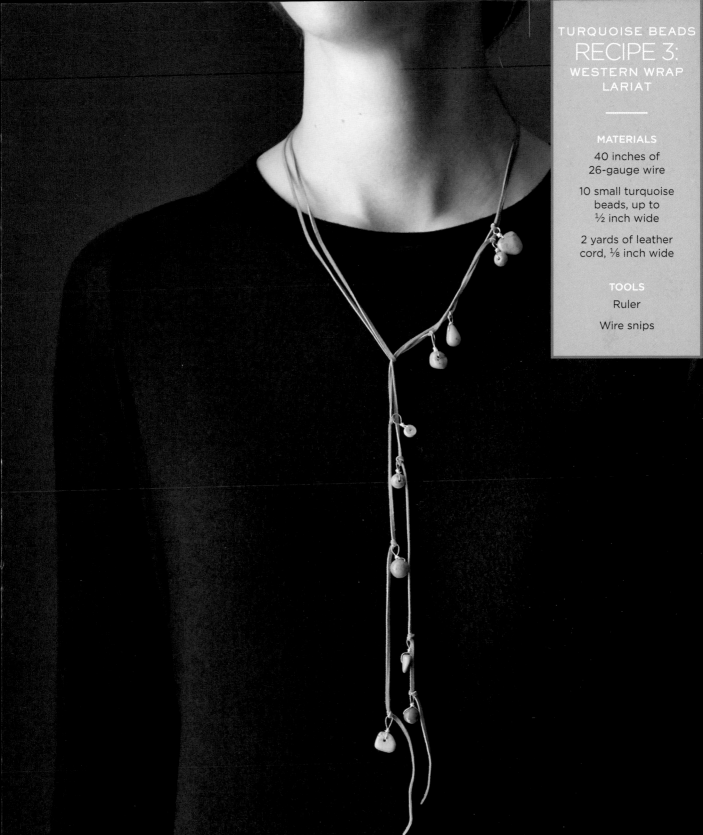

MATERIALS

40 inches of
26-gauge wire

10 small turquoise
beads, up to
½ inch wide

2 yards of leather
cord, ⅛ inch wide

TOOLS

Ruler

Wire snips

UTILITY CORD

When I hear the word *paracord*, I usually think of extreme outdoor activities, not jewelry. And indeed, parachute cord, otherwise known as paracord, is a lightweight nylon kernmantle rope originally used in U.S. parachutes during World War II. Paratroopers found it useful for many other tasks, and today, outdoor enthusiasts, firefighters, and soldiers often wear paracord woven into a compact bracelet that can be unraveled in the field if needed. Over time, these bracelets have also blossomed into accessories for the fashion-conscious. These projects use both paracord and rock-climbing cord, which have different thicknesses, and focus on the design and aesthetic aspects of the cord—no survival techniques needed!

> **TIP:** There are many places to buy paracord and climbing cord—both of which you can use in these projects—including craft stores, outdoor sporting shops, and specialty shops on websites such as Etsy (see Resources). When selecting cord, consider color, thickness, and weave pattern; buy small amounts of several styles to play with before deciding on a final design approach.

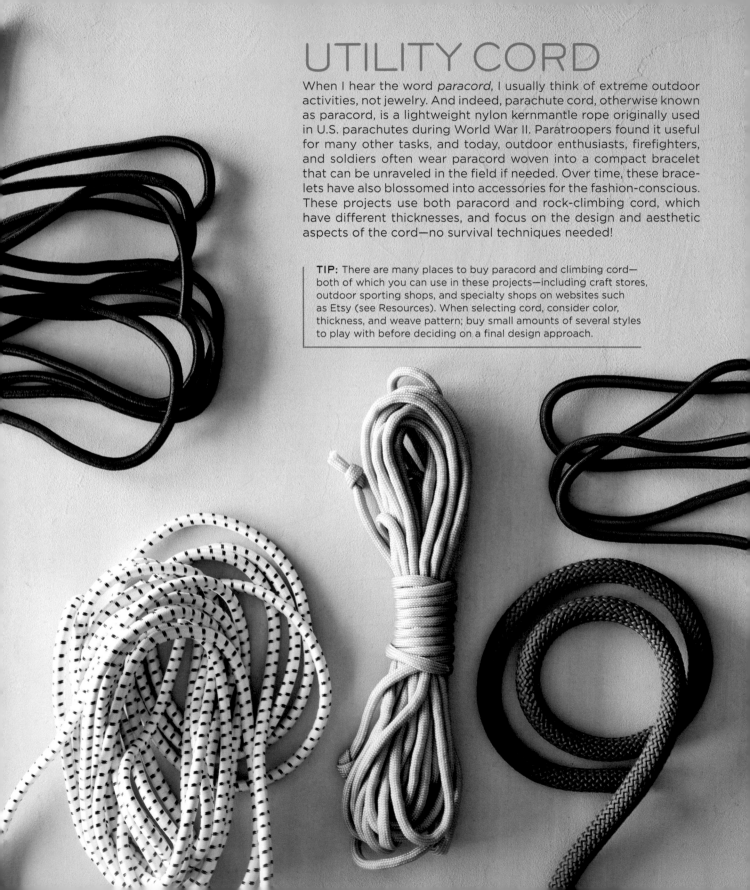

UTILITY CORD
RECIPE 1:
GLAM CORD
BRACELET

MATERIALS

1 pair of dangling
statement earrings

Premade wide fishtail
paracord bracelet

TOOLS

Plato flush
wire cutters

Wax paper

Hot glue gun and
glue sticks

1. Press wire cutters to the base of the earring posts and remove
 the posts from the earrings.

2. Lay the paracord bracelet flat on a sheet of wax paper.

3. Apply glue to the back of the earrings and press it firmly onto
 the center of the bracelet. Let dry for 1 hour.

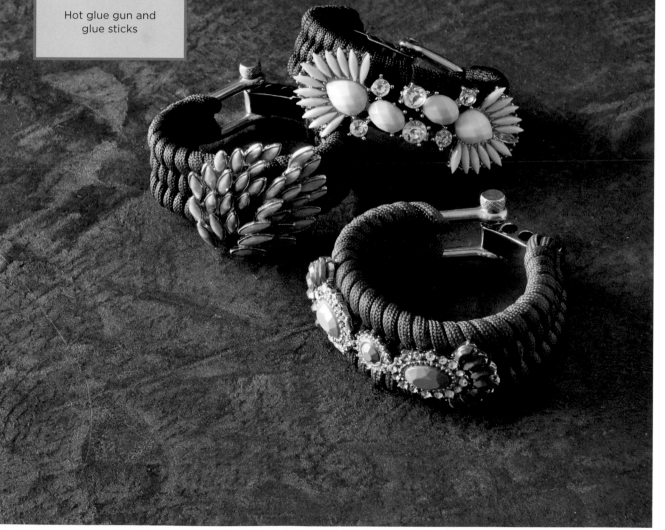

MATERIALS

25 inches of 10 mm climbing cord in light gray

Acrylic paint in white, black, lavender, and gold

Two 10 mm end caps

One 4 mm jump ring

1 spring ring clasp

TOOLS

Painter's tape, washi tape, or masking tape

Round-nose and flat-nose pliers

G-S Hypo Cement

1 Cut painter's tape into various lengths and wrap it around sections of the cord as desired.

2 Paint the untaped lengths of cord in white, black, lavender, and gold. Let dry overnight.

3 Once the paint is dry, remove the tape carefully. Using pliers, attach the jump ring to one end cap and the clasp to the other. Secure tightly.

4 Squeeze cement into the end caps and insert rope ends to finish.

NOTES

Use different widths of different kinds of tape, such as painter's tape, washi tape, and masking tape, to get desired stripes.

Wear as a necklace or wrap around your wrist multiple times to wear as a bracelet.

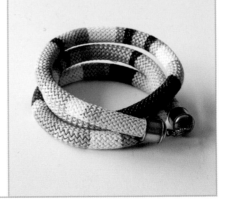

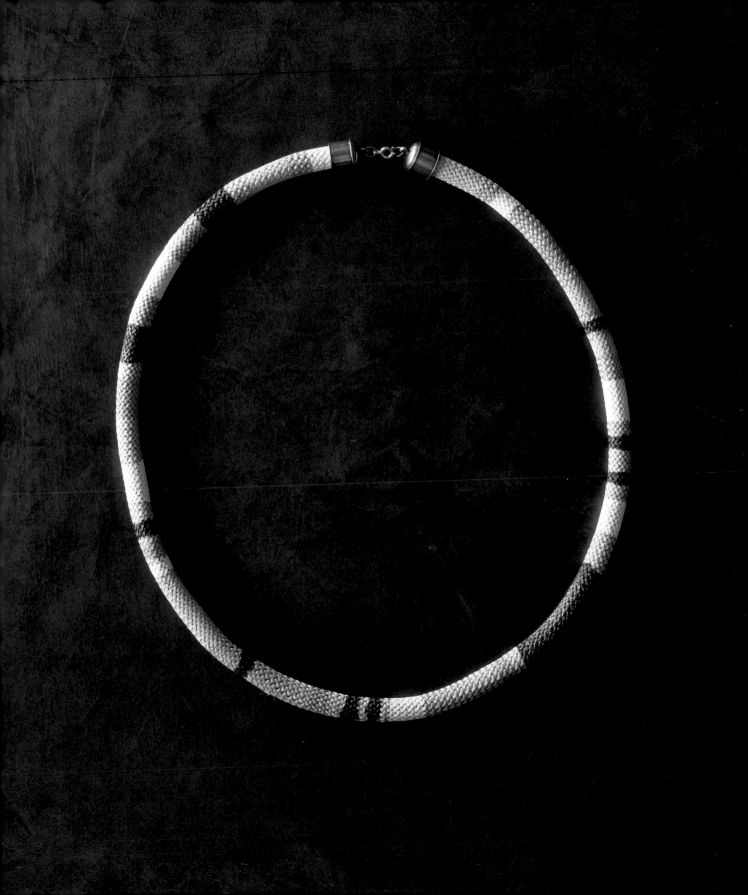

1 With sharp scissors, cut two lengths of cord: one 25 inches and the other 10 inches. To prevent the ends of the 10-inch cord from fraying, add a small amount of glue to each cut end. Let dry for 30 minutes, or until dry to the touch. Slide 4 beads onto the short cord and 5 beads onto the long one.

2 Lay both cords on a flat, clean surface, centering the smaller one on top of the larger one. Wrap a small piece of tape about ½ inch away from each end of the smaller cord, affixing it to the larger one.

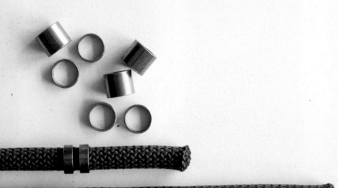

3 Wrap embroidery floss around the upper sections of the cord to cover the tape. Knot the ends of the cord on the underside of the necklace and secure with a dab of hot glue.

4 Squeeze cement into the end caps, insert them into the cord ends, and let them dry. Use pliers to attach one of the jump rings (see page 13) to the loop in one end cap, and attach the clasp to the loop in the other end cap using the other jump ring.

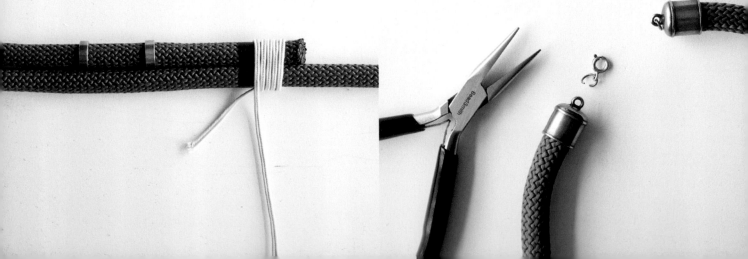

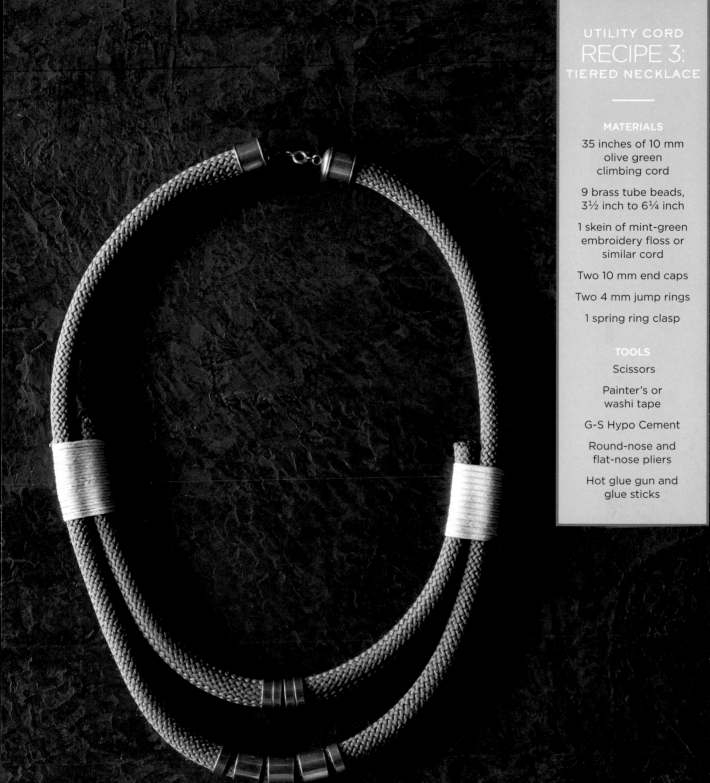

UTILITY CORD
RECIPE 3:
TIERED NECKLACE

—

MATERIALS

35 inches of 10 mm
olive green
climbing cord

9 brass tube beads,
3½ inch to 6¼ inch

1 skein of mint-green
embroidery floss or
similar cord

Two 10 mm end caps

Two 4 mm jump rings

1 spring ring clasp

TOOLS

Scissors

Painter's or
washi tape

G-S Hypo Cement

Round-nose and
flat-nose pliers

Hot glue gun and
glue sticks

VINTAGE PINS

The brooch, a type of pin, dates back to the Bronze Age, when pins were a popular (and practical) fastener/adornment for clothing; by the eighteenth century, brooches were more of a fashion accessory, although there were still many utilitarian brooches in use. In the early twentieth century, new materials and industrialization allowed designers to experiment with jewelry as an expression of style and creativity, using non-precious materials to create bigger, bolder designs that we often refer to as costume jewelry. These projects feature vintage pieces made of rhinestones and enamel, both of which can usually be found at antique stores and flea markets. Chances are you already have at least one!

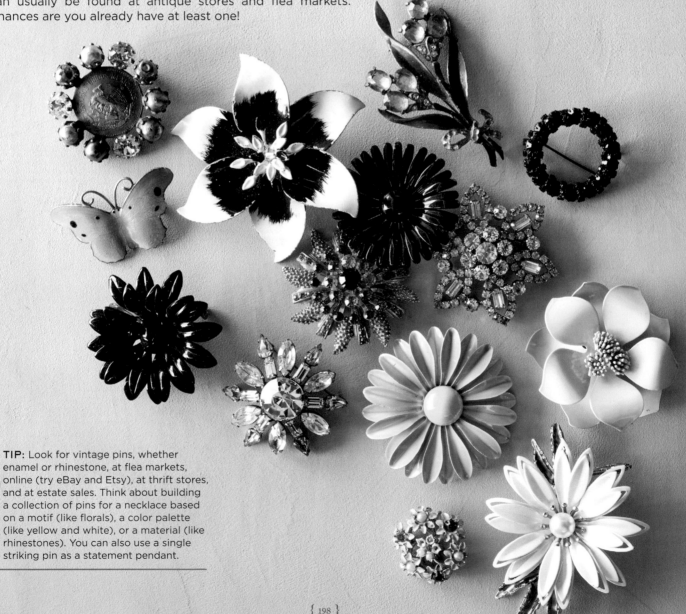

TIP: Look for vintage pins, whether enamel or rhinestone, at flea markets, online (try eBay and Etsy), at thrift stores, and at estate sales. Think about building a collection of pins for a necklace based on a motif (like florals), a color palette (like yellow and white), or a material (like rhinestones). You can also use a single striking pin as a statement pendant.

RECIPE 1:
RHINESTONE BROOCH NECKLACE

———

MATERIALS

Vintage rhinestone pin (silver-dollar size or larger)

1 yard of silk, grosgrain, or velvet ribbon, between ¾ and 1 inch wide

Clear plastic earring back (optional)

1. Thread the ribbon through the securely closed backing of the pin. Dull the pointed end of the pin spoke (see page 12) so that it doesn't scratch or poke you and/or cover it with the earring back.

2. Center the pin in the middle of the ribbon and tie a knot directly onto the pin spoke.

3. Tie the ends of the ribbon in a knot or a bow to wear the necklace at any desired length.

RECIPE 2:
ENAMEL BOUQUET NECKLACE

MATERIALS

6 vintage enameled flower pins (silver-dollar size or larger)

18-inch heavy-weight textured chain in an antique brass finish

1 large lobster clasp in an antique brass finish

2 large jump rings in an antique brass finish

6 clear plastic earring backs (optional)

TOOLS

Camera (optional)

Round-nose and flat-nose pliers

1 Lay out the pins and organize a design. If desired, photograph the design as a reference.

2 Attach the center pin first. Open the pin back, find the middle of the chain, and insert the pin through a link of chain. Attach the pin to the chain with the point of the pin going up. This will help prevent you from getting pricked by the tip. Close the pin to attach. (See page 12 for instructions on how to dull the end.) If you wish, use earring backs to cover the tips.

3 Continue attaching the pins to the chain in the order chosen, building from the center of the design out. You may need to pin and unpin the flowers a few times as you figure out the best spacing.

4 Securely attach the lobster clasp to one end of the chain using a jump ring (see page 13). Attach a jump ring to the other end of the chain to complete the clasping mechanism for this piece.

NOTES

Small plastic or metal earring backs can be used on the tips of the pin spokes for additional protection.

Having the edges of the flowers overlap one another not only looks pleasing but also helps to lock in the positioning of each flower, as they hold one another in place. Start with a larger pin as a focal point in the center and work out from there.

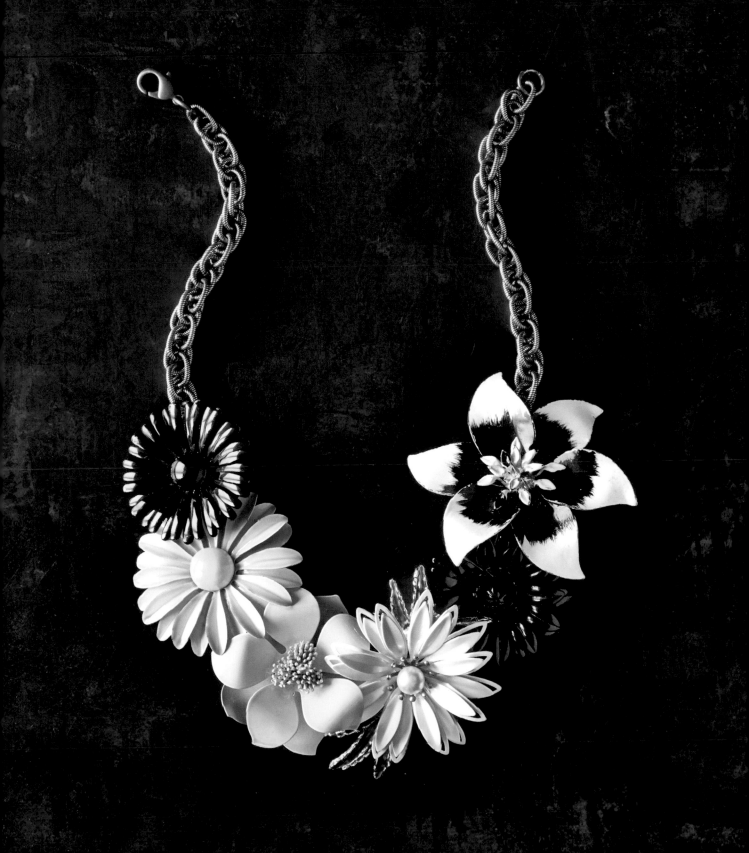

Using the flexible beading wire and crimp beads (see page 12), string three strands of beads: 8 inches (twenty-six beads), 9 inches (thirty beads), and 10 inches (thirty-four beads). Set the three strands aside.

2 Cut or divide the heavy-weight chain into two 5-inch sections with a jewelry chain wire cutter. Attach the lobster clasp to the ends of the chain using two of the jump rings (see page 13).

3 Use a jump ring to attach one end of all three beaded strands to a 5-inch section of chain. Open the jump ring with pliers (see page 13) and place the strands on it in order from longest to shortest. Add the 5-inch chain section and close the jump ring. Repeat on the other side.

4 Attach the vintage pin to one side of the beaded strands by opening the pin and placing it over all three stands, about four beads down from where the strands start. If you are working with larger beads, be prepared to play with the placement of the brooch and possibly attach it to just one or two strands of beads so that the pin will close. Larger beads will take up more space in the back of the pin.

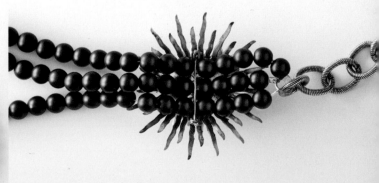

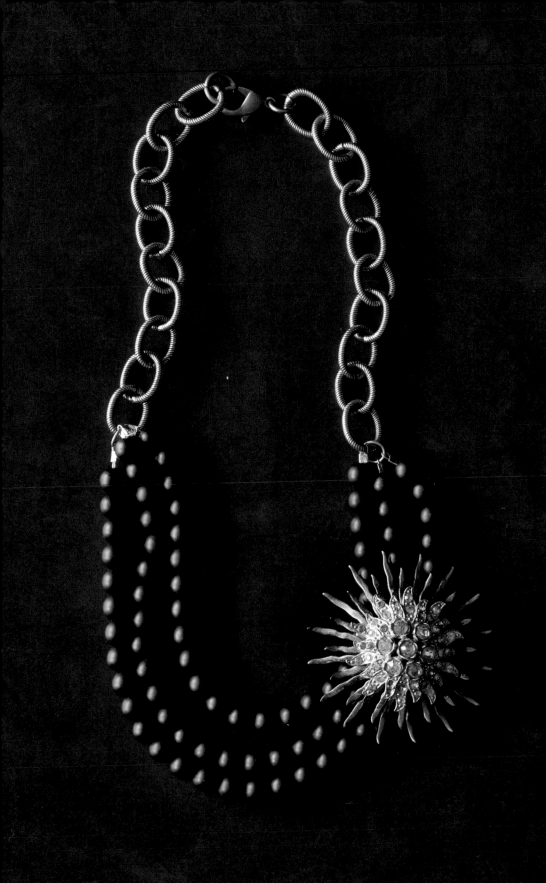

VINTAGE PINS
RECIPE 3:
COCKTAIL NECKLACE

MATERIALS

1 yard of flexible beading/ stringing wire

6 small crimp beads

Ninety 8 mm round black glass beads*

10-inch heavy-weight textured chain in an antique brass finish

1 large lobster clasp in an antique brass finish

Four 8 mm jump rings in an antique brass finish

1 vintage rhinestone pin (silver-dollar size or larger—the pin clasping mechanism must be at least 1 inch in length from hinge to latch)

TOOLS

Round-nose and flat-nose pliers

Jewelry chain wire cutter

* To create our cover necklace, follow these instructions, but substitute 8 mm faceted glass turquoise beads for the black glass beads.

WIRE

Wire wrapping is one of the oldest techniques for making jewelry by hand, and even today, it's a technique rarely used in mass-produced jewelry. Wire is a very manageable material, easy—even for beginners—to work with, and it can be used to create some beautiful, unique pieces. It comes in various shapes and sizes, such as round and square, as well as in several patterns, such as flat and pretwisted, and it is available in a number of materials, including copper, brass, sterling silver, and gold-filled. For the Wire Bangles, wire is wrapped around the wrist to create a simple, elegant, customized bangle, showing how easy yet beautiful wire can be to work with.

TIP: Wire is measured by diameter, which is indicated by the gauge numbers (noted in the material lists and on wire packaging). The lower the gauge, the thicker the wire, so a 12- or 14-gauge wire is pretty heavy, making it perfect for creating bangles and chokers, and a 26-gauge wire is fairly fine, great for wrapping.

RECIPE 1:
WIRE BANGLE

—————

MATERIALS

70 inches of
26-gauge wire

5 to 7 inches of
22-gauge wire in a
contrasting color

TOOLS

Wire snips

1. Loop the 26-gauge wire around your wrist as many times as you can, to make about eight to twelve loops. Make sure the loops are large enough that you can slide them on and off your wrist. Trim one end so that the two wire ends meet up.

2. Wrap the 22-gauge wire around the loops, covering about 1 inch. Make sure to cover the loose ends. Trim any excess wire.

MATERIALS

5 assorted glass or
stone beads, ranging
from ½ inch long to
1½ inches long

Brass bracelet cuff,
¾ inch wide

14-inch length of
24-gauge wire

TOOLS

Hot glue gun and
glue sticks

Round-nose pliers

Wire snips

1 Anchor the largest bead to the cuff with a dab of hot glue at the center of the cuff while threading the length of wire through the bead so that there are equal lengths coming out of each end of the bead.

2 Working from both ends, wrap the wire tightly around the bead and the cuff, covering the bead with the wire as desired. The beads and wire should feel secure.

3 When the wire is wrapped back to the top of the bracelet, thread another bead, arrange it as desired on the cuff, and continue tightly wrapping the wire to secure the bead. Repeat until all of the beads are secure on the bracelet. Tightly twist the two ends of the wire together and tuck underneath the cuff.

NOTES

As you wrap the wire around the underside of the bracelet, push the wire flush to the metal to keep it flat.

Play with different sizes, shapes, and colors of beads. Mix them to make a different look. (If you're using larger stones, you may need extra wire to secure them.)

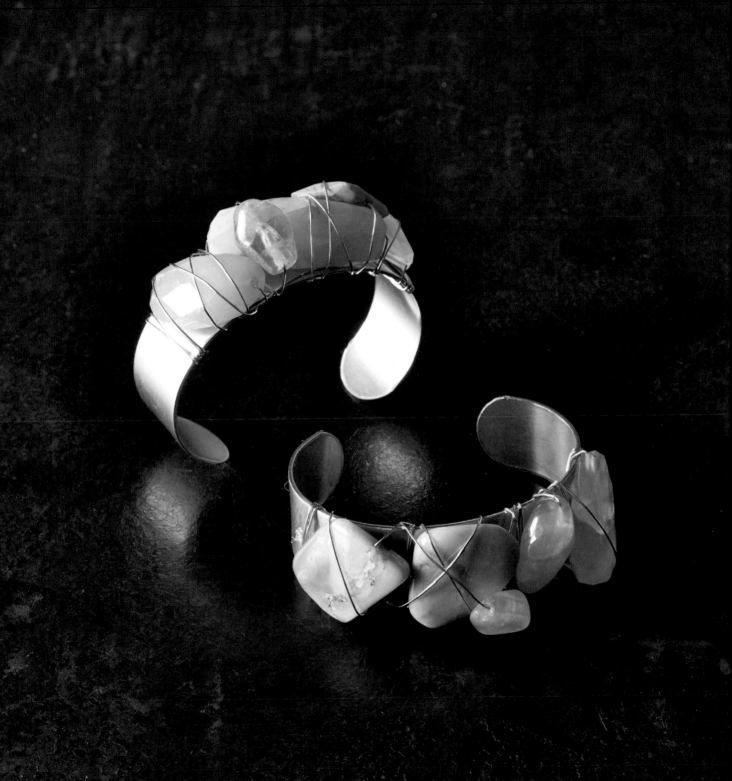

Use round-nose pliers to make a small ¼-inch loop (see page 15) at one end of the wire.

2 Thread one or several beads onto the wire from the opposite end. Thread over both wires until the bead sits on a single wire.

3 Loop the wire length into a circle shape, slipping one end through the small loop on the other end.

4 Use round-nose pliers to make a small loop on the other end of the wire, leaving a small opening. Slip it over the bracelet and close the opening using the pliers.

MATERIALS

12-inch length of
24-gauge
memory wire

Glass bead,
approximately ¼ inch
to ¾ inch in diameter

TOOLS

Round-nose and
flat-nose pliers

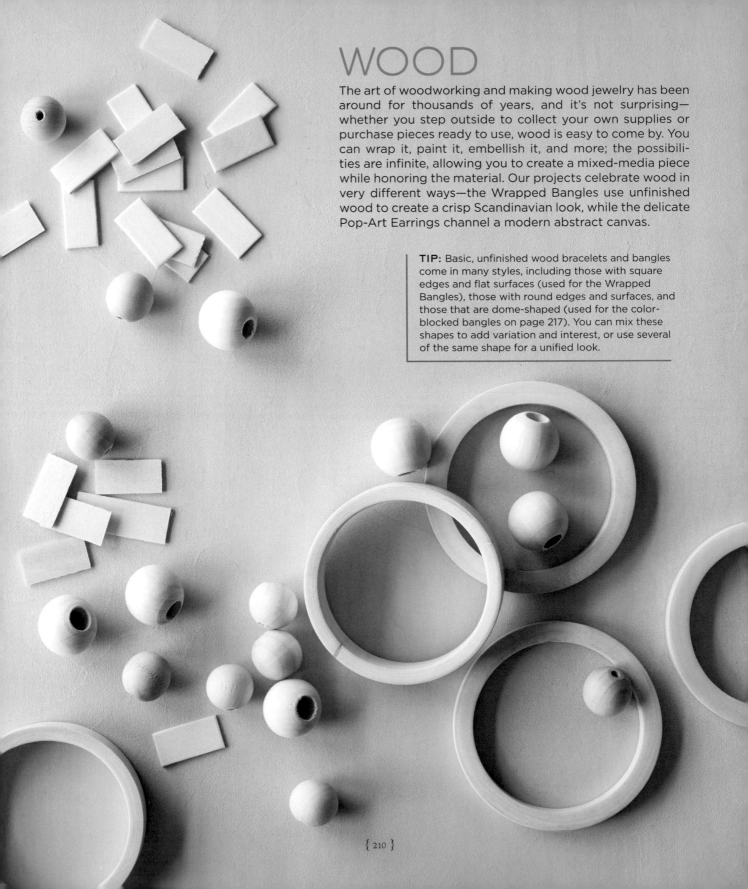

WOOD

The art of woodworking and making wood jewelry has been around for thousands of years, and it's not surprising—whether you step outside to collect your own supplies or purchase pieces ready to use, wood is easy to come by. You can wrap it, paint it, embellish it, and more; the possibilities are infinite, allowing you to create a mixed-media piece while honoring the material. Our projects celebrate wood in very different ways—the Wrapped Bangles use unfinished wood to create a crisp Scandinavian look, while the delicate Pop-Art Earrings channel a modern abstract canvas.

TIP: Basic, unfinished wood bracelets and bangles come in many styles, including those with square edges and flat surfaces (used for the Wrapped Bangles), those with round edges and surfaces, and those that are dome-shaped (used for the color-blocked bangles on page 217). You can mix these shapes to add variation and interest, or use several of the same shape for a unified look.

RECIPE 1:
WRAPPED BANGLES

MATERIALS

Waxed twine in pop colors (approximately 21 to 40 inches per piece depending on the size of the bangle)

Unfinished wood bangles in various sizes

TOOLS

Hot glue gun and glue sticks

1. Cut a piece of waxed twine that measures 21 inches.

2. Anchor one end of a piece of twine with your thumb on the inside of a bangle, then add a small dot of hot glue to secure. Let dry for 10 minutes.

3. Wrap the twine around the bangle at even increments (doubling or tripling rotations to achieve the desired design), pulling the twine taut as you work, adding a small amount of hot glue every so often to secure the twine to the wood. Once you've worked your way around the bangle, place a dot of hot glue on the inside of the bangle to secure the loose end. Let dry for 10 minutes and trim any excess.

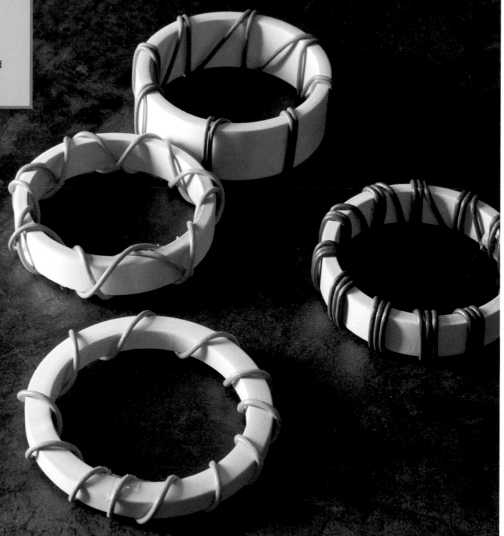

RECIPE 2:
DYED BEADED NECKLACE

MATERIALS

RIT dye (shown here: Lemon Yellow, Cherry Red [pink; see page 13], and Sunshine Orange)

Unfinished round wood beads, 30 to 40 per strand

3 lengths of cotton cord (each approximately 35 inches)

TOOLS

Glass bowl or plastic container (1 per color)

Bamboo spoon or slotted spoon

Paper towels

1. Create a dye bath (see page 13) in a dedicated glass bowl or plastic container.

2. Submerge the beads in the dye bath until the desired color is achieved. The beads will float to the top. To keep them submerged, consider placing a small plate in the bowl to press the beads down. Otherwise, stir the beads occasionally for even dye coverage.

3. Using a disposable or dedicated craft spoon, remove the beads from the bowl; blot them on paper towels, then let them dry for 3 hours.

4. Organize the dry beads into a design, then string onto the cotton cord and knot to finish the necklace at the desired length. Trim any excess.

NOTES

To achieve a richer hue, leave beads in the dye bath for an hour longer than recommended (see page 13).

We decided to string our beads in one color per strand. However, it is easy to open up the knotted closure if you decide later on to restring the beads to create a mixed-color necklace.

With a pencil, mark each wooden slab at the top center. Punch a hole through each mark using a Japanese screw punch (which will punch through the wood very easily).

2 Select a paint color. Dip the wood slabs ½ inch into the small pot of paint.

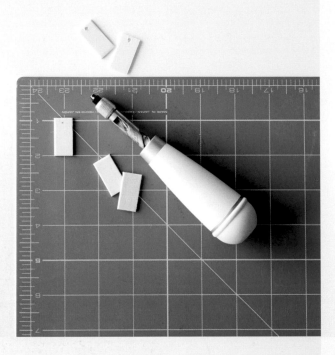

3 Immediately hang the dipped wooden pieces to dry, using head pins or open large paper clips extended over a small glass bowl for 45 minutes. Make sure the painted wood pieces do not touch the bowl as they dry, as this can smudge the paint.

4 Connect an earring blank to a small jump ring (see page 13). Secure tightly. Connect the small jump ring to a medium jump ring. When the hardware is fully assembled, attach the medium jump ring to the painted wood slab. Close off with pliers. Secure tightly. Repeat for the other earring.

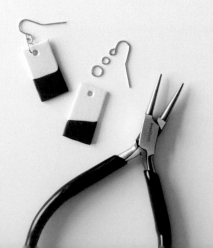

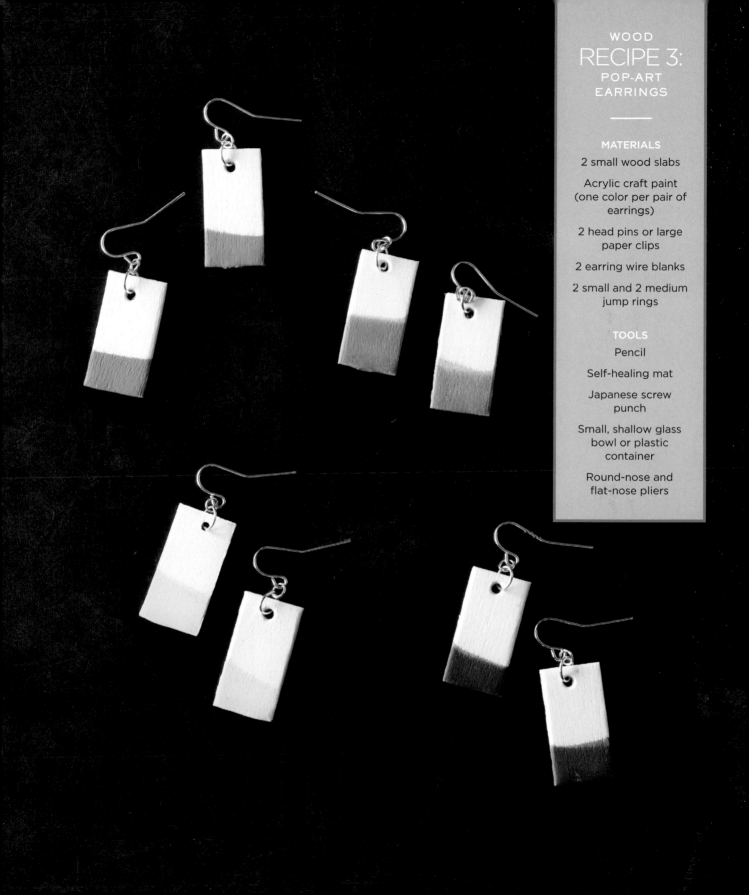

MATERIALS

2 small wood slabs

Acrylic craft paint (one color per pair of earrings)

2 head pins or large paper clips

2 earring wire blanks

2 small and 2 medium jump rings

TOOLS

Pencil

Self-healing mat

Japanese screw punch

Small, shallow glass bowl or plastic container

Round-nose and flat-nose pliers

YARN

I am not a big knitter, but I cannot resist the other possibilities that yarn offers. It comes in many colors, textures, fibers, and weights (thicknesses), and can be made from a number of synthetic or natural fibers. Cotton is the most commonly used plant fiber and sheep's wool is the most commonly used animal fiber, though yarn is often spun from cashmere, silk, alpaca, angora, mohair, and llama as well. I often associate yarn with cozy winter wear, like the Sweater Necklace, but an easy wrapping technique can transform yarn into the simple modern bracelets seen in the Color-Blocked Bangles. Yarn is a material that transcends trends and can be woven, wrapped, or knotted into almost anything.

TIP: Save leftover yarn from knitting or crocheting projects, even if you only have small amounts left; these pieces are great for any of the wrapping technique projects, and are the perfect way to color-block.

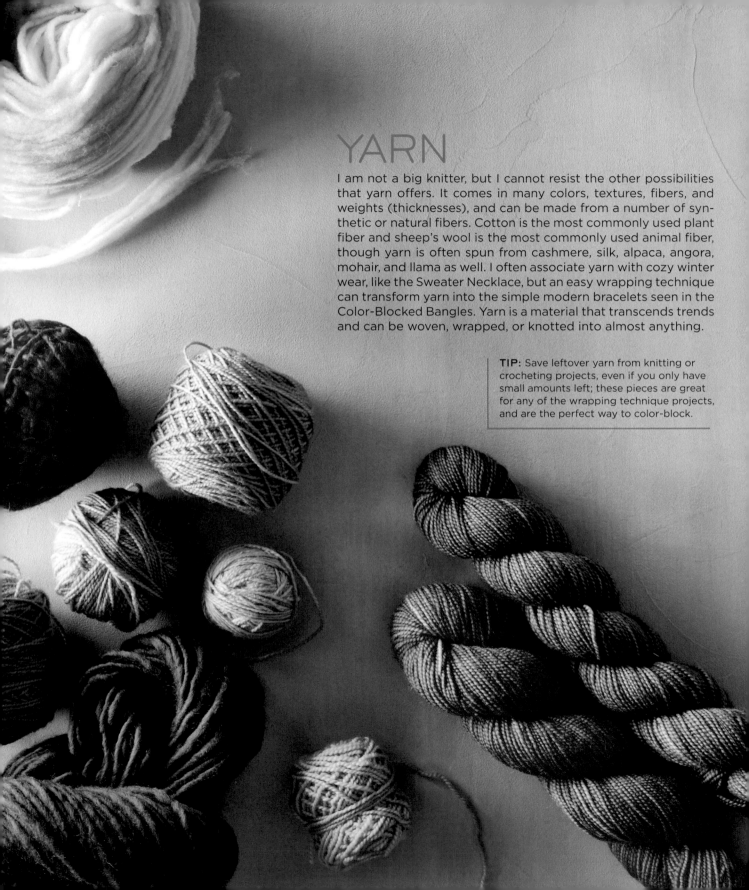

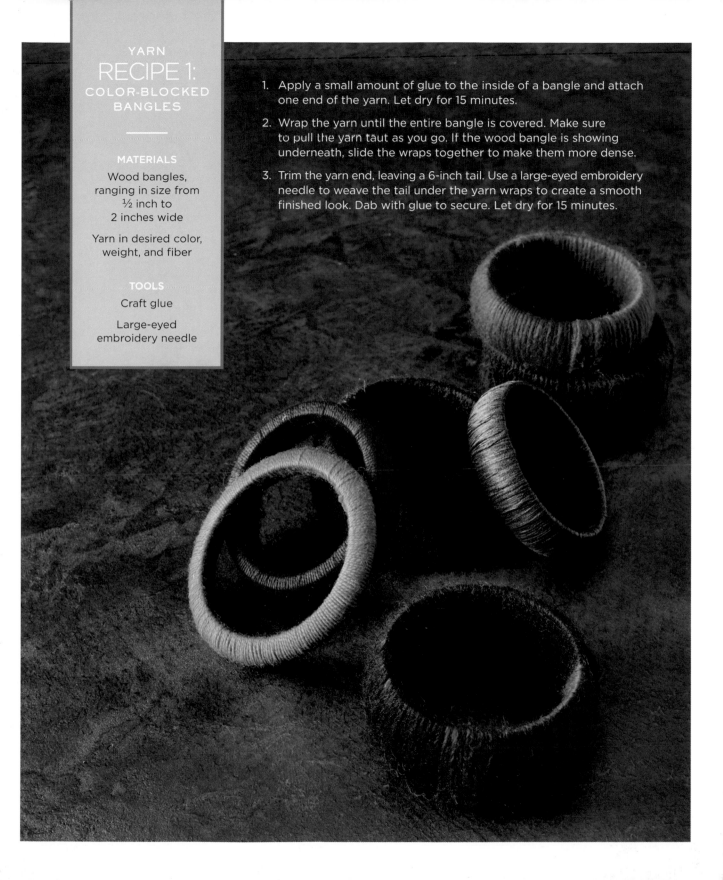

RECIPE 1:
COLOR-BLOCKED BANGLES

―――――

MATERIALS

Wood bangles, ranging in size from ½ inch to 2 inches wide

Yarn in desired color, weight, and fiber

TOOLS

Craft glue

Large-eyed embroidery needle

1. Apply a small amount of glue to the inside of a bangle and attach one end of the yarn. Let dry for 15 minutes.

2. Wrap the yarn until the entire bangle is covered. Make sure to pull the yarn taut as you go. If the wood bangle is showing underneath, slide the wraps together to make them more dense.

3. Trim the yarn end, leaving a 6-inch tail. Use a large-eyed embroidery needle to weave the tail under the yarn wraps to create a smooth finished look. Dab with glue to secure. Let dry for 15 minutes.

RECIPE 2:
SWEATER NECKLACE

MATERIALS

1 ball of worsted-weight yarn

2 yards of grosgrain ribbon, cut into 2 equal pieces

TOOLS

Crochet hook in size N-13 (9 mm)

Fabric scissors

Large-eyed needle

1 | Holding two ends of yarn together, and leaving a 4-inch tail, make a slipknot.

2 | Crochet a 100-inch chain (see page 12).

3 | Fasten off by cutting the yarn and pulling the end up through the last loop on the crochet hook. Leave a 4-inch yarn tail.

4 | Knot the yarn tails together; trim the ends. Fold the crochet chain four times to create a smaller layered circle of crocheted yarn. Slip a piece of grosgrain ribbon through each end by using a lark's head knot (see page 13). Tie the ends to wear the necklace at the desired length.

NOTES

When you join the two ends together, you will have a tail left over. Using the large-eyed needle, weave it through the crocheted chain to hide it.

Instead of ribbon, use a different material to tie the necklace, such as rope, leather, or cord.

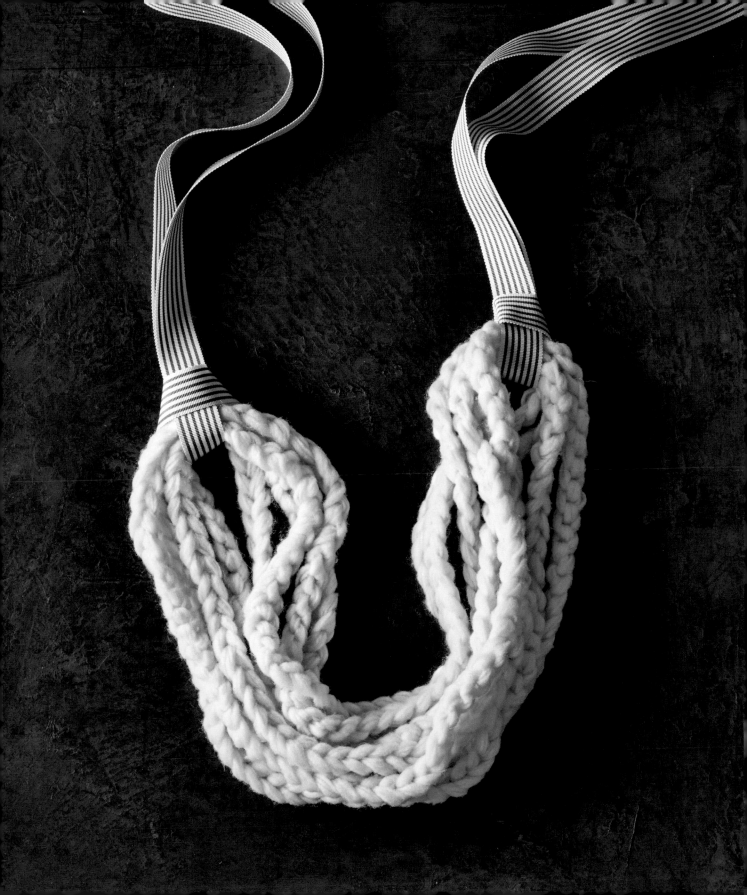

Cut and arrange the yarn and fabric: Cut strands of yarn that are 26 inches long, five to ten strands for each color. Cut fewer strands of the bulkier yarns, more for the thinner yarns. Cut one 26-inch length of fabric that is ½ inch wide. Last, cut two extra pieces of fabric that are 4 inches long and ½ inch wide. These will be used as ties in step 2.

2 Hold the yarn, fabric, and bead lengths together and secure them 3 inches from one end by tying a fabric tie tightly around them. Arrange the strands as desired, twisting the strands around each other or weaving some strands through the bunch. Wrap the beaded strand around the outside of the yarn bunch so that it is visible. Secure the other end with a fabric tie and trim the ends of the yarns to about ½ inch from the fabric tie.

3 Cut three 36-inch lengths of fabric, about ½ inch wide. Knot them together, leaving a 4-inch tail. Braid them tightly and knot the other end.

4 Cut two 7-inch-long, ½-inch-wide pieces of fabric and set them aside. Put a dab of fabric glue on the knots of the braided cord, and connect them to each end of the yarn necklace at the fabric tie. Hide the connection by wrapping a 7-inch length of fabric around it and securing with fabric glue. Trim any excess pieces once the glue has dried.

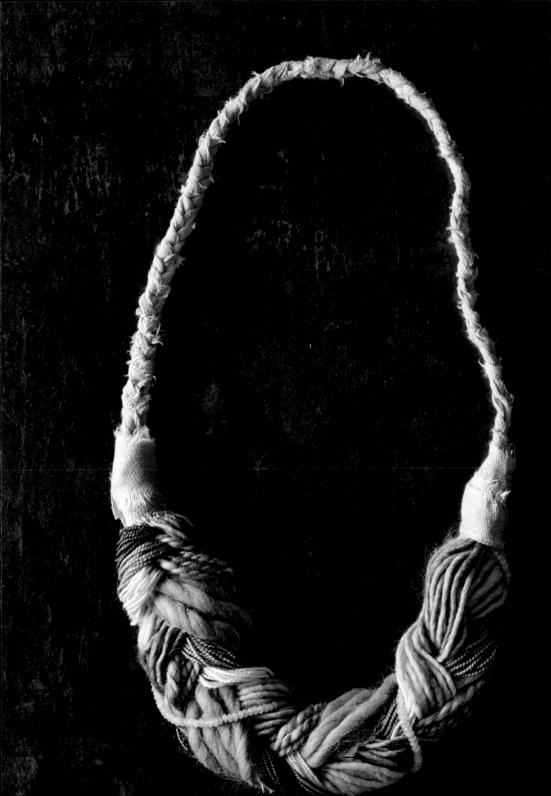

YARN
RECIPE 3:
BOHO YARN
NECKLACE

————————

MATERIALS

Yarn in 6 assorted
colors and weights
ranging from fine
to bulky

¼ yard of linen or
cotton fabric

24-inch length
of beads strung onto
beading cord, with
a 4-inch tail at
either end

TOOLS

Ruler

Sharp scissors

Magna-Tac 809 or
other fabric glue

RESOURCES

Below is a list of vendors from which we either sourced materials for this book (specific items for specific recipes are noted) or generally rely on for basic tools and supplies as well as harder-to-find items.

GENERAL SUPPLIES

Create for Less
www.createforless.com

eBay
www.ebay.com

Etsy
www.etsy.com

Hobby Lobby
www.hobbylobby.com
(800) 888-0321

Jo-Ann Fabric and Craft Stores
www.joann.com
(888) 739-4120

Michaels
www.michaels.com
(800) MICHAELS

Save On Crafts
www.save-on-crafts.com
(831) 768-8428

TRIMS, BEADS, CHAINS, AND NOTIONS

M & J Trimming
www.mjtrim.com
1008 Sixth Avenue
New York, NY 10018
(800) 9-MJTRIM

Toho Shoji
www.tohoshoji-ny.com
990 Sixth Avenue
New York, NY 10018
(212) 868-7465

Rings and Things
www.rings-things.com

Baubles and Beads
www.baublesandbeads.com
1676 Shattuck Avenue
Berkeley, CA 94709
(510) 644-2323

CANDY

Shopbaker's Nook
www.shopbakersnook.com

Economy Candy
www.economycandy.com
108 Rivington Street
New York, NY 10002
(212) 254-1531

FABRIC

B&J Fabrics
www.bandjfabrics.com
525 Seventh Avenue
New York, NY 10018
(212) 354-8150

Mood Fabrics
www.moodfabrics.com
225 West 37th Street, 3rd Floor
New York, NY 10018
(212) 730-5003

METAL HEXAGONS

Finding Club
www.etsy.com/shop/FindingClub

Metalliferous
www.metalliferous.com
34 West 46th Street, 3rd Floor
New York, NY 10036
(212) 944-0909 (store)
(888) 944-0909 (mail order)

PAPER

Jam Paper & Envelope
www.jampaper.com
135 Third Avenue
New York, NY 10003
(212) 473-6666

PARACORD

CLIMBING CORD
Vess 65
www.etsy.com/shop/vess65

PARACORD BRACELETS
Tough Bands
www.etsy.com/shop/ToughBands

PINECONES

Save On Crafts
www.save-on-crafts.com

SHELLS

Sea Shell City
www.seashellcity.com
708 Coastal Highway
Fenwick Island, DE 19944
(888) 743-5524

WOOD

BEADS
Woodworks, Ltd.
www.craftparts.com
(800) 722-0311

BANGLES
DIY Bangles
www.diybangles.com
(503) 992-8105

FOR THE MOSAIC PAPER NECKLACE, PAGE 121

FOR THE SHELL BIB NECKLACE, PAGE 163

ACKNOWLEDGMENTS

I am so thankful for the opportunity to create *The Jewelry Recipe Book* and work with such a talented group of people. This book would not be here were it not for that terrific team.

First, a big thank-you to Lia Ronnen for entrusting this project to me. I am honored and excited to be part of the Artisan "family." Thanks to Michelle Ishay-Cohen for her beautiful designs and guidance and to Keonaona Peterson and Sibylle Kazeroid for taking my words and making them better. To my core team: James Ransom, for his exquisite photography and wonderful personality, and for making every day we shot a fun experience, even when we had to rework projects right on set. Jenn Andrlik, my talented project manager, who is an extraordinarily organized, calm, and focused person, and a great source of knowledge. (She also makes a mean Life Savers candy necklace.) India Donaldson, who was always there with creative ideas and solutions, worked her magic on fabricating and set styling (she is the queen of styling what I refer to as *spillage*—loose beads), and is one of the key designers/makers of the projects in this book. James, Jenn, and India, thank you for always being there with great ideas and an endless can-do spirit. Carol Kemery of Caromal Colours for making our beautiful hand-painted surfaces. Gorgeous. And to the other key designers/makers for the many beautiful projects they contributed to the book: Laura Kaesshaefer, whose dyed wood beads are a favorite; Alison Caporimo, who brought passion to shrink plastic and polymer clay; and Tamara Schafhauser, for her exquisite vintage designs and our cover necklace. A shout-out to Erica Midkiff, a wonderful wordsmith, and to my sister, Susan Mernit, who always listens to my ideas. And finally, but most of all, to my family, Sidney and Asher, who give me the strength and encouragement (and time—all those weekends) to create this book as well as to pursue all things creative. Thank you.

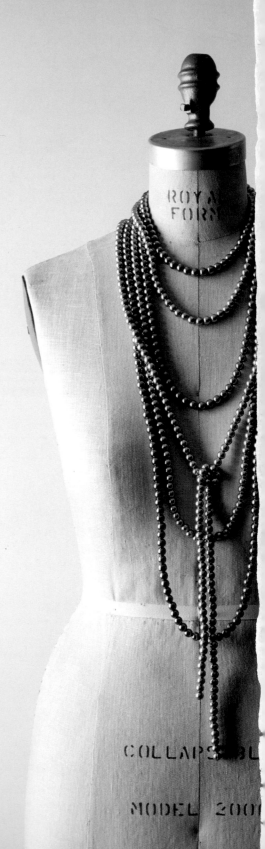

ALSO IN THIS SERIES

The Flower Recipe Book The Plant Recipe Book The Wreath Recipe Book